motion blur: onedotzero: graphic moving imagemakers

To cross the gap between philosophical and scientific
concepts – modelling – and the sensual experience,
the excitement of perception – simulation.

zeitguised

I want to create simple and cute things.
The influence is myself, what I used to be.

りょく どう
緑道で

きまりを

ぞなかよく

スマイル

キャッシング

tanaka hideyuki

motion blur: onedotzero

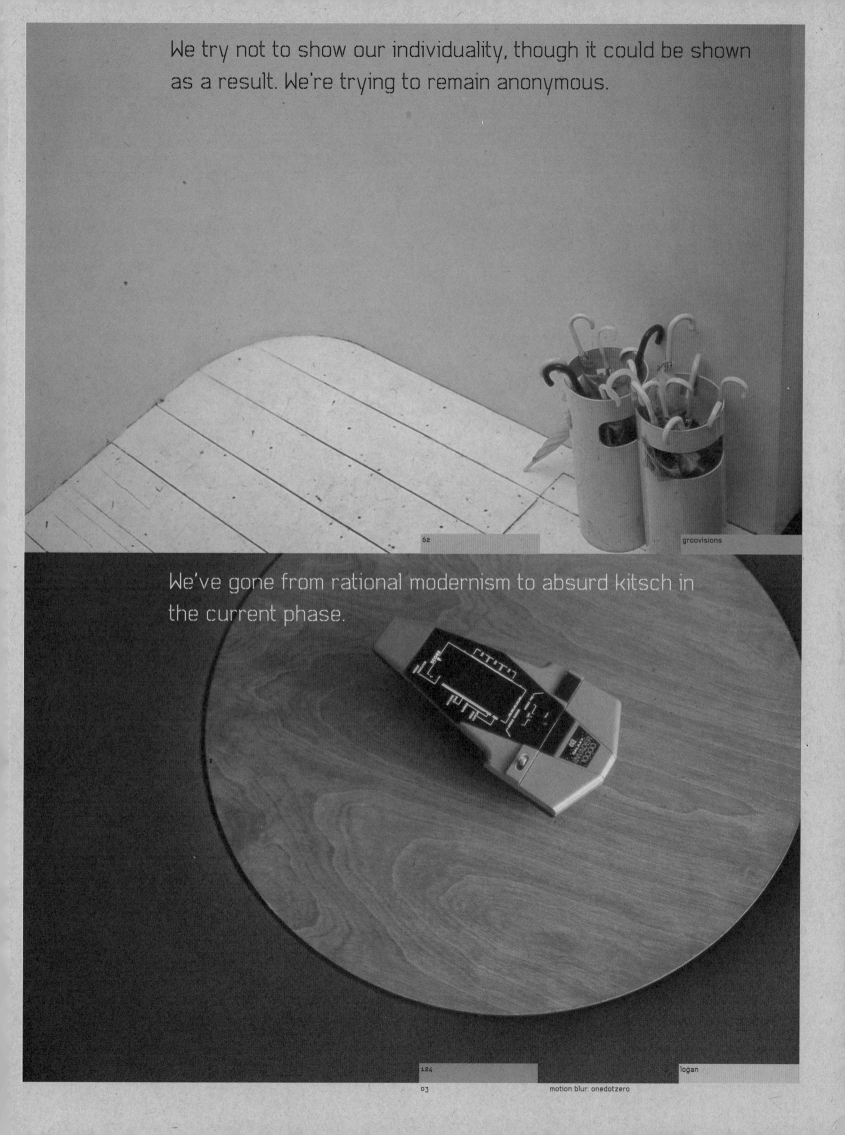

We try not to show our individuality, though it could be shown as a result. We're trying to remain anonymous.

We've gone from rational modernism to absurd kitsch in the current phase.

Current media styles are the last thing to react against, being so lame and insignificant. If you can coolly identify 'your style', then maybe you've had your time.

78 johnny hardstaff

A character can be perfect, more than human.

112 kuntzel + deygas

I love graphics, I even do graphics about graphics.

geoff mcfetridge

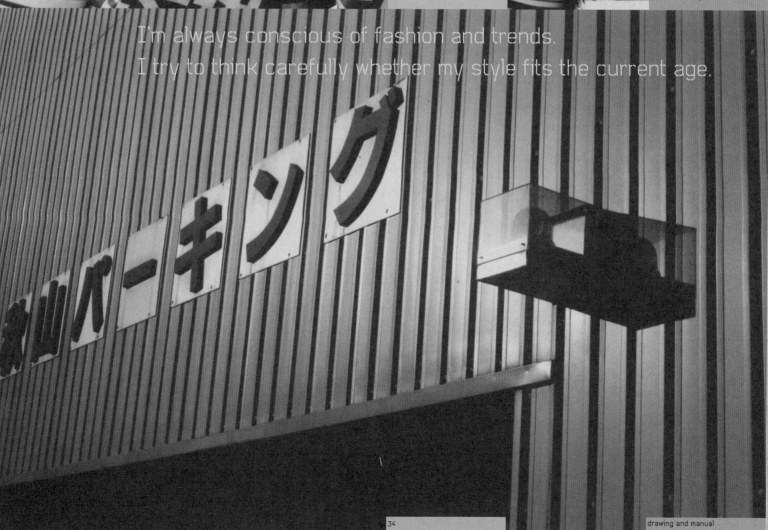

I'm always conscious of fashion and trends.
I try to think carefully whether my style fits the current age.

drawing and manual

motion blur: onedotzero

It's not possible to prove that the colour red I'm seeing is the same red as the colour you're seeing.

All the tools we're working with are just regular computers so there's no extremely big expensive machines that you need to have or something. Anyone can do it. Try it.

For some reason we want to adjust the 'pop feeling' that probably helps some people get up in the morning to artistic, scientific and philosophical thoughts.

zeitguised

The strange thing for me has been the slow development of a new part of my brain. I never really had a visual language before the age of 28.

tim hope

motion blur: onedotzero

We need to know loneliness to be creative.

186 tanaka noriyuki

In the beginning we started with what we could find, the first thing being a job for a funeral parlour to show people what was new in the world of death, like cardboard coffins.

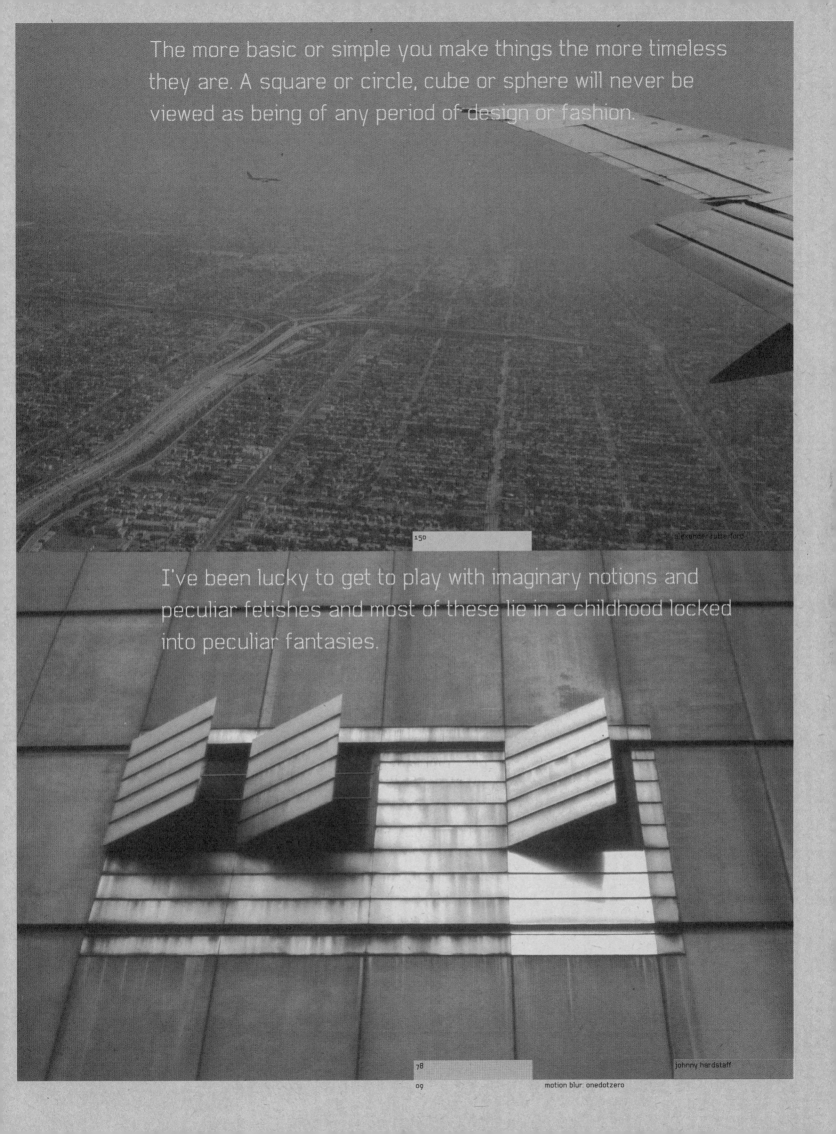

The more basic or simple you make things the more timeless they are. A square or circle, cube or sphere will never be viewed as being of any period of design or fashion.

150 alexander rutterford

I've been lucky to get to play with imaginary notions and peculiar fetishes and most of these lie in a childhood locked into peculiar fantasies.

It's like a pyramid of consumerism and even desire. So we just
play on that whole theme of changing the minds of the masses.

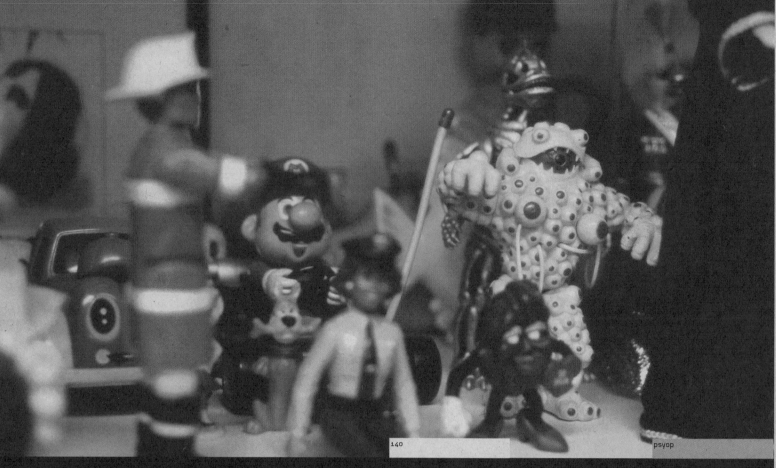

140 psyop

We want to create graphics that make people feel happy.
This is our way of communicating with the audience.

18 caviar / tycoon graphics

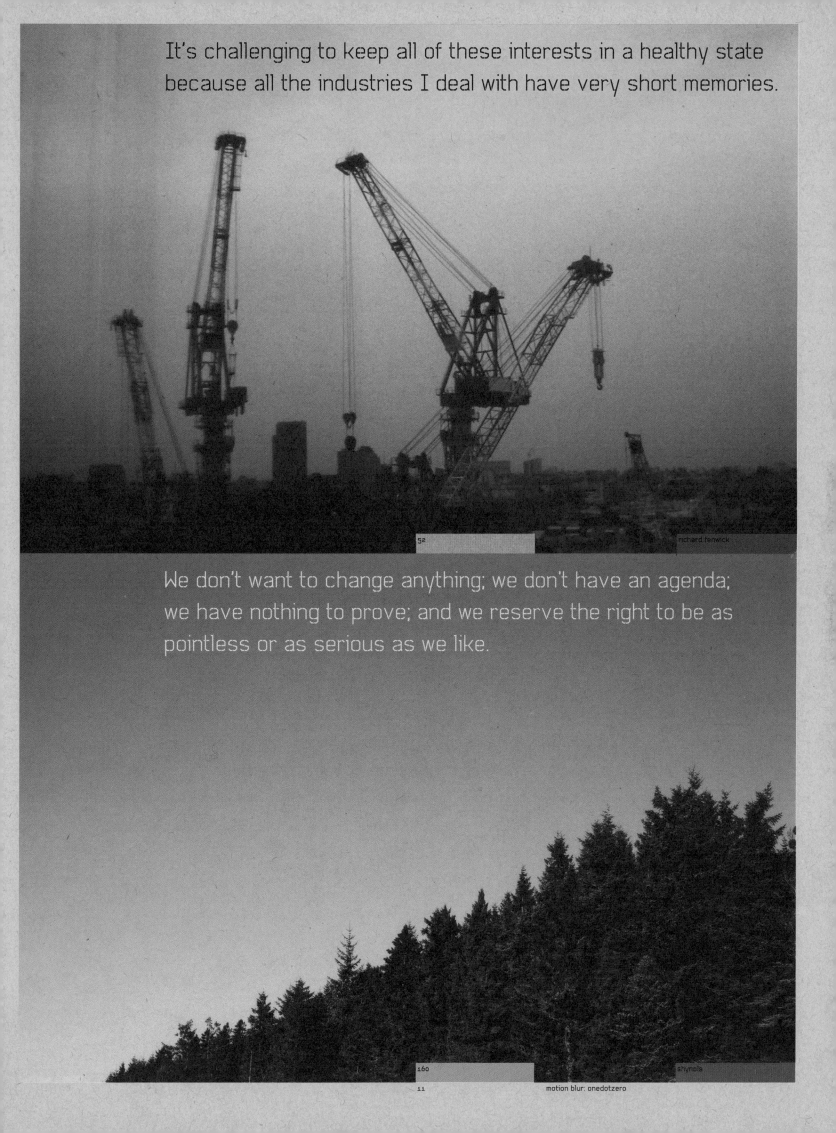

It's challenging to keep all of these interests in a healthy state because all the industries I deal with have very short memories.

We don't want to change anything; we don't have an agenda; we have nothing to prove; and we reserve the right to be as pointless or as serious as we like.

52

richard:fenwick

160

shynola

motion blur: onedotzero

LAURENCE KING

First published in Great Britain in 2004
This paperback edition first published in 2005 by
Laurence King Publishing Ltd
71 Great Russell Street
London WC1B 3BP
United Kingdom
Tel: +44 20 7430 8850
Fax: +44 20 7430 8880
e-mail: enquiries@laurenceking.co.uk
www.laurenceking.co.uk

DVD produced by: onedotzero

Design: Book + DVD: Philip O'Dwyer, State

onedotzero adventures in moving image
www.onedotzero.com / www.onedotzero.jp

A catalogue record for this book is available from the
British Library.

ISBN-13: 978-1-85669-465-0
ISBN-10: 1-85669-465-8

Printed in China

motion blur: onedotzero: graphic moving imagemakers

introduction:
print to video

Motion Blur is a book about the new graphic landscape of moving image. It is a landscape that has been rapidly assimilated by a worldwide culture, so much so that it is remarkable to think what has been made possible by the revolution in digital filmmaking. The last decade has seen an incredible change in the way moving image can be created. This continuing process is producing a coruscating variety of visual exploration, notably within the areas of animation, motion graphics and digital effects.

Motion Blur gathers together twenty-eight exhilarating talents from around the world who have contributed to this transformation. The moving imagemakers profiled exemplify the different ways of working, and the wide variety of work enabled by this graphic evolution of the image. It is a selection anchored by onedotzero's continuing investigations into the area, and its mapping of the constantly shifting contemporary visual terrain.

The book offers an intimate encounter with the creative approaches of those profiled. Like the onedotzero festival and events, it is about creating a dialogue between these creators and the audience, between maker and viewer. And it does this not by simply showing the visual results, but by revealing the creative processes, motivations and pathways which result in this artistic production.

The interviews featured here suggest a creative community with common concerns and motivations, but it is also evident how the creative process has become even more individual. The digital process has empowered individual forms of visual expression and this has resulted in a myriad of mutating moving-image forms. These forms rapidly propagate and are increasingly being assimilated by other areas and creators, contributing to the drive for innovation.

The talents within this book have one thing in common: they could never be described as traditional film-makers. Predominantly their work has moved from the page and onto the screen, they print visual expressions to video. The flowering of time-based work around digital media has created opportunities for a generation of digital creators to move seamlessly between creative disciplines and the chance for their artistic output to range across an unprecedented assortment of media and delivery platforms. They approach the medium from different standpoints, from the areas of architecture, animation, computer game design, new media, fine art and club visuals, but mainly from graphic design.

First came the tools and then the creators. The rise and ubiquity of non-linear editing tools and composit-ing software gave the means of production to a new type of visual artist. It shaped the exploded filmmaker, one who shatters the conventional boundaries of creative disciplines to create moving-image forms. This has resulted in a spectrum of styles that break away from easy classification. The boundaries

between animation, motion graphics and digital effects, and their relation to the 'filmed' image are essentially meaningless. The pure film has given way to hybrids of moving image that have influenced other more traditional animation areas and have colonized areas from broadcast design to music videos. Live action is fused with graphic-fuelled stylings to create fresh visual approaches and forms of storytelling.

As the interviews in this book suggest, the demarca-tion between art and commerce has become blurred along with the lines between traditional artistic disci-plines. The notion of pigeon-holing your creativity is coming to an end with the convergence in production, application and consumption. The mantra of 'I am my own client' has been made possible through this digital cross-breeding, so the division between art and commerce, personal and client-based work has returned to a more holistic experience.

In a historical context, much of what this book explores has come from a reinvention of graphic pioneers and experiments in early cinema: a necessary investigation to examine the possibilities of the tools. But this learning curve from the infancy of digital filmmaking to a maturing visual landscape has been phenomenally steep. The new developments examined in Motion Blur have come about as a direct break away from the conventional constraints of a mainstream 'Hollywood' cinema.

onedotzero's focus as a visual ideas laboratory has given us a fantastic opportunity to witness and participate in this shift. In 1996 there was no such thing as Final Cut Pro. Outside the rarefied atmosphere of the downtown post production suite, realtime effects didn't exist. Compositing meant watching a crawling black bar for hours, days. We had to explain to people what motion graphics meant. Now a more mature environment of creative applications, and broader acceptance of different visions of moving image exist, and the time is right for us to record in book form artists who have come along that journey.

onedotzero was created at the advent of desktop digital filmmaking, an event signalling the end of celluloid. But rather than the demise of 'film', this moment resulted in the birth of a whole new spectrum of moving-image exploration to complement and also challenge the more established medium.

onedotzero's adventures in moving image have resulted in a blur of motion and ideas. International inflections and creative disciplines further smudge traditional definitions and boundaries. This book charts and celebrates these adventures, capturing them in print form at the same time as setting them free to inspire and excite the future of moving image.

Shane RJ Walter / Matt Hanson

contents

motion blur: onedotzero

caviar /
tycoon graphics

The moving-image collaborations between Caviar and Tycoon Graphics have achieved a mystique that has been accentuated by the difficulty of finding information about their creators in the West. Individually their work has very different flavours, Caviar preferring a more freeform approach to its video pieces, while Tycoon Graphics almost exclusively limit themselves to cool print-based projects. Their rare collaborations together, extending Tycoon Graphics' visual treatments to video via Caviar's unique touch, generate a third zone of creative endeavour which showcases how co-operation can bring about artistic dividends. This work stands out for its obsessive detailing and obtuse takes on reality. Caviar and Tycoon Graphics have created consummately ironic and stylish video clips together for fashion labels such as Boycott and, separately, mindblowing work for music acts such as Fantastic Plastic Machine and Tei Towa. Panning and scanning across a myriad of motion-graphic styles and approaches, their partnership has produced virtuoso works of motion design.

01-02
Vivid work bursting with vibrant colours that Caviar created for the short film-focused Japanese TV programme 68.

03-04
Caviar's first collaboration with Tycoon was the award-winning Iron Tank project for fashion brand Boycott. Nakamura Takeshi of Caviar directed the film work based on Tycoon's print campaign of 1998.

01

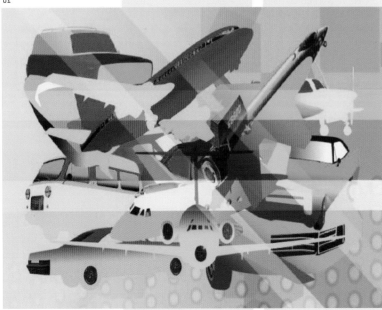

02

How did you get involved in moving image?

NT: I've liked drawing since my childhood and used to paint in oils. I went to art school, where I studied graphic design. But I didn't attend regularly, and was searching for a specific direction. I liked pictures and design so much and wanted to animate them. I was really interested in moving-image work, so it was natural for me to become a director.

SN: The reason I decided to work in this field is because I like drawing and creating something. I wanted to be an illustrator, but it was too tough to make a living as one, so I started working at a design studio part-time.

How do you collaborate with each other?

SN: When we worked for the fashion brand Boycott, the designer Tayama Atsuro would give us a concept. We then worked out how to visualize the idea in 2D, but we thought that it would be more interesting if there were motion graphics using the concept, not just print. When we were commissioned to make the Boycott promo video I wanted to do it with Nakamura and called him. Boycott is one of our best projects, I think.

NT: The first piece was Iron Tank, which had a military theme and Tycoon did the catalogue first. They showed me the print design and asked me to make the graphics move. I tried to expand the idea using these images and made 12 short jingles. The next theme was Easy Rider, about motorbike riders' fashions.

03

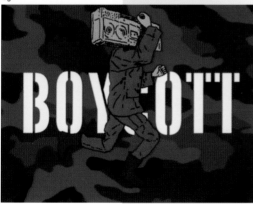

04

SN: When we did the video for that, Men's Rider, we made everything using photography. We shot everything with stills first, like the scene with the biker revving the accelerator. How many cuts did we shoot? About 200 in total.

Each season at Boycott has a different theme. With that first video, the idea was to sublimate the military image into fashion. We wanted to create something that is not only stylish, but something ridiculous like an iron tank. We always want to create humorous stuff. There are some people who create shocking visuals with a negative approach, like Benetton. We want to create graphics that make people feel happy. This is our way of communicating with the audience. With Iron Tank, we thought it would be good to do something ridiculous, but in a serious way.

How did the Champagne Design project come about?

SN: We don't want to disappoint ourselves. We want to create work that we love, that comes from our imagination and is inspired by our surroundings. This is better for us than simply developing a trendy idea. The reason why we decided to do the Champagne Design project was because we wanted to do something that would create an immediate reaction. Ginza Graphic Gallery where the project took place is very traditional, but we didn't want to do any detailed designs just to gain recognition from people in the same field as us, by using special inks or something like that. We basically wanted to communicate with people through our design, so we decided to do motion graphics.

How do you apply ideas to your work?

SN: About ten years ago when I lived in New York, a group called Dee-Lite were very popular and I met Tei Towa, who was then a member. I started thinking about the remixing process in house music, sampling all types of sounds to create one stream or concept. Designers used to have a certain way of thinking about their work; 2D artists used to have a way of thinking in graphics. But like what Miyashi Yuichi and I are doing now, we think it's good for us to mix all sorts of things, not limited by form. In a band each member plays a different instrument individually, but when they play together, they make great music collectively. When you do something alone, you usually come to a dead-end, but it's good to collaborate to see yourself objectively.

Have you been working on anything that you would class as unexpected?

SN: We've worked on the Atehaca electrical appliances project with Tei Shuwa, who is Tei Towa's brother. He's an architect and doesn't usually do product design. But when he goes to buy electrical appliances, he can't find anything he wants in the store, so his solution is to design his own. Once you limit your territory, it becomes restricting. It's important to collaborate with many people regardless of their speciality.

lolJP
interviewed:
Nakamura Takeshi [centre], Caviar Suzuki Naoyuki, Tycoon Graphics

Nakamura Takeshi operates from his own studio, but has worked with Tycoon Graphics, part of the Graphikers Collective, for many years. Both companies are based in Tokyo.

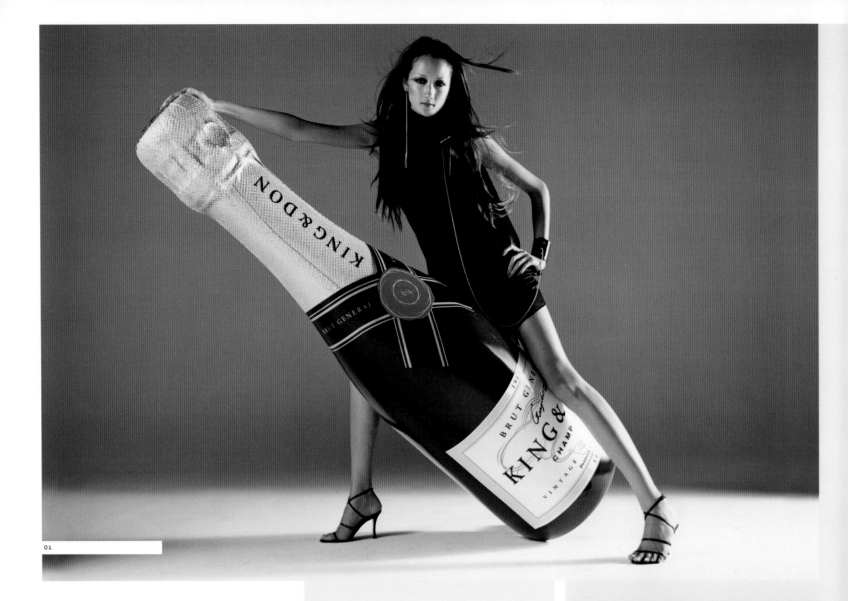

02

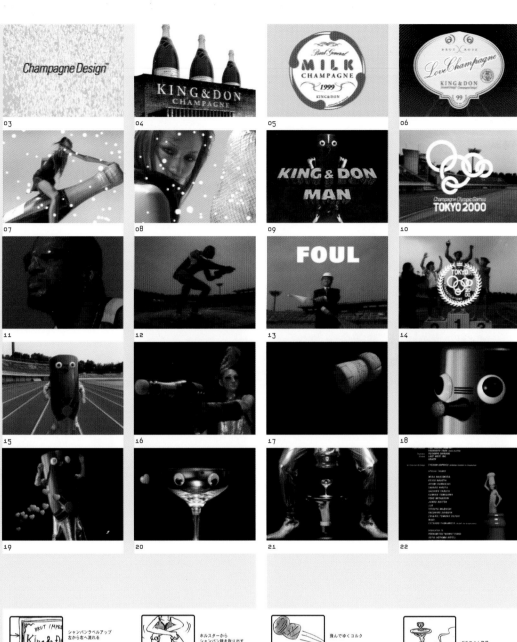

03 04 05 06
07 08 09 10
11 12 13 14
15 16 17 18
19 20 21 22

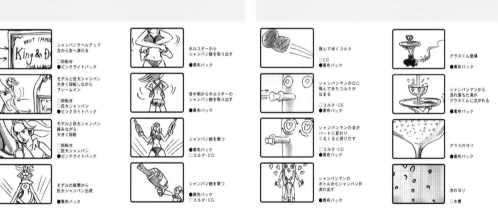

<u>Champagne Design Posters</u>
The Champagne Design project
was created for the traditional
Ginza Graphic Gallery in Tokyo.
Tycoon wanted to create an
immediate reaction with work that
had no obvious links to their usual
style. Large posters were pro-
duced alongside motion-graphic
pieces with Caviar.

03–22
<u>Champagne Design Film</u>
After collaborating on the Boycott
campaign, Caviar and Tycoon
continued working together on
the self-generated Champagne
project, a series of films that
included an intoxicating motion-
graphics and live-action mix
featuring champagne Olympics
and Tokyo starlets straddling
oversized bottles.

23
<u>Champagne Design Storyboards</u>
Storyboards for the Caviar
directed films for the Champagne
Design project.

01–48 overleaf
<u>Mother, until we meet again</u>
Caviar created an animated short
series featuring the daring
adventures of 'super salaryman'
Daisuke. Full of action and
surprises, it's a humorous,
madcap story, which stunningly
blends colourful 2D illustration
with 3D CG.

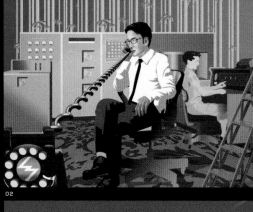

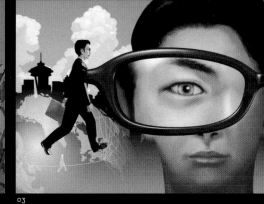

01

04

05

06

07

08

09

ビジネスマン
再会物語
第一回 再会への旅立

13

14

15

16

17

18

19

20

21

22

23

24

25

26

27

28

29

30

31

32

33

34

35

36

37

38

39

40

41

42

43

44

45

46

47

48

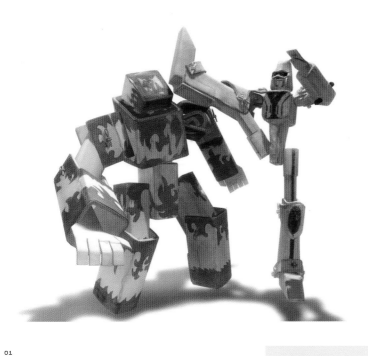

01

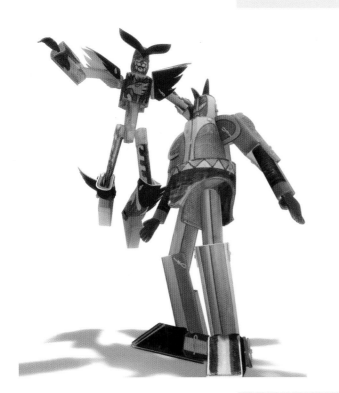

02

03

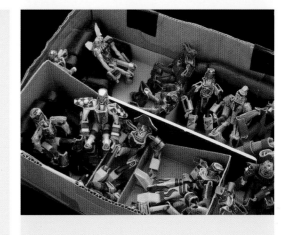

01–05
Kami-Robo is a personal docu-
mentary project looking at the
world of Yasui, a 30-year-old man
who has created dozens of paper
robots which he battles and cre-
ates tournaments with alone. Live
action, security cameras and CG
are combined in the production.

01–03
CG tests of the paper robots.

04
The actual collection of paper
robots, awaiting battle.

05
Paper robot template.

05

geoffroy de crécy

Although he works in full 3D, Geoffroy de Crécy's animation is grounded in classic characterization. In a world of cool, clinical motion graphics, his work feels crafted and more human. In his music-video collaborations with his electronic music-producing brother, Etienne, which take sideswipes at automobile and fast-food culture, not to mention Wall Street, he is already showing a flair for fluid storytelling.

01-08
In the music video Scratched, made for his brother, French house producer Etienne, Geoffroy de Crécy takes a swipe at auto culture. In this superb animated journey two dog characters go in search of batteries to fuel their TV remote at the cost of gallons of petrol.

01

02

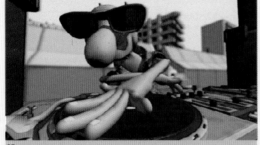
03

04

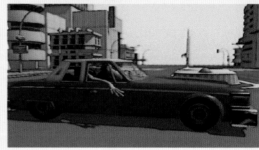
05

06

07

08

motion blur: onedotzero geoffroy de crécy

How did you learn animation, and on what type of projects did you start acquiring your skills?
I learned how to turn on a computer when I started work for a French video-game company, Ubisoft, in 1996. It was the beginning of full 3D games, so the company gave us 3D software, dropping us in at the deep end and telling us, 'Now you are 3D graphic designers!' I worked for three years creating backgrounds for video games like Rayman 2. I first started creating animation when I left the company and made the video for Am I Wrong?

There is a very distinctive cartoon style to this and your following work. Why did you pursue this style?
This is my personal style. Firstly, I was an illustrator, and my 2D work had this cartoon style. I love the work of Robert Crumb, for example. When I discovered 3D tools and software, I thought they were particularly well adapted to the kind of characters I wanted to design. At the time, the people who used these software applications tended to make very stereotyped heroic-fantasy works, with aliens and knights from the Middle Ages. So working with my good old cartoon style was rather original. Of course, I'll try to work with different styles in the future, although I think you will

always be able to recognize my 'touch'. Working in different media, such as clay or traditional cartoon, would help me to expand my styles and find new approaches, but at the moment I'm still very involved in 3D CGI. It was my original job, and I still feel possibilities in this medium, so creating in this style continues to fascinate me. At the present time I feel more concerned about directing and how to tell a story, rather than about changing my graphic style.

Can you guide us through the creative process on a typical project such as Am I Wrong?
As Am I Wrong? was my first work, it is not a very good example of how one should proceed: I didn't make any storyboards, any preliminary drawings of characters, or anything. In a way I didn't need to because I worked by myself, and didn't have to communicate my intentions to anybody. But for the two other videos for Etienne's album, Scratched and Tempovision, I worked with a team, so the process was different: I made a 3D animatic, which set the timing of the cuts, the camera moves and the editing. It's a kind of super-storyboard, a basis for the whole team's work. I don't draw any sketches for the characters because I created the models directly for them myself.

→

09–11
Test animations and character development.

IIIIFR

Geoffroy de Crécy's studio lies in the same courtyard as those of his brothers, recording artist Etienne and fellow animator with H5, Hervé.

09

10

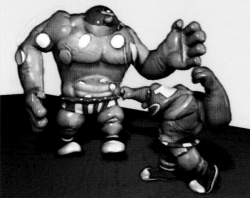
11

The initial ideas often come from little sketches drawn on the corners of bits of paper, with no particular intention behind them. In fact, what I did with the first video was bring together some ideas and environmental sources I had been playing around with in the month before, and tried to find a story from that stuff, linking these characters and environments.

What is it like working with your brother Etienne de Crécy, and how do you view the videos you have done for him?
It was very comfortable working with my brother because with just a few clues and simple directions he could imagine what the final film would look like. I didn't have to explain things and reassure him, which is what I often have to do with other clients. After we had agreed on the scenario and storyline, he really trusted me to create the rest. It was a very close collaboration, as I could hear him working on his tracks in the room next to the one I was working in.

Of course, the three films are not technically sophisticated, but I'm very happy that we made these music videos together, because I think that using them as three episodes of a series gives a real value to the music-video medium.

What motivates you to animate?
At the beginning my motivation was to make some entertaining designs, and to find some fun stories that I could fit with these designs. Now I feel more interested in editing, telling a story with good backgrounds and characters.

Why do you think France is creating such great animation at the moment?
I'm really not connected with the other creators in Paris, except my brothers who are also involved in animation. I've not been to art school, so I really don't know if there are some common motivations among French CGI artists. Factors such as the economy of music videos and the success of techno music have simply given an opportunity for young graphic creators to show their skills.

01–09
Tempovision. Geoffroy's third collaboration with brother Etienne, follows the two animated hounds in another colourful adventure in the dawg-eat-dawg world of stock-market trading. An inspired animated romp that fuses Breakdance with Wall Street and brings a whole new meaning to the term 'movers and shakers'.

05

02

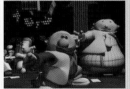

04

06

08

07

09

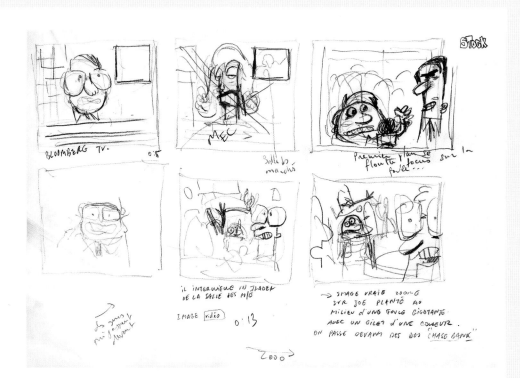

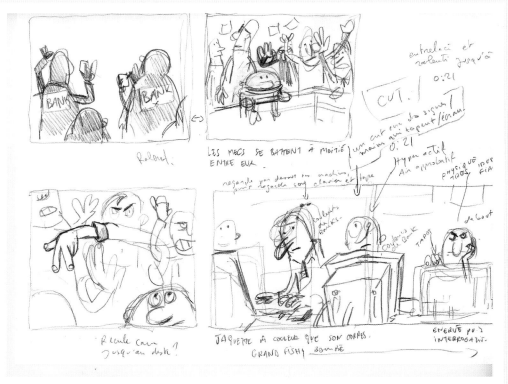

10–12
Storyboard sketches for the music video Tempovision.

10

11

12

motion blur: onedotzero geoffroy de crécy

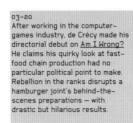

03–20
After working in the computer-
games industry, de Crécy made his
directorial debut on Am I Wrong?
He claims his quirky look at fast-
food chain production had no
particular political point to make.
Rebellion in the ranks disrupts a
hamburger joint's behind-the-
scenes preparations — with
drastic but hilarious results.

un bon taff

01

02

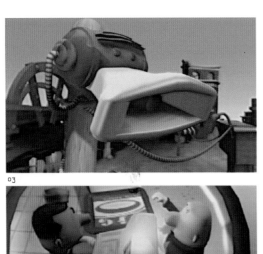

03

04

05

06

07

08

09

10

11

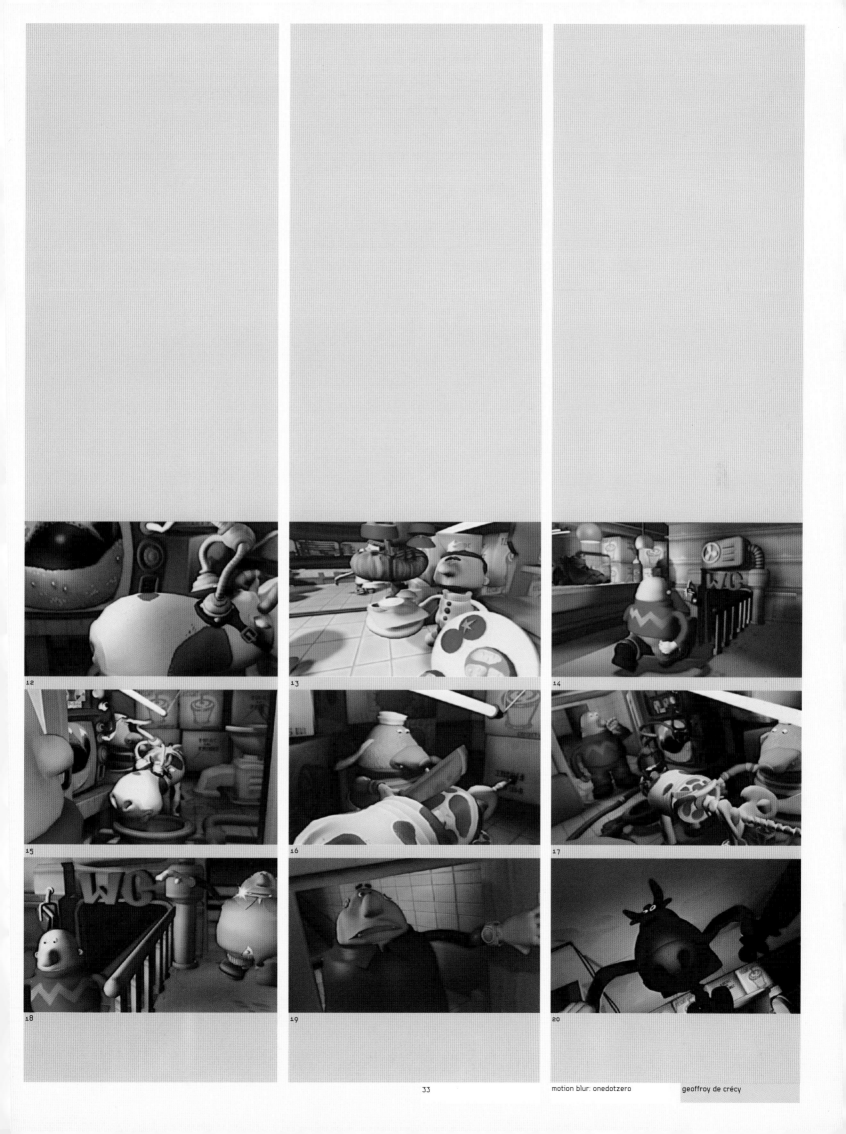

12

13

14

15

16

17

18

19

20

motion blur: onedotzero

geoffroy de crécy

drawing and manual

Hishikawa Seiichi's company is a busy, multi-purpose creative centre. The Drawing and Manual building comprises subterranean design and motion-graphics studios, and above ground the D&Department, a recycled-furniture centre, gallery and café. It's a world where first appearances can be deceptive. Underlying D+M's signature frenetic and kinetic style is a calm and considered approach that is able to ground a wide range of visually diverse work in a common aim.

01

02

03

04

05

06

07

08

motion blur: onedotzero

How do you describe what you do and your background?

Basically I don't see myself as a moving imagemaker. I think I'm a creator. I'm also a designer. A designer who creates moving images.

My first job was at a record company. I was originally a sound designer. I started working as a recording engineer at recording studios where there were loads of music videos, and my interest naturally shifted to promos. I talked with my boss and said, 'I want to do something related to video. Are there any good jobs?' Then I got work with a post-production facility in New York, and started there as an editor, which was when I got involved in moving image. I was in New York for three years from 1991.

What cultural influences do you have?

The biggest influence is Brian Eno. He made <u>Thursday Afternoon</u> with Sony in around 1989 or '90. When I first saw it, I wanted to create something like that. I've been influenced by avant-garde contemporary art and experimental moving images like those of Brian Eno and Nam June Paik. I often went to galleries to see experimental moving images. I don't think that I create artworks or that I just do a job. When I'm commissioned to do something, I always think whether my idea fits it or not. I'm always conscious of the fashion and trend. I try to think carefully whether my style fits the current age, whether they need my work. I think about that almost every day.

What specific Japanese influences do you have?

Basically film. I've been influenced by Japanese visual creators' films. The Kurosawa films are well known in the world, but I prefer the old films of Yasujiro Ozu. I like the Kitano films as well. I've been influenced by such films, and also by animation. I think this is the same for all our generation. The <u>Tensai Bakabon</u> animation that I watched on TV in my childhood is a great influence for me.

In Ozu's films the camera is pretty static, but your work has tremendous movement. What do you have in common with him?

Ozu said his concept for his films is 'nothing'. It is a concept somehow related to traditional Japanese

→

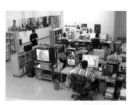

lol JP
<u>interviewed: Hishikawa Seiichi</u>

Hishikawa's design company Drawing and Manual is a busy, multi-purpose and highly creative centre, which includes the D&Department café and recycled-furniture/design store run by partner Nagaoka Kenmei.

09

10

11

12

01-13
Hishikawa's creative talents and versatility are expressed in two personal, contemplative and atmospheric film pieces, made in collaboration with D+M animator Jogano Nobuhiro. These fluidly choreographed shape and form animations — 01-08 <u>Prelude</u> and 09-13 <u>Airline</u> — are inspired by the hues of the natural world, and the flow of wind, water and air. They are accompanied by piano and orchestral soundtracks, which give them a timeless quality.

13

01

02

03

04

05

06

motion blur: onedotzero

drawing and manual

beauty, the elegance of simplicity, which is called 'Wabi Sabi'. It's a state of perfect self-effacement. Do nothing. I imagine that Ozu was trying to catch something like an atmosphere in his films. It's not easy to do.

I respect Ozu's view of the world. I hope I can make such films. If I can put what I feel into moving image, and if it can represent 'nothing' as a result, this is when my style will be complete. It's far from being complete yet. I keep trying all sorts of new techniques and styles.

What about foreign influences?
Music videos. In my school days, there was a TV programme, The Best Hit USA, with Kobayashi Katsuya as the presenter. I liked to watch it every week and it influenced me a lot. During the '8os rock and pop music from London was really popular in Japan. I vividly remember the music videos of Culture Club, Duran Duran, A-Ha and others, so I was strongly influenced by them.

How do you develop an idea?
My work now is totally different from what I did three years ago, and of course from five years ago as well.

The point I focus on is always changing. The most important thing for me today is whether I can explain my work in one word, like 'happy' or 'disgusting'. That's my initial approach.

I don't think about my commercial and personal work separately. I see both of them from the same point of view. With a Macintosh, anyone can make something on their own. New creators are really lucky in creating moving image, compared to our generation. I've been strongly influenced by younger people's work. I guess they use computers like a musical instrument, creating moving image and VJing in the same way they might play a guitar. I envy them in some ways as I wanted to spend my youth like them.

Have you ever thought that your work doesn't look very Japanese?
I'm very conscious of foreign feedback, how I'm recognized internationally. I want to be free from the limitations of Tokyo and Japan, and this is why I studied English. I'm always aware of the international market and I'm glad to be internationally recognized. But I was born and bred in Tokyo, so it's natural for my work to represent Tokyo in some way.

01-06
Global brand moving-image sequence for Sony Ericsson. Creative director: Hishikawa Seiichi. Designer: Jogano Nobuhiro.

01-12 overleaf
Ideas for the abstract personal pieces Airline and Prelude. Hishikawa explains: 'Thinking about the process, I try not to be a factory. Members of our team always try not to see themselves as a moving-image production line. I define myself as a designer. We always see ourselves as a creative team. We try to avoid traditional styles.'

07-12
1999–2000 Special opening sequence for a special TV programme on the Viewsic Music Channel. Creative director: Hishikawa Seiichi. Co-director: Okada Masato.

13-18
Hishikawa created the opening sequence for Apple's Creators Portfolio exhibition.

07

08

13

14

09

10

15

16

11

12

17

18

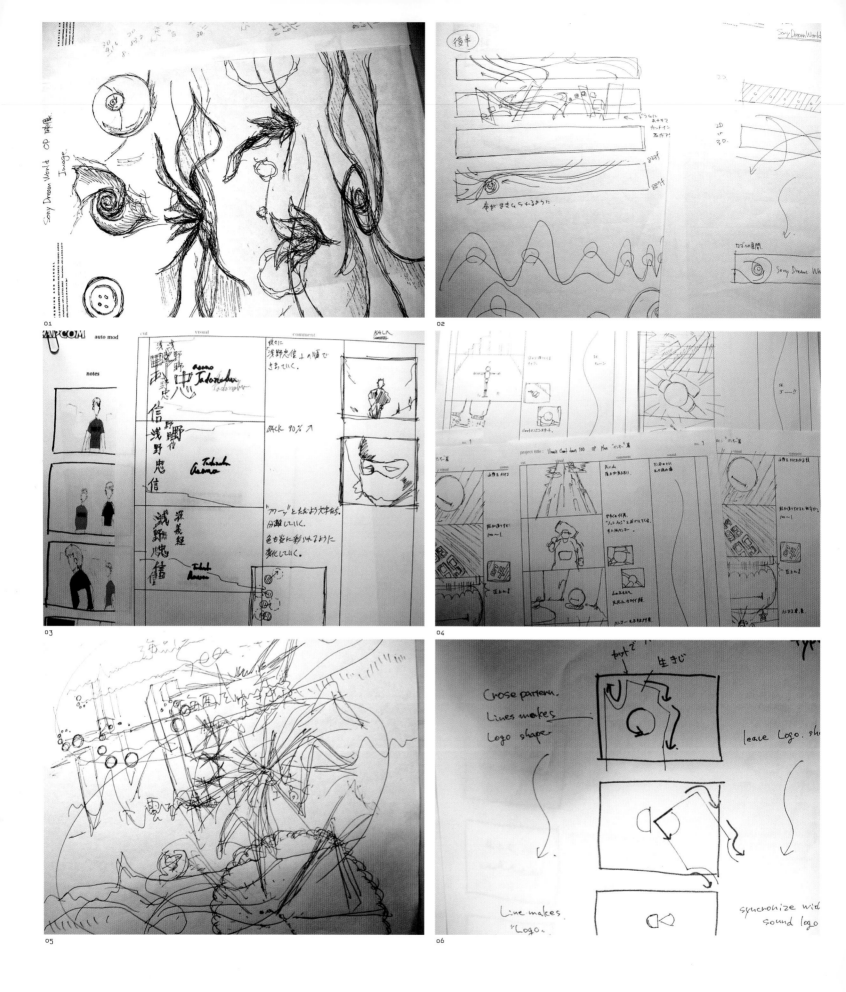

07

08

09

10

11

12

01–12
Sonic Temple is an animation
a-go-go music promo from D+M
lab director Okada Masato. Rough
sketches, illustrations and digital
images combine to produce a
flash-frame frenzy in this intense,
unrelenting piece of work.

13

14

15

16

17

18

19

13-19
Creative director Hishikawa
co-directed Grand Prix, a high-
tension work inspired by the
fastest sport in the world, with
Okada Masato. The piece was
commissioned by onedotzero for
a onedottv TV series.

eyeballnyc

Distinctly urban–American in outlook, EyeballNYC
have managed to combine some highly professional
work for corporate clients such as Nike and Sony
PlayStation with more modish projects, such as
creating graffiti stylings for Mos Def, restrained
minimalist credits for filmmaker Richard Linklater's
film Tape and documentary/motion graphics hybrids
for the Disc Jockey series for Shotime Networks.
Rather than espousing a narrow and visually dis-
tinctive aesthetic, EyeballNYC continually explore
fresh approaches which they see as most relevant
to the project at hand.

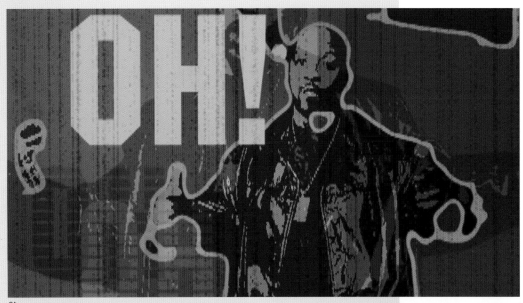

01

01–06
The Oh No! music video for Mos
Def and Rawkus Records was
designed, edited and co-directed
by EyeballNYC and was nominated
by the MVPA for a hip-hop
music video of the year award.
EyeballNYC have worked with
Rawkus on many videos.

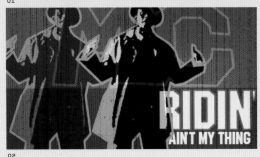

02

03

04

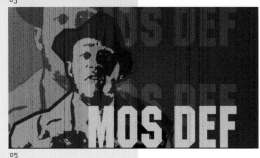

05

06

Can you tell us about the genesis of EyeballNYC, and what's different about your approach?
LS: I think you could look at the details of our process and find differences between our company and others, but there's nothing of great significance. We are traditional designers and thinkers. We want to make the most out of each job we take on. We enjoy the collaborative process.

Your Disc Jockey films splice together documentary interviews with a myriad of graphic styles. Can you tell us more about the evolution of this work?
AM: The initial idea came as a tongue-in-cheek backlash to all of the media hype around DJs over the past few years. We knew we were playing into it and we wanted to keep it entertaining, but we were very clear that it should never feel like MTV Cribs or other shows that simply promote an unrealistic view of life. So we came up with a way of combining very real interviews, where the DJs could feel comfortable being authentic, with fantastical interpretations of their true anecdotes. It was so important for me for the audience to really be able to relate to these people, instead of seeing them as untouchable icons, because, for all their fame and talent, they have normal concerns like everyone else. The style for each episode came from working with the DJs themselves, us getting inspired by the music, and our wacky ideas of things we had always wanted to see on TV but no one had ever done. Colour palettes were usually determined by the DJs themselves, and they were writing the music, so we worked together as much as we could to make something that really shows who they are.

We shot the episodes in one month, travelling around the States with a small crew. The design team rotated on each episode, but a lot of the credit should go to Tatiana Arocha, who helped shape the style and feel of most of the episodes. To get ourselves situated we watched hundreds of hours of anime, collected party fliers, pulled magazine clippings, read comic books — difficult stuff like that. I would quickly edit the DV footage to two minutes in a day or so, because I had been editing in my head, even during the interview. Then we would do quick storyboard sketches for how the animation section would work. The animation is a mix of 3D (Maya, Max) and 2D (After Effects) and all of the 3D had to be built from scratch for each episode because the styles were so different. I think we'll never do that again!

There's a great range of styles in your work. The minimalism of the Richard Linklater film titles for Tape really stands out, for instance.
JH: While designing it, I decided I wanted to keep the titles kind of abstract, like a mini-idea that we don't expect everyone to grasp right away. I think this treatment demonstrates that white type on a black background can still be interesting. I selected an industrial typeface to create the feeling of the simple text one might see on a cassette box or a tape-recorder housing. The key was not to make a stylized presentation, which would run counter to the tone of the film. I wanted the titles to pop on screen but not to appear to be digital animation, rather a little off, a little dirtied-up, as opposed to a creative typeface treatment.

Do you feel there any key differences in your field between what's produced in the US, Japan and Europe?
LS: I think there is a great difference between the three commercial markets. The Japanese seem to have a lot of fun and just do cool stuff. Europeans are smart and daring with their projects. The US is scared to push past the lowest common denominator, but once in a while pops out some really intelligent stuff.

≡ US
interviewed:
Limore Shur [right],
creative director
Alex Moulton [left],
director/editor
Jory Hull, designer

Production company EyeballNYC
are based in SoHo, New York.

07

08

07-08
EyeballNYC director Alex Moulton teamed up with Thomas 'Lord of the Marionette' Sontag to co-direct Hot in Herre, a tongue-in-cheek music video for Montreal's premier DJ, Tiga. 'Tiga was very excited about using Thomas's marionettes, so we came up with a dream list of locations and sets for the video and worked backwards from there,' says Moulton, who handled editing and cine-matography duties in addition to co-directing. 'We really wanted to make this feel as much like a true hip-hop video as possible — we directly referenced larger-than-life scenes in videos from artists like Puffy, Missy Elliott and 50 Cent in coming up with the concepts for the different backgrounds.'

01-05 overleaf
Titles for the Richard Linklater film Tape. 'The challenge was to develop a title concept that would not overwhelm the simplicity of the movie itself. The animated treatment is intended to look like it might have been shot with a miniature handheld DV camera and presents the titles and credits as if they are on a video cassette tape, passing through an invisible capstan and briefly stopping before the viewer,' explains executive producer Mike Eastwood.

06-17 overleaf
EyeballNYC seized the chance to explore fresh creative territory for the Shotime Network's ten-episode Disc Jockey series profiling American DJs such as Craze, VinRoc, Infamous, Disco D Reid, Speed and Terrac. Each of the smart, stylishly constructed interviews was given a look of its own to bring out each DJ's personality and style. The hilarious anecdotal sections are fantastically illustrated, playing with a range of genres from manga to flat Flash-style and old-school cartoons.

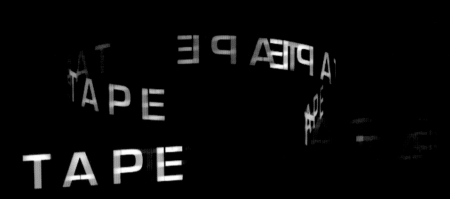

01

**The Independent Film Channel
Productions**
Presents

TAPE

02

03

TAPE

Directed by
Richard Linklater

04

05

motion blur: onedotzero

eyeballnyc

06

07

08

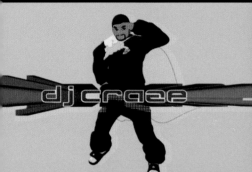

09

10

11

12

13

14

15

16

17

motion blur: onedotzero

eyeballnyc

felt

Spirit was an early personal film from directing duo Richard Carroll and Dominic Bridges. 'Our inspiration for Spirit was the Sumatran people. The title of the piece refers to their religion [Islam] and their fatalistic driving madness! And also the other spirits like the tiger in the jungles.'

Both members of Felt come from a graphic design background and apply this training to their filmed work, which features subtle touches of motion graphics. A documentary project for CIFOR, The Centre for International Forestry Research, filmed in Sumatra introduced a more issues-based edge to their work, which was all the more distinctive for having rarely been attempted in the motion-graphics arena before. This trajectory, which has seen them play with the short documentary form in Spirit and Underdog, is leading them to more ambitious storytelling projects. Felt are Richard Carroll and Dominic Bridges.

01

02

03

04

05

What are your particular backgrounds, and why did you want to get into film?

I studied graphic design, then worked for a packaging design consultancy and my own graphics consultancy. I became interested in making graphics move and bought a copy of Adobe's Premiere version one. This blew both me and Dom, who'd been doing some work with me, away. After a short period with other companies we set up Felt as a new venture specializing exclusively in moving image, leaving the print graphics behind.

Does your approach differ depending on whether you're making a personal or a commercial project?

I think we try to approach every project, personal or commercial, in the same manner. We go for the optimum solution – often at the expense of winning the project, if it's a commercial pitch. This may seem odd, but I think that if we didn't do this then our personal work would seem pointless. It's the crossover that interests us. We have had many responses from creative directors at ad agencies saying our treatments or tests blew them away but that they felt they needed to play it safe. Things are converging, however, the longer we continue to work. Agencies are catching up.

Tell us about Spirit.

It was shot over a week in February 1999. I was in France, shooting an experimental piece in the Camargue. At Montpellier airport I got talking to a guy and it turned out he needed a team to document an international workshop and conference he was involved with

→

06

07

08

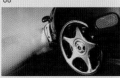

09

10

11

08–11
Felt have used their visual style for a range of advertising briefs from PlayStation games to Nissan car commercials via a whole series of spots for Fox Sports in the USA. They are now also producing music videos to add to their portfolio of work.

✳UK
interviewed: Richard Carroll [left]

Felt are Richard Carroll and Dominic Bridges.

motion blur: onedotzero felt

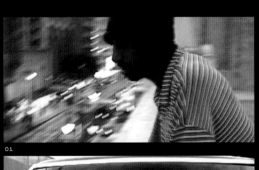

01

02

03

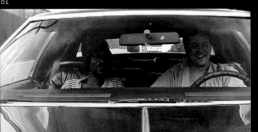

04

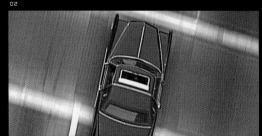

05

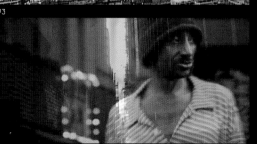

06

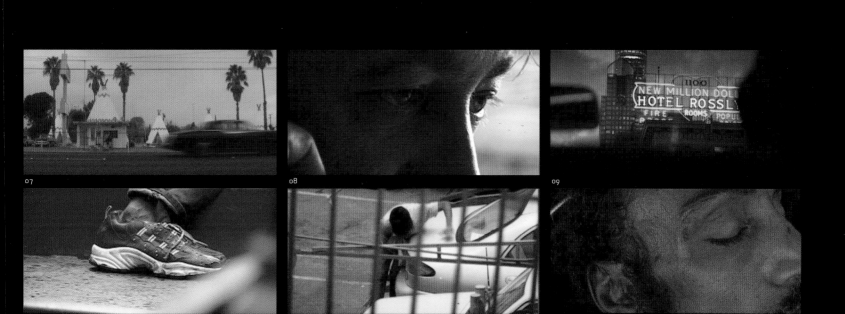

07

08

09

the following February in Sumatra. I said we'd do it. In downtime, we walked around the town, mixing with the locals, shooting anything interesting. The friendly Muslim population were extremely happy, even though they had few possessions. They had something else — belief. We took a trip into the rainforest and our guide, At, sparked our minds when he told us about the jungle spirits, life/death and the Koran. This was the catalyst for Spirit. We chose a phrase from the Koran underlining the importance of belief because it struck us how central this was to these people. We shot on Sony DV cameras and recorded audio straight into the camera. I think it has a brooding style. Images build with type throughout. You are made to read the copyline gradually as the underlying layers build beneath.

Underdog was a long process, and a departure in terms of its narrative and documentary style. Why did you want to do it, and what do you think you gained from it?

Underdog was the film which we wanted to make straight after Spirit as it had characterization and a storyline, but was still totally controlled by us and shot in a very free way. We had been directing commercials in Los Angeles and had been thrown in at the deep end. It was quite easy to talk to all kinds of people — we were non-threatening, quietly spoken English directors. We had met Billy Fox, the location manager on our projects, and through him had learned a lot about the business and how it is set up. This all inspired us to make a film about our view of LA in

→

01–12 previous pages; 01–15
Underdog is a personal film project that sees Felt move into documentary territory. It brings together two sides of LA and two different characters: 40-year-old, half-Cherokee, half-black street poet Greg, and God-fearing film-location fixer Billy. Greg has never left the confines of the city and longs to go fishing as his grand-father once did — but for a black man it is hard to buy a licence. The film follows their journey from the high rises of LA to the tranquil Bear Lake beyond the city limits, where Greg delivers his poem on the water.

01–04
The documentary starts in the heart of LA, where the evident poverty sits uneasily with the excesses of the movie industry. 3D wire frame and full renders were made to integrate with the live-action helicopter shots of LA which track Greg and Billy's limousine through the streets. These frames did not make it into the final cut of the film.

05

02

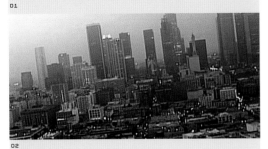

01

03

04

06

07

motion blur: onedotzero

felt

general, and the film/commercials production business.

Billy knew this 'street poet', Greg Turner, who apparently lived in a car park. We quickly realized that theirs was a mutually dependent relationship. Greg needed Billy's cash, Billy needed Greg's expert street knowledge and contacts when he wanted to use a few blocks of downtown as a location. We thought that we could use these two characters to show the real grassroots of film production and at the same time, using Greg's poetry, the racial divide between them; we used the fishing metaphor to turn it into a more impressionistic piece about these issues. Originally, we saw it as far more layered and involving more time-slipping of scenes. We have a whole van full of material which isn't in the film, though. We know that our next

film will be shot to script, or at least have a script. Underdog was part of onedotzero's documentary commissions.

What else would you like to explore in your work?
We want our work to diversify into distinct areas: one, to explore more pure live-action solutions with the arrangement of images telling the story as much as the dialogue and action; two, to develop our motion graphics to a new level where it could look like animation although shot photographically. We are also developing a feature-length project.

09
At street level the car was rigged to capture the candid scenes between the two men, with Billy driving and Greg rehearsing his poem Beneath the Belly of an Underdog.

08

13

09

11

14

10

12

15

01–04
RND#24: Artificial Worlds was
produced by Marcus Gosling who
also crafted the 3D work and con-
vinced IDEO to take Fenwick on
as an artist-in-residence in San
Francisco, where they created the
first seven RND# films. The basis
for the soundscapes for #24 and
#06 was recordings made by an
illegal scanner that allowed mobile
phone calls to be listened to. The
footage was filmed by Dylan Nolfi
around Pacific Way, Marin County.
'While we were there, we wondered
why everyone was talking about
their emails, cellular phones and
online banking while they were
supposedly enjoying a stroll in the
blissful Californian countryside,'
remembers Fenwick.

Fenwick is a great advocate of, and experimenter
in, graphic-based filmmaking. Constantly playing
with the dynamism of the screen, his work has
taken a twin-track course — an increasingly live-
action focus has given him greater commercial
viability, while his graphic output has become more
concentrated through his ref:pnt [reference point]
studio. Fenwick's work has matured from one-note
graphic explorations to complex mini-narratives,
with such experimental films as his RND# series
and incendiary pop promos for Timo Maas.
Emerging from all this is a fascination with the
discreet, hidden electronic worlds underpinning our
modern 'natural' environments.

→

05–06
Fenwick started as a designer at
Static 2358, working on channel
branding and broadcast design. In
late 1998 he left to co-found OS2
with Adam Jenns, an independent
studio with a remit to blend live-
action filmmaking with graphics.
Before OS2 was disbanded in
2000, he directed a number of
short experimental films including:
States [05], Fractions [06],
Centre of Gravity and the onedottv
commission People.

✳ UK
Richard Fenwick divides his time
between personal projects and
commercial jobs, working from his
base in London.

02

05

03

06

04

RND(#) Project

Introduction

Remit

General Information 2000-2001

Acknowledgments

Copyrights

Credits

ref:pnt (reference point)

Chronological Data 2000-2001

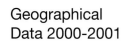

Country: USA

Country: UK

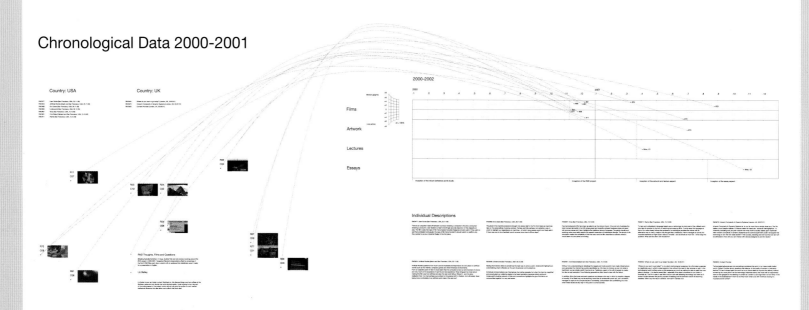

Films

Artwork

Lectures

Essays

2000-2002

RND Thoughts, Films and Questions

Individual Descriptions

Geographical Data 2000-2001

Gall Projection World Map Scale 1:200,000,000 (Approx.) Atlantic Centred

Gall Projection

Bay Area, California, USA

A

Marin, California

Oakland, California

San Francisco, California

B

World Map Symbol Guide

Flight Routes

A RND Lines

London, UK

Wembley, London

Islington, London

Clerkenwell and
Shoreditch, London

Key Personnel

RND Notes

Colour Guide

Symbol Guide

Key Locations

Colour Guide

Symbol Guide

Key Locations

Key Personnel

RND Notes

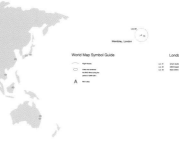

Statistical Data 2000-2001

Balance of Power

Colour Guide

Number of Collaborators - during period of 2000-2001
(Grey = new acquaintances)

You have very particular views about graphic moving image, don't you?
I think after I made my first graphic film [States] I immediately began to look for ways in which to make my graphic filmmaking meaningful, rather than simply showcasing it as a new technique or an aesthetic. So, over the last three years I've been mostly concerned with thinking and honing my views on combining graphic design with narrative filmmaking. Most of these ideas remain unpublished and the research is ongoing. However, I use my own studio, ref:pnt, to experiment with these thoughts at a cursory level and I've managed to get some of them out into the public domain.

Tell us about your most personal project, RND#.
RND# [random number] was born out of a time and place and a desire to question a subject matter that truly fascinates me — I mean, what better subject is there than an investigation into technology's effect on humanity as we enter the 21st century?

The project is an ongoing series of short films that investigate and question this weird and wired co-dependency. Taken singly, the films are little more than random thoughts and snapshot commentaries, but as an intended set of 100 they will, collectively, serve a more useful purpose: offering a comprehensive document charting these most challenging of times.

Artistically RND# also serves many purposes for me: it is a long-term commitment which allows me to return to it whenever I want to and gives me an evolving perspective on the subject matter. It is also the perfect project to try out graphic and narrative hybrids, as they often manage to visually mimic the struggle between technology and humanity I'm seeking to explore in the content.

What is your favourite piece of work to date?
I don't really have a favourite. If anything, I look to my existing works more in terms of their flaws so as to learn from them — in a perverse way the films with the most flaws are my favourites because they give me the greatest creative kick up the backside.

What has been your greatest challenge?
Not the projects themselves. More challenging has been the career route I've attempted to take — and that challenge is ongoing. Shifting across disciplines is very difficult, because you are forever convincing strangers to trust you — often without the work to back up your enthusiasm. In five years I've managed to jump from graphic design to motion design to narrative filmmaking and scriptwriting, and that arc of skills is still changing and evolving rapidly.

It is also challenging to keep all of these interests in a healthy state, because the industries I'm dealing with all have very short memories, so you can't dip out of one for too long without damaging the progress you were making, which I find very frustrating.

Can you chart your creative history to the present?
Heavily condensed: left-handed; only child; Lego; Atari 2600; supportive parents; Commodore 64; mouse and cheese; Mr Cadwell; Amiga 500; graphic design; MED; Blade Runner; Ridley Scott; acid; The Mayfair, Deluxe Paint 4; Aphex Twin; Magic Markers; John Dyer; Bedlingtonshire Safeway; Apple Macintosh; leaving home; Mike Luxton; Neville Brody; David Carson; linear edit suites; Stanley Kubrick; S-VHS video camera; Kerry Roper; London; Static 2358; Mark Rock; mini-DV; Media 100, After Effects; Chris Cunningham; OS2; Adam Jenns; the London graphics scene; Michelle Martin; Marcus Gosling; onedotzero; ref:pnt; Flynn; Mary Calderwood; Jo Phipps; Sam Brown; the music industry; film; narratives; San Francisco; IDEO; keeping a notepad; politics; RND#; Jo Godman; Unified Systems; BASIC*; DesignLAB; Nele Ströbel; Shanghai.

How do you come up with your treatments?
The ideas almost always come from the music: lyrics, composition or both. That might sound obvious, but not many promo directors that I've met seem to worry about the music too much. I put a lot of emphasis on the music and then shape narratives or scenes around its structure. All songs have an overall vibe, and it's important to find the right visual for that vibe without resorting to cliché. Because I feel comfortable across a few disciplines, my ideas are never limited to just live-action or graphic concepts. I try to be utterly appropriate: I think that this might come from being trained as a graphic designer where you are essentially taught to be a problem-solver rather than a stylist. This approach becomes obvious when you look at my promos for Chris Clark's Gob Coit and Teenage Fanclub's I Need Direction. They are like chalk and cheese, both musically and stylistically.

Your projects seem very self-referential. Is this whim or myth-making?
There's maybe a little bit of whim and myth-making in there, but ultimately it's more about day-to-day practicality. I put projects into mental spaces so that I can divide them up easily. Working on scripts, promos, print design and graphic films is a bit of a headfuck because they are all very different and yet they overlap, so it's easier for me to put projects into specific spaces — which, of course, I can't leave at that because of my graphic-design background and therefore logos and identities develop, too — which is handy, if only for a web presence.

Talking of self-referential, my own studio, ref:pnt, is entirely that. It's meant to be a transparent and visible journey of me as a creative. It falls completely outside of any commercial auspices, and for that reason alone can be followed as a clear and unambiguous journey. The RND# project could only ever have been born in this headspace, and I think that that shows.

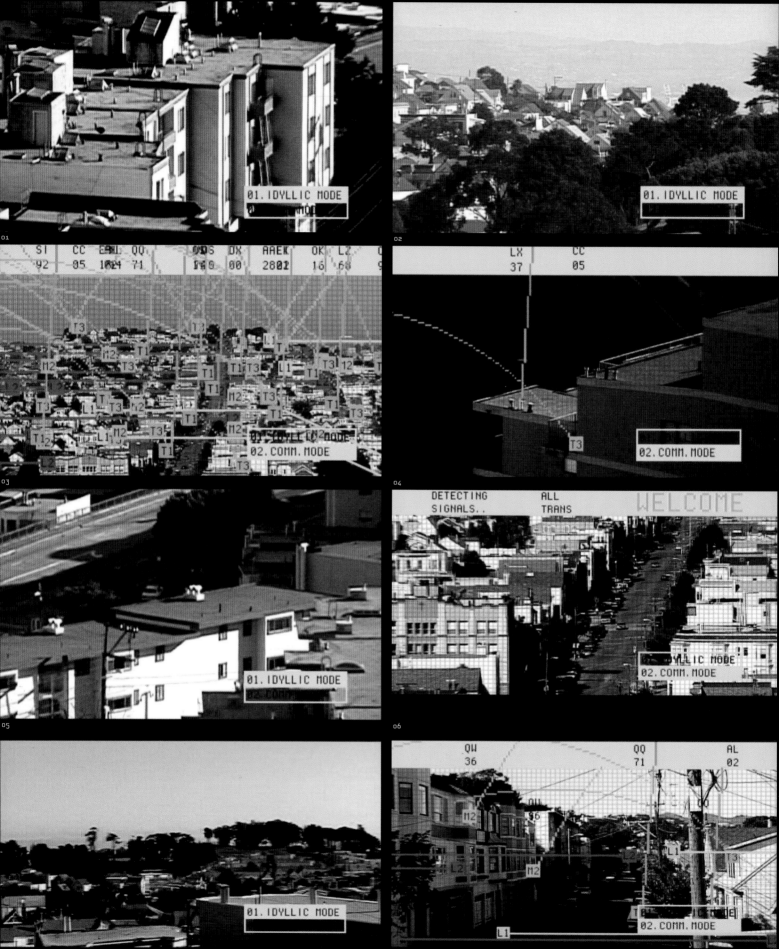

09

13

ECAM

10

14

PAL

11

15

12

16

motion blur: onedotzero

richard fenwick

furi furi

Furi Furi's style exemplifies 'kawaii', the Japanese word for all things cute. They are fixated by Disney as well as more adult Japanese animation, and their primary aim is to design characters who appeal to all ages. This fascination with the cute rather than the cool makes them stand out from the myriad of other Japanese character designers. Their work is a colour-saturated blast of childlike joy, ranging from print-motion and VJ works to exhibitions and products based on the original characters they create.

01-05
The funky and vibrant Yoshida kun and Furi Furi kun are two characters that have been pressed into service in print as well as moving image in videos such as the promo for Valsimicos by Kagami on Frogman Records. They are also the company's mascots and appear in their own video.

What is Furi Furi's definition of success?
TR: I have had one vision since I founded Furi Furi. When my characters are drawn on the ground in the park, this is proof of our success and the happiest thing for me. Even if I have plenty of money and own a big building, I would never be happy if children didn't know about us. I don't think making our company big equals success. If Furi Furi can do what they want and everyone appreciates the results, it means we've been successful.

There are many designers who create characters in Japan. What makes yours different?
TR: I don't target a subculture. What I want to create is like Pikachu or Doraemon. I think my way of thinking is more businesslike than other people's.

What influences come though in your characters?
TR: I used to be a fine artist in my 20s, and I've been trying to do something different since I quit. Now I'm trying to create something that's interesting for everyone, not just for the user or for myself. I want to create simple and cute things. The influence is myself, what I used to be.
OI: I'm influenced by everything, whether it's popular or cult, books, films and plays.
TR: I've loved the works of Osamu Tezuka since I was a kid. I like Disney as well, but the old ones. My favourite character is Devil Man. Second is Astro Boy. Both of them are so cute. To tell the truth, I hate all the Disney characters. I really hate them, but I often watch Disney films because I can learn a lot from them. My dark side is Devil Man and my happy side is Astro Boy.
OI: I love Disney characters' movements. I know who the character is from the movement. The great character animation overwhelms me.

How do you develop your characters?
TR: I always set up the entire concept of a character during meetings with clients. I'm never worried about it. The concept flows out. The most important thing for me in creating a character is to do everything for the audience, not for the client. I propose the best character concept after thinking carefully about what people want. In meetings, I usually draw a picture on the table and if the client says, 'It's so cute' or 'We want it,' that's OK. Just like that.

How do you approach the work?
TR: Characters we've been creating so far are not limited to any specific media. We animate characters on digital media, such as the web, because it's the easiest way to promote them. Actually we want to make them as products, so that everyone can touch them. We want our characters to be made for children to hold in their arms. I'm not interested in cool stuff or cool media, but want to create something that can please kids. Like the TV we used to watch in our childhood. I keep creating characters just for the sake of it.

How did you get involved in VJing?
OI: I was originally doing installations and production design. When I was doing lighting and playing with kit and materials, I started using the projector as one of the light sources. I think that was when I got involved with it. It didn't start from the visual side.

Recently trance music has become very popular in Japan, so I usually animate mandala illustrations made by Furi Furi.

Tell us about your most famous characters, Yoshida kun and Furi Furi kun.
TR: The secret story of Yoshida kun and Furi Furi kun is that there were two initial members of the Furi Furi company — that is my wife, Miho, and myself — and the first character she created was Furi Furi kun. We had an unused scene for a project with a cute character. Then I modelled and created Yoshida kun in only 30 minutes, as we just wanted to make some friends for Furi Furi kun. Now Furi Furi kun has a big family of nine in all. There's a planet where they live. One day the UFO manned by Yoshida kun crashed on the planet and he settled there. Yoshida kun doesn't say much but it seems he really loves Furi Furi kun. Furi Furi kun loves Yoshida kun as well. There's no violence or nasty things on the planet, it's an ideal planet for kids. It's a pure place.

02

04

03

05

loIJP
interviewed:
Tei Ryosuke [top], president
Osamu Iwasaki, web designer/VJ

Furi Furi was founded in 1998 by Tei Ryosuke and Sadaogawa Miho, who gave themselves a mission to 'design the cool and the cute to their extremes and bring a smile to everyone's face — all over the world'. They focus on the design, development and production of character-driven projects.

motion blur: onedotzero

furi furi

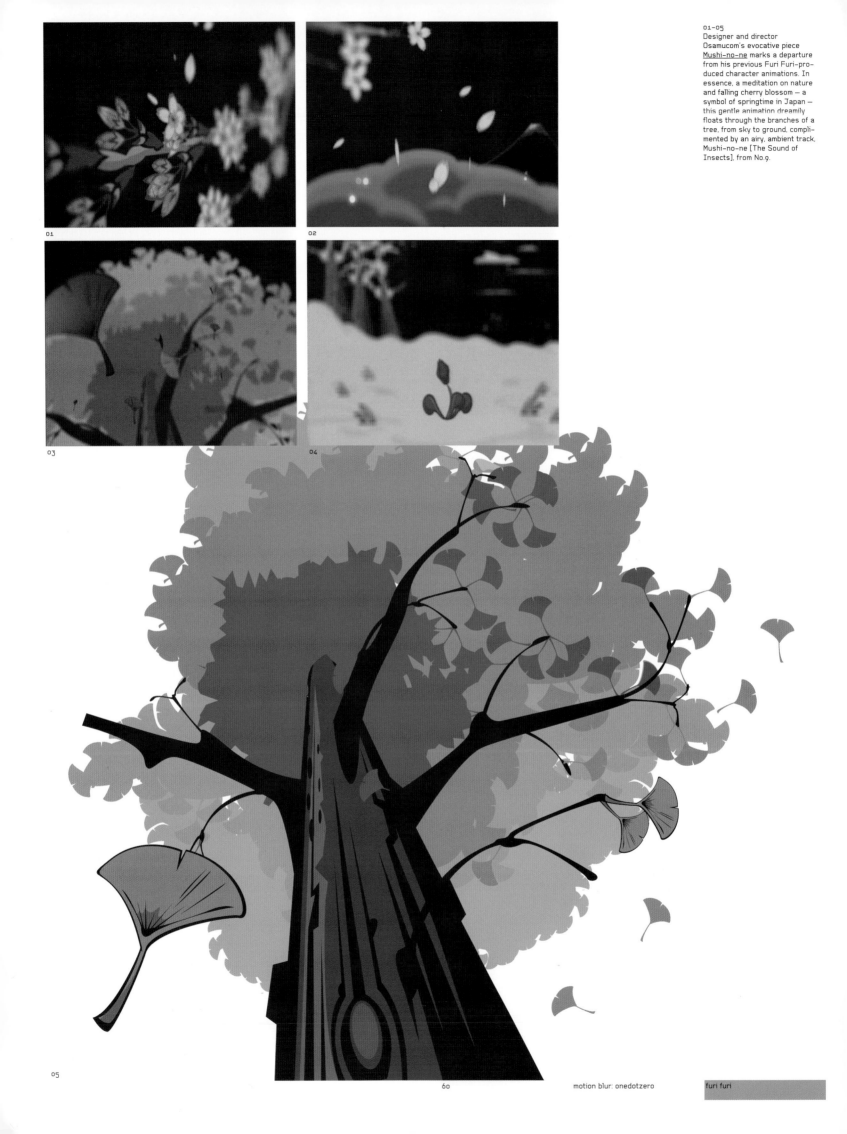

Designer and director Osamucom's evocative piece Mushi-no-ne marks a departure from his previous Furi Furi-produced character animations. In essence, a meditation on nature and falling cherry blossom — a symbol of springtime in Japan — this gentle animation dreamily floats through the branches of a tree, from sky to ground, complimented by an airy, ambient track, Mushi-no-ne [The Sound of Insects], from No.9.

01

02

03

04

05

motion blur: onedotzero

furi furi

06-13
The promotional video for the
fashion brand <u>Girls Power
Manifesto</u> was created for use in
stores and was produced by
A-MISH and Furi Furi. Furi Furi
also created the whole identity
and range of materials, designing
all the characters, logos,
advertising and the website
[http://www.girlspower.jp]. The
main characters are a girl
called Ginger, a boy named Roger
and Indigo the teddy bear.

06

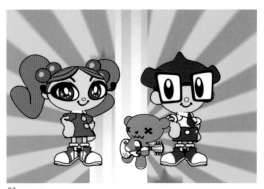

07

08

09

10

11

12

13

groovisions

01-25
GRV1778 is a 20-minute film produced for Groovisions' own DVD release with GASDVD and featuring music by Fukutomi Yukihiro entitled Rebel/Console pt1-pt4. The film plays with notions of geography and travel; it is initially confined to the city, tracking a running man who soon gets into his car and drives through the gridded streets. It features super-flat animation as if shot from above for maximum graphic effect. The flowing journey then traverses bridges and motorways, looking down on camouflage-like fields, planes and helicopters through cloud cover. It culminates in an Eames-like zoom out from the city and earth into space and then back again to the running man.

Groovisions' graphic design is inspired by the primary-coloured pop culture which surrounds them. Using a flat-colour, almost anonymous illustrative style, they design for print, web and motion, producing a distinctive range of work including, since 1993, live visuals for the crossover Japanese band Pizzicato Five, as well as music videos for them and for Fantastic Plastic Machine. But they are best known for their ubiquitous and asexual character Chappie. Adorning everything from stationery to clothing and interactive projects, Chappie has become a cult phenomenon and merchandising success. Chappie has taken many guises — dolls, a virtual pop star complete with album, single and video releases, and exhibited mannequins.

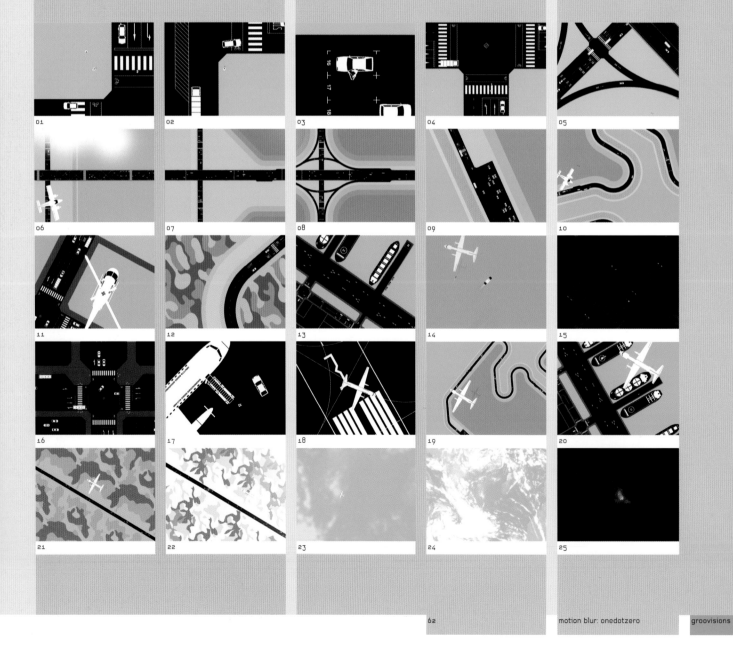

motion blur: onedotzero groovisions

How did you get involved in moving image?
HT: I studied design at university, so it was natural to get involved in moving image. I've been directly influenced by the film-title sequences of Saul Bass for our graphics, when we were VJing at clubs, and the Tokyo Olympics. At Groovisions I mainly take charge of printed matter, such as editorial design.
SK: I mainly do animations. I started doing motion graphics at events or clubs in Kyoto and it led me to do moving image as a job.

How do you work as a company?
HT: We basically work individually, but we sometimes have meetings depending on the project. Each member has both strong and weak points, so we can share work quite naturally. We never assign permanent roles, though. It changes every time. When we're commissioned to do a project, there will always be someone who is the most suitable to take charge of it.

Do you have any specifically Japanese influences?
HT: I've never been aware of direct Japanese influences. I like modern graphic design like Swiss typography. Those things could have been influenced by Japanese stuff in some way, so I might have taken Japanese influences indirectly from them. But I've not been conscious of it directly.

Tell us about your most famous creation, Chappie.
HT: Chappie started as a character for a game. Then our boss, Hiroshi Ito, started an exhibition of Chappie. Other characters have particular histories or certain concepts attached to them, but for Chappie we didn't set up any background. It just started with the idea that we wanted to make something flat. Then it changed into an artwork and product. The style is always evolving.

So what was the key idea behind Chappie?
HT: The most distinctive feature is that it's a plural set of characters. The original theme was juxtaposition or multiplication. It's an asexual creation. There are some rules it must adhere to, though, such as it must never move.

It's unusual for an animated character to become a pop star.
HT: The CD was released in 1999. Hiroshi Ito had wanted Chappie to make his debut as a singer for ages, and this was a good opportunity to realize his dream. We thought it would be interesting to have many different people sing as Chappie, rather than having one specific singer. One of the special features of the character is its fashion changes, so we thought it was interesting to change voices as well.

What was the process behind the Fantastic Plastic Machine music video Dear Mr Salesman? It's in a totally different style.
HT: The piece is not composed of any moving images. We shot each frame and animated them. It was not the way we wanted to do it; the record company proposed the direction. We usually don't propose anything. It's good for us to adopt a case-by-case approach.

What separates you from the crowd in the design world?
HT: We try not to show our individuality. We try to remain anonymous. I know that people who see our works often find the specific style of Groovisions in them, but our stance is to try to remain anonymous.

Chappie is well known in the world, so we're regarded as people who create cute and stylish things, but it's not true that this is the only thing we do. I don't care about how we're regarded, though. Actually, we're not particularly stylish people.

What does the future hold for Chappie?
HT: We don't have any concrete plans. Recently we've been getting offers to show Chappie internationally. It's really great for us and we'd like to do exhibitions in many places. We took part in the Super Flat exhibition curated by Takashi Murakami at MOMA in Los Angeles, did an exhibition at the Colette gallery in Paris and exhibited Chappie at the Jam exhibition at the Barbican Gallery in London.

What inspires you about Tokyo?
HT: People, music and films. Yes, there are so many things that excite me in Tokyo. It's actually good to work here, I think. Meeting up with people sometimes leads to a new project. Relationships between different people inspire me.

lo|JP
interviewed:
Hara Toru
Sumioka Kenji

Groovisions produce visual art, graphic design, moving image and websites. In 1997 they moved from Kyoto to Tokyo, where they are still based today. They focus on music, fashion and movies, and sell their original works at exhibitions as well as concentrating on building the Chappie empire.

01-22
Groovisions have taken their
creation Chappie into many areas,
from art to merchandising and
even into the world of pop.
Chappie has actually released a
number of singles and an album;
the identity of the singer[s] is still
a secret, however. Some tracks
from the album New Chappie
[GRV1257] had accompanying
videos featuring the iconic
non-gender character[s] in
different guises and fashions.
The preoccupation with travel and
flight is also intermixed in the
bright videos shown here: Suichu
Megane [01-17] and Welcoming
Morning [18-22].

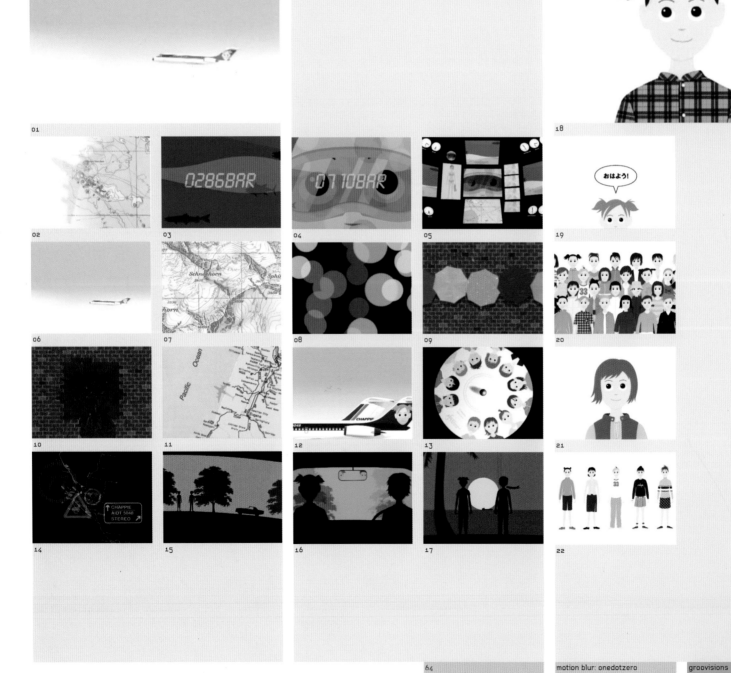

GRV1756 was made for a Nike
project by the agency Wieden +
Kennedy in Tokyo. A number of
artists were invited to produce a
piece of work for the Movement
Series, released on DVD. In their
trademark style Groovisions
delivered a stark graphic piece
featuring a solitary runner
sprinting, hurdling and leaping
through the urban landscape
which then becomes countryside
featuring silhouetted wildlife such
as camels, racing hounds and
dolphins which contrast with
the cityscape iconography.
The accompanying music was
composed by regular collaborator
Fukutomi Yukihiro.

As well as self-driven projects such as the Chappie sensation and commercials, Groovision also create music videos for some of Japan's leading groups. Fantastic Plastic Machine, aka Tanaka Tomoyuki, is one of the key players in the Japanese pop music movement known as Shibuya-Kei, which is named after the trendy Shibuya shopping district of west Tokyo. FPM first appeared on a handful of compilations before signing with Readymade Records, home of Pizzicato Five, another of the Shibuya-Kei bands and friends of Groovisions. The video for Sixties-J-pop-meets-bossa-nova hit Dear Mr Salesman wittily mixes a range of animation styles; a live-action Tanaka Tomoyuki repeatedly pops up throughout.

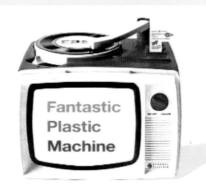

01

02

03

04

05

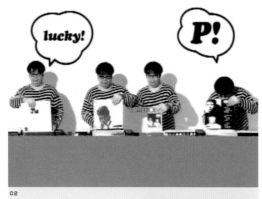

06

07

08

09

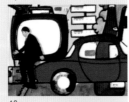

10

11

12

13

14

15

16

17

18

19

20

21-37
Well-known Japanese crossover
band Pizzicato Five are long-time
creative collaborators with
Groovisions, who have been
producing live visuals for the
group since 1993 as well as music
videos. For the track Catwalk,
motion graphics and some live
action are stylishly employed in
this early work with a distinctly
Sixties art direction.

21

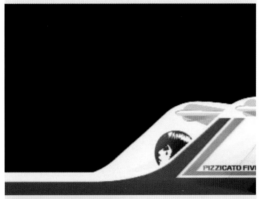

22

23

24

25

26

27

28

29

30

31

32

33

34

35

36

37

motion blur: onedotzero groovisions

01-06

Oualalaradime for the French band Zebda is a virtuoso animation running the gamut of animation styles from computer-gaming sports SIMs to childlike hand drawings via Hanna-Barbera and manga imaginings. H5's tour de force hits every style spot to make a startlingly cohesive whole.

H5 made their name designing record sleeves for music artists such as Etienne de Crécy and Alex Gopher. They quickly staked out their patch on the Parisian graphics scene, and their visual style, synonymous with the cool electronic sound of the 'French touch', is now instantly recognizable from a range of astounding music videos. Oualalaradime for Zebda runs the gamut of animation styles from Hanna-Barbera to anime and computer games, while Gopher's The Child, a world conceived typographically, is one of the most original videos of recent years. Antoine Bardou-Jacquet left H5 in 2002, while Ludovic Houplain has carried on directing with Hervé de Crécy, continuing to make instant classics such as the infographic tour de force of Röyksopp's Remind Me video.

01

02

03

04

05

06

How did H5 begin?

LH: Antoine did a work-experience placement with my father and at the end of our studies we decided to start a graphic design business together. We created H5 after we came out of design school — five years at l'Ecole Supérieure de Graphisme in Paris. We did not want to join someone else's business and work in that sort of atmosphere. We wanted to create our own business even if it meant hardship, so that's what we did and things moved on from there.

AB-J: I went into the army to help my country, which was in danger! I was in the cinema section of the armed forces, where we made animation films about the effects of drugs on the brain. This was my first contact with animation, and it was a fulfilling experience — a fantastic year! After that I rejoined Ludovic, who had already created the firm to avoid military service, like the coward he is! In the beginning we started with what we could find, the first thing being a job for a funeral parlour to show people what was new in the world of death, like cardboard coffins.

We had been friends for a long time with Alex Gopher and Etienne de Crécy, who started their record label at the same time. We created their first sleeve. After that, bigger labels contacted us to work for other people, who paid this time.

How quickly did you start using digital tools in your work?

AB-J: Compared to what is going on now, things were very different in France seven years ago. The beginning of our firm coincided with the arrival of computers, which helped people to do things they could not do before. In fact, at design school we weren't even taught about using computers.

LH: We wrote letters by hand.

AB-J: And used photocopiers too. It was a different view of design. But I think it gave lots of freedom to people in general and us in particular to try lots of things. We really love typesetting, for us it is the basis of design: drawing a letter, a logo, is hard. Designing an elegant logo is a challenge.

Were you forced into more typographic and animated styles because the artists you work with didn't want to be identified?

LH: You've said it. Musicians want to hide, especially in electronic music. Many French artists don't even want their names to appear on the labels. They want their music to take first place, in contrast to pop music where image comes first and the music is generally rubbish.

AB-J: We did the things we knew how to do, and what we did best at the time was typography rather than photography. It is pure chance that our style developed as it did. These people could never have made music without computers and we could not have produced our sort of graphics without them either because it would have been too complicated.

What's your usual working process?

LH: Usually when an album is finished a record label will send us a copy. We never meet the person who wrote the music and we have to have the sleeve ready in a week. But with Source and artists we know, the process starts at least a year in advance. It is the same thing with Etienne de Crécy.

AB-J: Yes, that is the difference with Etienne. We put our heads together even before he has written any music. It is very important for him to search for and develop visual and musical concepts at the same time, and this is why we work together as friends and discuss our work all the time. We already know how we are going to give his next album shape visually, even though he hasn't written the music yet. It's very different to the attitude Ludo was talking about earlier on: when a record company sends a cassette requesting a sleeve.

Who did you look to for inspiration when you first started working?

LH: When we came out of design school our references in graphics were the The Designers Republic and Ben Drury. They were the best as far as we were concerned.

AB-J: Ben Drury, Will Bankhead, lots of designers, architects. There is not much good graphic design in France: just look at our signage, for instance, compared with England, the US or Switzerland, all of which have a strong graphic culture. Look at police cars in France compared with those in Holland. Ours are horrible while in Amsterdam they are great to look at.

What are your creative aims?

AB-J: The aim for me is to do everything as if it were an experiment, whether it's a video or an ad; to learn new techniques and create a very good clip without using any special effects. This is my dream. The goal is to get into cinema and make a film. This is like a very well-paid training session!

LH: For me it is different: I haven't filmed a lot. It has more to do with 3D animation and playing with the different synthetic modes — how they interact, how they could work together. They are experiments, as Antoine says: we try, we look, we make mistakes, and sometimes it works... It could be playdough, except it is something else.

AB-J: For me, it's to tell a story with new pictures, not necessarily to startle visually but to concentrate on narration.

LH: I think I'm just trying to surprise myself at the moment. Later on I will see. I am more interested in pictures than stories, that's for sure. I am on a sort of quest.

AB-J: We do not intellectualize everything. We work together on things that interest us and make us laugh. Things happen at H5 by accident rather than by design.

What are your ambitions?

LH: To spearhead French graphic design.

A-BJ: And have a swimming pool shaped like an Apple Mac or a mouse.

LH: To turn every brief into a personal interest, not an order.

A-BJ: To get big companies to trust us small studios to create their logos.

IIIIFR
interviewed:
Antoine Bardou-Jacquet [top]
Ludovic Houplain [centre]

The H5 studio is based in a building in Paris which also houses more of the de Crécy clan, with animator Geoffroy and recording artist Etienne close by.

01

02

CUTAWAY MODEL
of a modern two-storey house

03

04

05

06

GRACELAND STREET. North East

● MR AND MRS MC BRIDE
Married. 3 children. 1 cat
Purchased: July 1981
Annual salary: £54,000
● MISS WINTER
Single
Purchased: March 1999
Annual salary: £18,000
● MR AND MRS CUNNINGHAM
Married. 2 Children
Purchased: December 1988
Annual salary: £32,000
● MR O'DONNELL
Divorced. 1 Child
Purchased: February 1995
Annual salary: £24,000

07

SUBURBAN STATION

KEY TO
Stairs
City bus terminal
Parking space
Taxi
Information

130

08

09

A Employes type 1
B Worker
C Unemployed

10

ESCALATOR

11

12

IT Dpt
(the open space)

13

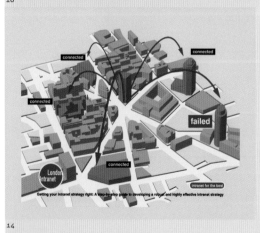

connected

connected

connected

failed

London
Intranet

Getting your intranet strategy right: A step-by-step guide to developing a robust and highly effective intranet strategy

14

15

Delicious Burger

1 FRENCH FRIES

Delicious Burger VS The Chinese Box

Magic Ketchup

The Chinese Box

Delicious Burger

16

DON'T WALK
ON THE GRASS

17

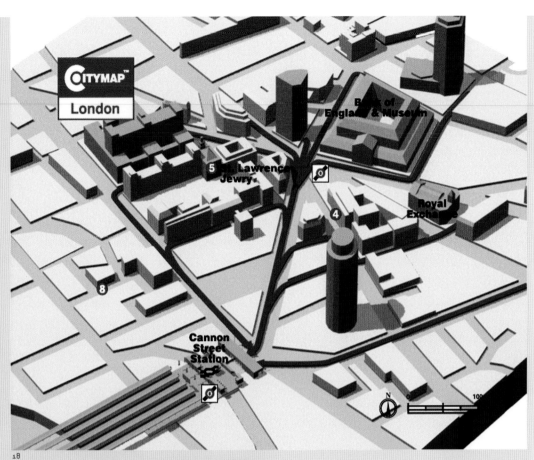

01-21
H5 pulled out all the graphic stops
here in a stand-out music video
for Remind Me by Röyksopp. A just
winner of an MTV award for best
music video, it constructs and
deconstructs a day in the working
life of a city in intricate and
colourful detail, delivering a
critique of universal, systemic
behaviour and the banal intercon-
nectedness of human urban life.

01-08 overleaf
H5's immense animation skills
were put at the service of disco
for Trevor Jackson's Playgroup
project and the music video for
Number One. A package unex-
pectedly splits and unfolds into a
self-assembling robot, who has
moves ready to groove. This is a
dance video that pastiches every-
thing from Michael Jackson's 'Billy
Jean' to Saturday Night Fever.

01

02

03

04

05

06

07

08

01-14
H5 have a long history of sleeve design work for French record label Disques Solid. On Use Me they teamed up again with French house prince Alex Gopher to produce a constructed 3D animated music video for his WUZ project, co-produced with Demon.

01

02

03

04

05

06

07

08

01–06 overleaf
A landmark music video that brought H5 to fame, The Child by Alex Gopher takes the exquisitely simple idea of presenting the people, objects and buildings within a city as moving type to tell a story.

09

10

11

12

13

14

01

02

03

johnny hardstaff

A swarm of references infest Johnny Hardstaff's world of uneasy organic-tech. Seemingly random cultural and historical pointers add rich associative layers to his work and hint at dark narrative undercurrents. Graphic, live-action, CG and other visual elements are fused together to create uncategorizable and startling visions. Whether working for PlayStation, Radiohead or FC Kahuna, Hardstaff still manages to produce material that feels very personal, delivering graphically filmed opuses delicately poised between heralding technology as saviour and alarming danger.

How did you get into filmmaking and animation?

My sharp collision with filmmaking was entirely accidental. I studied graphic design at Central Saint Martins College in London but spent the entirety of the course making physical 3D graphic models. On graduation I wholeheartedly shunned the whole media thing and slipped into life in a design- and media-free world. This period of contemporary ignorance subsequently proved to be particularly refreshing. When you extract yourself from contemporary fashions and notions, and avoid magazines, galleries and museums like the very plague, you initiate a kind of self-imposed cultural vacuum that provides you with an opportunity to recharge.

During these few years, I did quietly maintain my sketchbooks, drawing incessantly at every opportunity, developing ideas, building them further into odd imaginary environments that I would draw up with a clumsy strand of architectural precision. I developed graphic forms into freeforms that I discovered I would love to animate.

How did your particular animation style emerge and how would you define it?

Being very frank, I remain generally unaware of contemporary styles and who is doing what. Current media styles are the last thing to react against, being so lame and insignificant. If you can coolly identify 'your style', then maybe you've had your time. Style is an evolutionary process that mutates with the demands of each idea, not a conscious premeditated act. I hope I work beyond any fashion for 'this approach' or 'that software', and would hesitate in actually claiming to be an animator. I don't actually have a love of animation or technology as such, but am fascinated by graphic design and photography, and, very simply, it is a personal hybrid of the two that excites me.

What most influenced how you work?

Childish preoccupations and passions are the formative elements. I've been lucky to get to play with imaginary notions and peculiar fetishes, and most of these lie in a childhood locked in peculiar fantasies. The early films of Terry Gilliam (Time Bandits particularly), The Empire Strikes Back, war films, death, Englishness as an essence, the National Trust, Ray Harryhausen, football violence, West Bromwich Albion, my first few pallid girlfriends, growing up on the edge of a forest, small towns and big ideas, lower-league teenage arson, THX and, most importantly, Leonard Charles Hardstaff. These kinds of influences are to me the important ones, effortlessly separating you and 'them'. Distrust anyone who specifically only cites filmmakers. They're shifty. If someone cites any archaic experimental graphic designer or filmmaker, either punch them hard or be content in the knowledge that in a year or two you'll never have to see them again as they'll be half-heartedly lecturing at a college somewhere. If software has influenced you, then retire. Now.

→

The History of Gaming: 'The sense of "Englishness" that inspires and influences me is something of, as I see it, a wonderful perversion of the nation's past. I adore English traditions, whilst simultaneously being sickened by this country's endemic racism. I simultaneously love and hate this country's hybrid blend of heritage and nostalgia. I would hate this nation to be without its royal family, if only because their very existence is so perfectly anachronistic. Their very survival quaintly suggests that the possibility of rebellion remains very real in this country. I like the nastiness behind "quaint" in some way. I like an oppressive regime to work under. I admire dissent. I long for widespread anarchy, and at the same time I am wholeheartedly charmed by the visual manifestations of the class system and all its cruel idiosyncrasies. It's a strange paradox of being both in love with and yet also sickened by all that is good and bad about this nation. I think that being English means that naturally one has a great love for other countries. Our dismal imperial past and our now wonderfully multi-cultural society suggests that we naturally should be very comfortable with foreign influences.'

✳ UK

'What seems vital is that individual nations worldwide retain a sense of exactly who they are and what they are about, rather than melding into one uniform mass, if only because the meeting of very different cultures produces incredibly dynamic results.'

striptease me on a motorway... our curious cargo, all chi chi la la, splendid beside in all her knickerbocker glory, plumped warm thigh cupping sweet supercharger as she sucked full lips hard on filter.

01

لاعب واحد فقط

ابدأ

أختر

شغلوا المحركات يا أيها السادة

Doctor Hanssen- you're late. I trust this wont take long.

02

motion blur: onedotzero johnny hardstaff

الخوف هو الظلام الذي نحمله في رأسنا

تحيا بالكل

Los Angeles

أحلم بشراسة

I understand. Playstation 2.

أحلامك الاقتصادية هي كابوسنا

VI·VI·VI

إرشاداتكم تلهم شكاستنا

Beijing

أحلامك المختصرة هي كابوسنا

لا تحتاج لتعليمات

بشدة

I thought we dealt with this?

How would you describe History and Future of Gaming? They are neither corporate videos nor traditional short films.

History of Gaming was intended to be, and became, a very positive celebration of our past. Even though it celebrated all that is good and bad about English culture in the '70s and '80s, it was simply a way of identifying where we have come from and what formed us. It had a little corporate money behind its production, but ultimately that was peripheral. PlayStation-backed, it still remained very naïve and did not march to a corporate drum. As I have no formal training in motion image, and because prior to History of Gaming I had taken one serious sabbatical from all things design, I approached the film with a sense of freedom.

Future of Gaming, however, was very different. When a corporation returns to you and asks you to prophesy the future of its product, who is really going to come back to them four months later and tell them it's rosy? I'd rather turn tricks for sailors than toe the party line when something as bland as marketing is involved. What was positive about History of Gaming was that it had started to live a life of its own beyond its supposedly left-field 'guerrilla' marketing initiative. Future of Gaming had to do the same. Unfortunately, initially I was rather too successful in directing and designing what is essentially a very anti-corporate film for a large corporation, and the film was more or less buried due to its tone and content. No corporate client wants to hear the audio to 'their' film publicly admitting on their behalf that 'they have toilet-trained the developed world to shit in their own backyard', though for the life of me I can't think why not. However, Future of Gaming, largely through onedotzero events, became very popular indeed.

There was some controversy over the imagery concerned with the conjoined twins in the Radiohead promo Push, Pulk / Like Spinning Plates. Did you anticipate this, and has it affected your views on artistic censorship?

I think that any sense of controversy about the Radiohead film — and it was less outrage and more like quiet discomfort — is unfounded and misguided. My aim was to create what I hoped would be a poignant, sensitive and perhaps beautiful film. I think that to an extent the media look for a sense of 'controversy' in these instances in order to make them feel that they inhabit a more dangerous arena than they really do. Through channels of commissioning, and through censorship of the media generally, controversial subject matter is almost exclusively stripped away at the drawing board, other than those constant cynical attempts at creating some kind of publicity storm. The last thing I wanted to do was to make a calculated film, and when airplay was refused, what was most upsetting was the possibility that people would interpret the film as a concerted effort to be 'risqué'. In retrospect, I could have milked it 'for the press', I could have revelled in it, but instead I went home and fretted about it.

I don't even consider self-censorship. There is nothing I would not be prepared to put down on film, no matter how dark or socially unacceptable. Unless you know yourself to be some kind of monster, there is nothing within your imagination that is taboo, nothing within or outside of human experience that is inappropriate. However, what I have only recently started to understand is that most other people really do not want to be challenged with uncompromising ideas. Whether natural or nurtured, most people want to

→

01–04 previous pages
The Future of Gaming is a PlayStation 2-commissioned short exploring a retro-futuristic world in which aliens appear. Allusions to the military classifications of the console's chipset are brought to life with a dark narrative subtext and graphic visual cues. There are a blizzard of cultural and historical references — even including Brian Sewell, the much-maligned art critic on the London Evening Standard newspaper, and Wedgwood pottery, the quintessential English china.

01–09
A double promo for the band Radiohead, Push, Pulk / Like Spinning Plates is a work of precision genius — a compelling epic rather than a mere music video in which Hardstaff unleashes a dark futuristic vision of organics-tech.

01

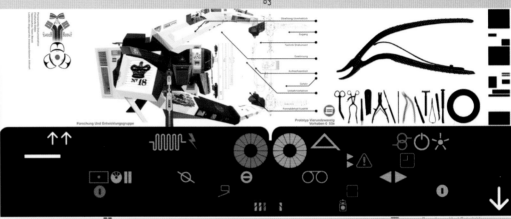

02

03

04

05

06

07

motion blur: onedotzero

johnny hardstaff

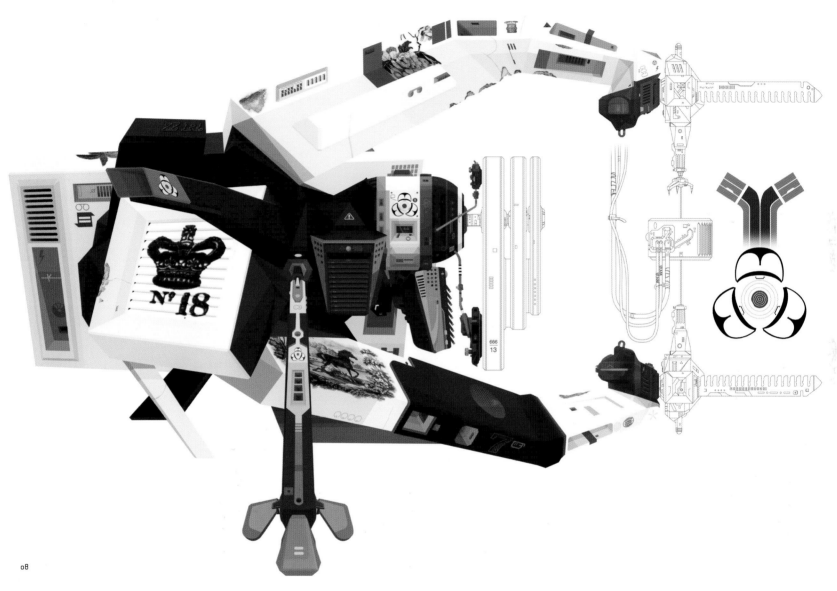

08

09

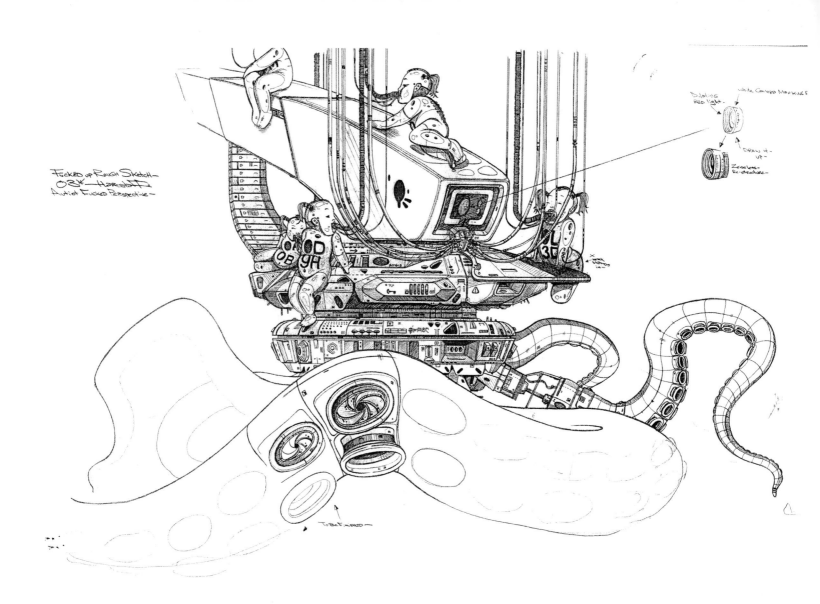

Fucked up Rough Sketch-
03*—Hardstaff—
Artist Fucked Perspective-

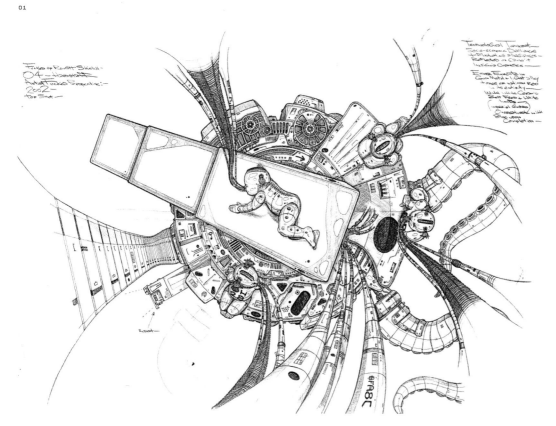

Fucked up Rough Sketch-
04—Hardstaff—
Artist Fucked Perspective-
2002-
Top Shot—

01

02

01-02
A superb draughtsman, Hardstaff
meticulously develops models and
plans by making finely detailed
and intricate drawings in his
notebooks. It is here that ideas
are generated and worked
through before storyboarding and
shooting begin.

03

04

05

06

07

08

09

10

03-10
In this music video for UK dance act FC Kahuna's hauntingly beautiful track Hayling, luscious live action is merged with glorious CG in what seems almost a test film for later Hardstaff projects.

remain fat and happy. The ultimate taboo seems to be rocking the boat. From my viewpoint the bonus is that I just instinctively love a little bit of boat rocking, even if I am often unaware that I'm doing it.

There seem to be strong narrative and story anchors in your work.
Ironically, I'm not entirely convinced that narrative is something one can talk about. It's instinctive. If you read voraciously as a child, then you're going to be exposed to the notion of a reasonably non-abstract narrative being a very desirable form, that storytelling is the ultimate aim, and that the conveyance of a message is paramount. I have little or no interest in fashion as such, I have no particular interest in producing 'fashionable' work, no interest whatsoever in 'what everyone else is doing right now', no special interest in the masturbatory side of abstract experiments. I'm not so much interested in the materials themselves, just the message and how perfectly it can be delivered, how subtle a message can be for it to slip under your radar and fuck with you a little. Make you feel a little ugly about yourself. Stop you and coax you into thinking outside of the media hyperbole that gnaws at this planet constantly.

With advertising constantly force-feeding its own shit to an already gorged and jaded public in so many manipulative ways, it forces you to be inventive. The best work isn't selling you anything, no product, no lifestyle, no kudos. The best work brings you a notion that lingers, a train of thought that liberates, an emotional reaction free of cynicism. It lets you complete its narrative yourself.

hexstatic

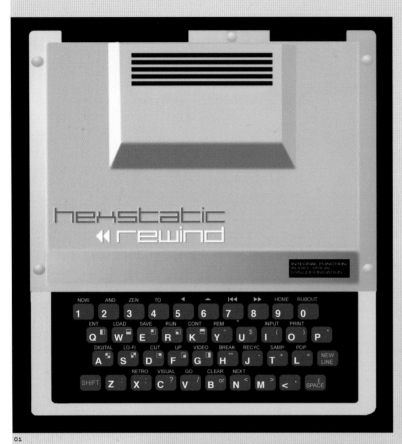

01

01–04

Bringing VJing out of the clubs, Hexstatic have had a number of releases on the UK label Ninja Tune, including the seminal AV album Rewind and the EP singles Vector and Bass Invader. Hexstatic also create all their own sleeve designs. 'The possibilities with DVD are very exciting, especially compared to the restrictive nature of CD-ROM,' says Stuart Warren-Hill.

As ideas, trends and styles are propagated ever more rapidly through worldwide networks, seminal UK VJ outfit Hexstatic retain and enhance their quintessentially English take on this audiovisual discipline. Whether they're filtering global satellite feeds in Deadly Media, retro computer gaming in Vector, or reappropriating old British TV titles and cult programmes, a signature playfulness is paraded in their work. It's this, alongside their engagement with pertinent activist issues, that sets them apart as real innovators in a discipline too often attacked for the superficiality of its visuals. This is most starkly seen in their influential video for Timber, a collaboration with Coldcut, which is arguably the most famous piece of VJ work yet created. Hexstatic are Stuart Warren-Hill and Robin Brunson.

02

03

04

05

06

05-06
A particularly British sense of humour pervades their work and nowhere more so than in their spoof Hexstatic idents of the 70s TV test card and Thames Television's on-air identity.

What were the influences that pointed you in the VJ direction?

We were born around the time of the first microchip being used for consumer goods, so we feel we have been evolving with computer technology. We've always been into electronic music like Kraftwerk, Herbie Hancock's Rockit, the Art of Noise, and the whole electro scene in the early '80s. We were hooked on the new computer arcade games and then the home arcade machines like Atari 2600, Sinclair Spectrum and Commodore 64. Television is also a huge influence. Our fathers worked in the television industry too.

What we do now is take all of these influences, mix then remix them, and spit them out again. We think VJing is a very powerful form of entertainment.

Your major work so far has been the full audio-visual album Rewind. Can you tell us how you put this together?

We chose subjects that looked and sounded good. Each track was really an experiment and made differently. Vector took '80s vector-graphics arcade games and we cut up the sounds to electro beats creating vector-graphic scenes and shapes. Deadly Media was made using a motorized satellite dish on our roof that picked up satellites from all over the globe. I randomly captured newsreaders from various countries and edited them into a beat. It was all created by editing in Premiere. We released the album as a CD-ROM but would have preferred DVD. Unfortunately it was too expensive at that time.

What do you think of the current VJ scene and other VJs around the world?

It's great that the VJ scene has grown massively over the last few years, because the attitude of promoters has obviously changed to accommodate this new talent. There's more open-mindedness to visual mixing and this interaction with the music. Having met many VJs on our travels, I've noticed more now turn up to shows with amazing visual software they or a friend have created. For years we used VHS but now we mainly use computers for mixing and real-time visual effects. It makes me laugh how I used to carry huge boxes to gigs, but now everything goes over my shoulder and I can get on a bus to a gig, which is great.

Hexstatic have grown to become key figures in the UK VJ scene, but when did you start and what was the scene like then?

In 1988 I started a visuals company called SP Visuals with Pod Bluman. It wasn't easy in the late '80s because no one was really that interested in getting visuals into clubs — promoters weren't prepared to pay for it either — so we earned very little money, which went on new equipment anyway. Over the years we amassed a large collection of slide and optikinetics projectors, while providing visuals for many UK bands and clubs. In the early '90s we dabbled in our own audiovisual club nights with the Ambient Club, and became involved in the Big Chill when it started in 1994. It was held at the Union Chapel in London, and the punters lounged on mattresses covering the floor, while we created a visual soup of slides, effects projectors — oilies and that sort of thing — and video. We started inviting different VJs to come down and mix for us. At this time there were very few VJs around. The Big Chill became a catalyst for VJs and DJs to get together and experiment with light and sound.

It was at The Big Chill that I met Matt Black from Coldcut. Matt was running Hex with Robert Pepperell and Jonathan More, who were already established multimedia artists by that time. In 1996 I began working with them and experimenting with ways of connecting images with sound. I also started VJing under a new name. Hexstatic was born.

The first promo video I made was for Coldcut's Atomic Moog in '96. Done on a very slow Apple Quadra 80MHz, it taught me how to edit using Adobe Premiere. This became my main tool for the fast cut-up AV style of the Natural Rhythms trilogy that would appear on Coldcut's Let Us Play multimedia album. Frog Jam and Natural Rhythm were the first two parts of the trilogy, completed by Timber. For Timber we needed footage of trees being cut down with axes and chainsaws, so we approached Greenpeace. They were keen to be involved and now use the video at anti-deforestation campaigns worldwide.

I met Robin at the Channel 5 launch party, where I had created some visuals for each room. Robin was a DJ who had studied 3D animation and worked in the computer-game industry. He worked on the 3D Coldcut characters seen on the More Beats and Pieces album cover and video. We VJed for the Coldcut world tour, and Timber was released as a single in February 1998. After this success Robin and I decided to create a completely audiovisual album. This became Rewind, which was released in August 2000.

Why did you start using the English trademarks you use in your sets, from the old Thames TV signature titles, to catchphrase samples from UK comedy shows like The Fast Show?

British TV is a huge influence on us, especially comedy. Friends tell us to never lose the humour in our shows as this really adds something. We tend to take anything we think is funny or just plain mad from TV, film or video, mixing this up with the footage we take on our travels, and then remixing it with music. There's far too much seriousness in clubs these days.

01-09 overleaf
Heavily nostalgic about early computer games, Hexstatic played with the medium's iconography and distinctive electronic sounds to take Space Invaders to the next level and create the audio-visual track Bass Invader.

10-17 overleaf
Communication Breakdown is a bold and simple black and white piece using tones, bleeps and universal computer symbols from today's communication-obsessed world.

18-28 overleaf
Machine Toy takes music and visual samples from classic kids' toys.

29-34 overleaf
A car fetishist's dream, Auto remixes car safety adverts, crash-test footage and souped-up Chicano Lowrider cars.

35 overleaf
The message is in the medium. Deadly Media comments on mass media, global-news junkies and satellite channels by building up beats with cut-and-pasted samples from international TV presenters. It works particularly well as part of their live set. 'There is a lot of scope for AV environments, so we intend to look into ways of truly encapsulating an audience with multi-screen projection,' says Warren-Hill.

36 overleaf
Stylophonic — nostalgia for retro keyboard toys.

01-05 page 92
Vector — a blast from the past, old school vector computer-gaming heaven.

06-14 page 93
An old martial-arts B-movie was the source of inspiration for Ninja Tune, a cut-and-chop AV work.

15-23 page 93
Robopop — Robot Heaven.

24-32 page 93
Part of the trilogy produced with Coldcut and used by Greenpeace, Timber is a classic sample track, complete with a chainsaw solo.

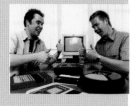

✳ UK
interviewed:
Stuart Warren-Hill [left]

Hexstatic are Stuart Warren-Hill and Robin Brunson and they work out of London.

01

18

29

19

20

21

22

23

24

25

26

27

28

30

Clunk Click

31

32

33

34

35

36

01

02

03

04

05

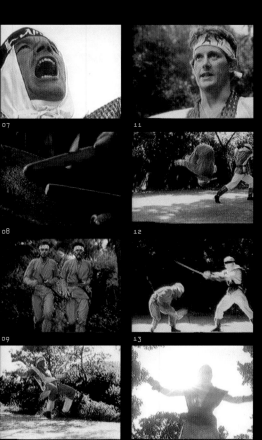
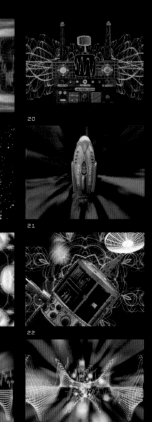

jeremy hollister

Building on an illustrious career in Manhattan's heavyweight post-production industry, having worked previously at R!ot Manhattan, Jeremy Hollister is now developing a new boutique operation, Plus et Plus. This is allowing him to broaden his range to include more live-action projects outside his motion-graphic specialities, and offering him greater flexibility to create his own films and exhibitions in conjunction with a talented core team. He's equally happy making polished animations for clients ranging from MTV to the Sci-Fi Channel, or pursuing self-initiated video and print graphic experiments as part of the downtown scene. The latter increasingly engage with Hollister's interest in political theory, adding sharp and informed subtexts to his output.

01

02

03

04

Can you explain your approach and where the overall visual ideas come from for your personal pieces?

The overall visual ideas grow out of whatever current environment and mental state I am in, as well as a compulsive desire to always change my expression. My approach to creating an editing and visual style varies from project to project. For example, in the work I did for Flips, the editing was central to the essence of the piece. For that project, the brief was to do a piece based on a style from a certain period. My solution was to look at the transient nature of fashion as something that you can never fully grasp; once you think you understand a trend or style it mutates and moves on. I used a montage of rapidly edited still images to communicate this idea.

How did Peacekeeping come about?

Reading some essays by French philosopher Paul Virilio on the strategy of deception, I was influenced by his ideas about the next battlefield being through information – a post-modern idea to the core, also repeatedly discussed by Baudrillard. In Peacekeeping I use a matrix of peace signs in a way similar to the early dot-matrix printers and ASCII art works, and take imagery to a level that is minimal yet recognizable. The pixellation in the video at times becomes completely abstract, but the movement remains intriguing; it's like watching an information flow. The images chosen for the installation work were either human or vehicles that carry personnel; this deliberately contrasts with the proliferation of 'smart' non-human weaponry and satellite technology in modern warfare over traditional manpower. For the printed images also displayed in the installation, the semi-translucent Plexiglas refers to the smoke-and-mirrors illusion and deception through the myth that the 24-hour news media coverage of global events is 'reality' and always accurate.

How conceptual, as opposed to simply aesthetic, is your work? And how do you feel about these different approaches?

I try to achieve multi-layered effects in my work, both in visual terms and at conceptual levels. It is a challenge to give longevity and interest to the viewer by allowing them to 'read' or interpret something new in the piece each time they see it. While I can sometimes be seduced by something that is purely aesthetic, I often find it can lack range and depth if there is no comprehensive idea. Work that is solely conceptual has a much better chance of holding up. Saying that, though, one potential pitfall in the conceptual side is that it can tend to take itself too seriously. I am a huge fan of concept mixed with quirkiness and comedy.

What ideas do you pursue in your personal moving-image work?

It's always my goal to try to incorporate subtexts into the work I create while maintaining a refined and well-presented image. This way, viewers can absorb the meaning even if they don't initially get the overall context, or subtexts. I like to play with motion and try to reinterpret what is thought of as 'correct' movement, leaving in slight imperfections or breaking down commonly believed rules of motion. The temporal nature of animation and film also leaves a large area open for exploration – it's a unique medium in which we can play with linearity and sequence.

Was the decision to start up Plus et Plus principally a creative, financial or lifestyle choice?

Starting the studio was definitely more a creative and lifestyle choice. Having a small studio of this kind, we can still work on large-scale projects, assembling teams with the talents suited to each particular piece of work. At the same time we can take on a wider range of projects, everything from album covers to furniture, exhibitions to commercials. It allows us to expand into different areas of design. As far as looking for a new direction, we are always trying to keep it fresh and come up with new ideas and different techniques. It is also important to be able to make time for self-initiated art projects.

How important do you think narrative is to a moving-image work?

Narrative is an interesting issue – not much of my work has a narrative structure to it, it is maybe a bit more conceptual. In the video I directed for Steve Reich's Coldcut remix of Music for Eighteen Musicians, my approach was very structured and controlled. This was a way of exploring the tonal repetition in the music. Just as traditional music has evolved from strict classicism to the more open and abstract formats of ambient and electronica music, moving imagery has moved away from conventional narrative structures to a more abstract 'essence and concept'-based format. What I would like to achieve is a new balance of solid narrative work with a strong, complementary graphic element – graphics that enhance the narrative form and take it to a new level.

01–04
Peacekeeping was a personal work in print and motion that Hollister exhibited at the Zakka Gallery in New York. It was also featured in onedotty. 'The exhibition looked at the irony of peacekeeping through violence and military occupation. The pixellation aesthetic reflects the increased use of digital communications in expanding surveillance and intelligence operations around the world.'

05–06
Live-action military footage of helicopters, personnel carriers, explosions, etc, were used as the source and then a pixel matrix of ASCII art-like peace signs that were deployed to create the minimal but effective end result.

01–12 overleaf
Hollister worked on various projects for the Sci-Fi Channel including the 2.0 relaunch, image campaigns, show packages and idents in a relationship that developed over several years. The relaunch created a look and feeling for the channel that was expanded and explored though a fruitful creative relationship.

13–21 overleaf
The show and category packaging for the 2001 MTV Movie Awards was a homage to the look, feel and energy of Seventies movie culture. The brief was 'to create a package feel as if it was the 1979 Academy Awards on acid'. Hollister directed and co-designed it while at RIot Manhattan.

05

06

US

After many years at New York production house RIot Manhattan, Hollister has started his own creative design company, Plus et Plus, based on Fifth Avenue.

01

02

03

04

05

06

07

08

09

10

11

12

motion blur: onedotzero jeremy hollister

13

14

15

16

17

18

19

20

21

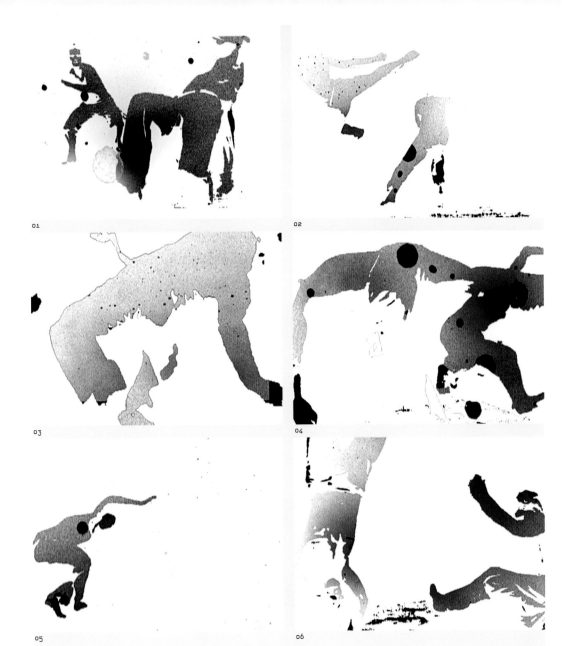

01

02

03

04

05

06

01-06
Espiritos da Capoeira is a
contribution for the book Brasil
Inspired from Judy Welfare at
Hollister's Plus et Plus studio.
It was created with stop-frame
animation of stencil graffiti
that both highlights and abstracts
the ever-shifting balance
between dance and battle in the
Brazilian martial-art form.

07

08

09

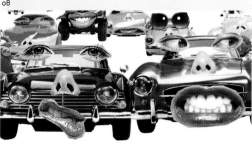

10

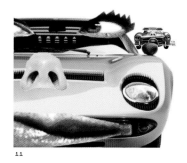

11

12

07-12
Commercial campaign for Tokyo's
hip designer store Laforet. 'The
look was an eye-catching pop
photo-animation of a crush of
car/women characters racing and
vying to get to and score the best
deals at the once a year store-
wide blow-out,' says Hollister.

01-12 overleaf
Music video directed by Hollister
for Music for Eighteen Musicians:
Coldcut remix on Reich Remixed
on Nonesuch Records. Hollister
looked to reflect the minimal tones
of the track with elegant visual
work of repeating themes and
refined simplicity. 'I wanted to
approach the video with the same
sensibility with which Steve Reich
and Coldcut had approached the
music. Their music is minimalist,
with a limited palette of sound, so
I wanted to restrain myself and
use a limited palette of colours.
Working on a video was fun
because it is less targeted than
a commercial. It didn't need to sell
a product — it was more of an
experimental video piece. That
gave us flexibility. We shot the
live-action elements on 35mm film
over two days at locations in and
around New York City. We shot on
the beach, around John F.
Kennedy International Airport and
in other areas. We chose locations
that gave the idea of open space
while still being in the city, which
was an interesting twist. We want-
ed the images to be very simple.
All the blues in the video are sky
blues, and the only artificial colour
is white.'

motion blur: onedotzero

jeremy hollister

01

02

05

06

09

10

03

04

07

08

11

12

motion blur: onedotzero jeremy hollister

tim hope

01–05
In the music video for King Biscuit
Time's I Walk the Earth, the simple
line drawing and crafted look
perfectly matched the mood of the
music. It took best animated
music video prize at the Annécy
Animation Festival 2001 in France.

Tim Hope is proof that a neurotic sense of humour
can take you a long way. With animated triumphs
such as The Wolfman, Jubilee Line and Coldplay
videos, and more rough-and-ready work for King
Biscuit Time and his own crudely rendered birthday
cards, he has injected a heavy dose of self-
deprecating humour into a world that often takes
itself far too seriously. He has created a kaleido-
scope of cut-out characters that are ready to
burst out of the confines of short-form and music
videos to become stand-alone creations, and his
highly amusing Pod spin-offs point to a bright
future as an animation superstar.

01

04

02

05

03

✳UK
From stand-up comedian to
animation star: Tim Hope.

Your path into animation was not a traditional one. How has this influenced you?

I have tried out loads of things in my life: music, playing guitar, doing stand-up comedy, sound pieces, theatre and acting. What has brought me to animation and filmmaking is probably the fact I finally learnt that I am better at crafting and shaping things than performing them. I'm more of a 'sit in a room and slowly chisel away and construct things' kind of person. It took me about eight years to discover this. That was my 20s.

However, I did learn a lot from performance and comedy. I think it gave me an understanding of the audience or viewer that is quite immediate and objective. Unsentimental. Comedy gave me a simple, brutal lesson in life. I saw it as a kind of boot camp for me after university. I was a bit soft and needed toughening up. I was always playing around with sound, electronics and computers, creating multimedia comedy shows. The Pod was a complete audiovisual graphics and multimedia comedy environment. I toured the country with it and did the Edinburgh Festival. We even had our own radio show. Going from that into pure animation and film has been just a steady evolution.

The strange thing for me has been the slow development of a new part of my brain. I never really had a visual language before the age of 28. I thought and conceived things in terms of words and sounds. I've slowly developed a more intricate and effective visual vocabulary. My actual verbal vocabulary feels like it's decaying. But I now know lots of new words like 'nurbs', 'median' and 'specular'.

There is a very distinctive style to your work. How would you describe it?

I don't think I really have a style as an animator. I have used many different illustrators and set designers in my work, but I suppose the one defining thing is how it is all put together, which is in a 3D computer program. I get all these elements, someone's drawings, photographs or models, and scan or capture them. In the end it feels like my work because I am often the one who arranges things in the computer and lights it and colours it all. It is my little model world that I have complete control over.

When I'm building all this stuff, my objective is quite simple: to try and make everything not look like ugly CG. This is actually quite difficult to do. If I ever run out of ideas I will always be useful for lighting and texturing CG.

I think I am actually steadily heading towards live action. Animation is a very exciting new arena, but it is also a bit of a killer. You can burn out very easily. Working 100-hour weeks and sitting in front of computers for years is socially destructive. I can't really keep it up.

You seem to be challenging the 'accepted' way of doing things.

I have started doing these remixes of my pop videos, putting the images over classical music because they just seem to work. It's a lot to do with the fact that it's an animated world. If you got Shynola's videos and Numéro 6's stuff and stuck different music on it then the same thing would happen. In the end pop videos always feel a bit cheap, like adverts. No matter how good the track is, it always feels a bit like a commercial, so I just want to put different music on my films. When I tried it with my first video the whole thing suddenly took on a life of its own. I put Wagner on the Coldplay video and the thing suddenly became timeless, no longer limited by the very dull associations with MTV and pop charts. It became a story about love, break-up and hurting people.

Maybe it's because my pop videos are actually desperate attempts to make short films. I wish I could make a proper pop video with dancing and everything.

Although you already have a signature pseudo-3D montage style, do you want to develop and change this?

I'm basically revisiting as many different styles of film and animation as I can, but using 3D animation software. It's me trying to copy loads of things using my limited hardware and tools, and that's how I get my look. All the problems and accidents become part of it. I am still playing around in an area that is evolving at a fantastic pace, so I am aided a lot by the technology.

What other creative imperatives do you want to explore?

I've been talking with Shynola and other 3D pop-video animators about trying to make some kind of New Media Fantasia, or something along those lines. I also want to continue remixing the footage I've made for pop videos to different music, like Arvo Pärt or John Adams. I'd like to finish off the Pod film Future War so I can send it to festivals, and thus get festival funding to go around the world on holidays.

06

07

08

06
A personal project and pilot TV series, The Pod was created with Hope's comedy collaborator Julian Barrett. The deadpan humour and irreverent characters reflect the pair's stand-up comedy roots.

07-08
Hope's experiments with computer graphics and editing packages led to him discovering the possibilities of animation. He started out by making short personalized birthday cards for his family and friends, which more often than not starred Hope himself. His unique style and wit can be traced to these early pieces.

01-10 overleaf
An early, atmospheric short film, The Wolfman, in which a seemingly gentle astronomer turns into a frightening beast while gazing at the night sky. The film launched Hope onto the animation scene and won a number of awards, including the Mclaren Animation Prize at the Edinburgh Film Festival 2000, a prize at the Japan Digital Animation Festival 2000, and both the cutting-edge and public-choice categories at the British Animation Awards 2000. It went on to be used by PlayStation 2 in the UK.

motion blur: onedotzero ✳tim hope

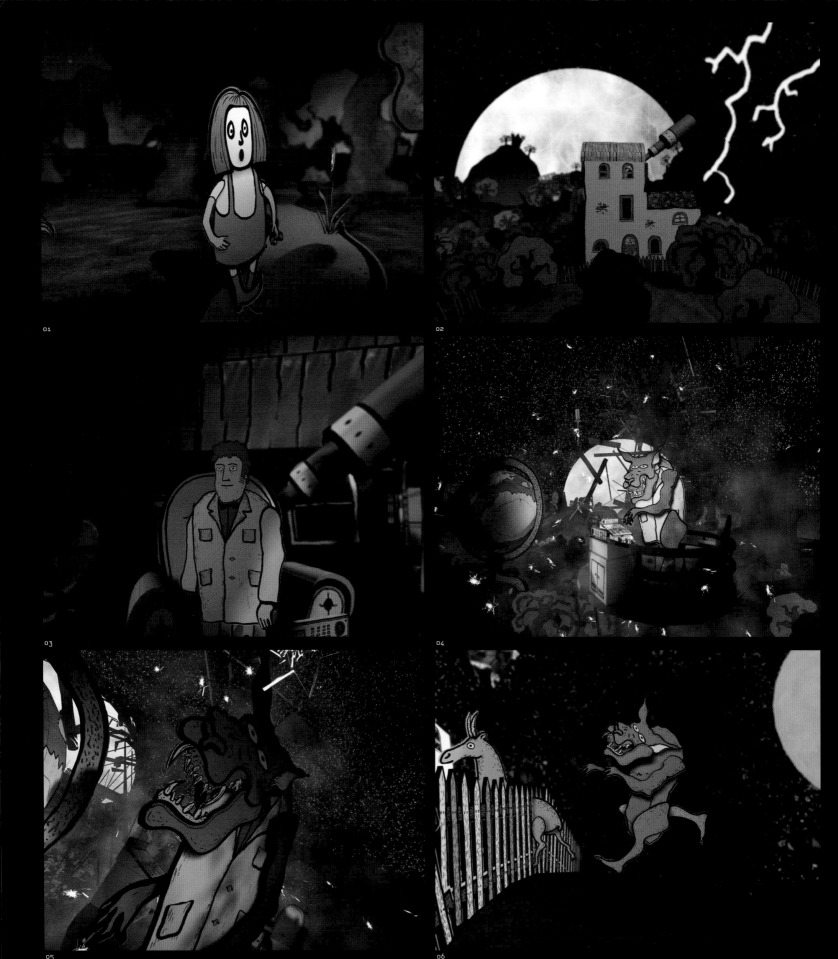

01

02

03

04

05

06

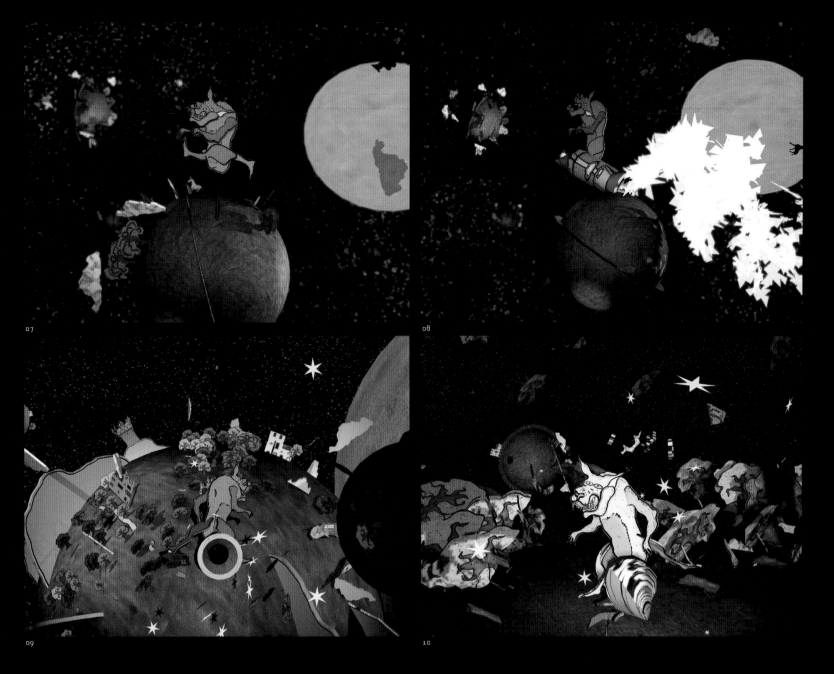

07

08

09

10

01

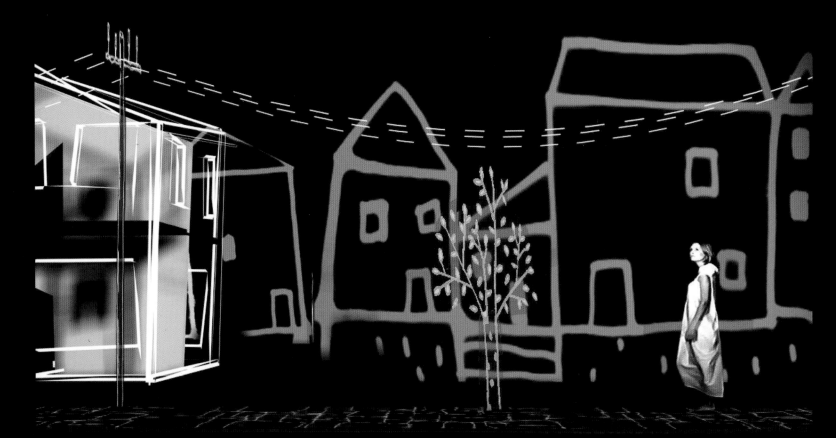

02

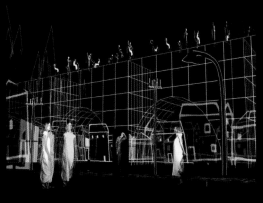

03

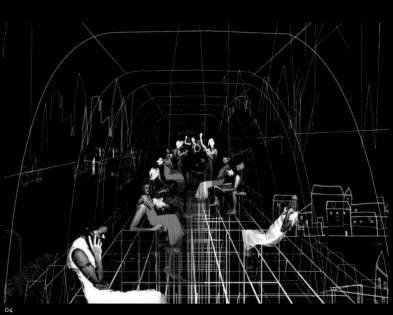

04

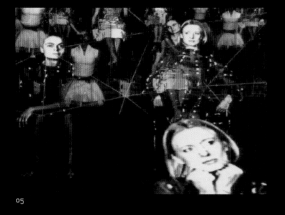

05

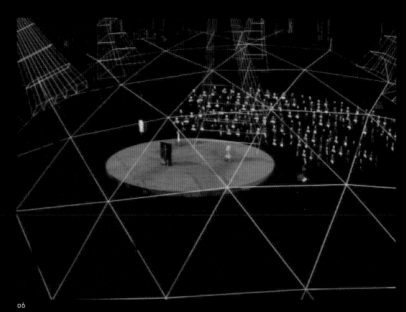

06

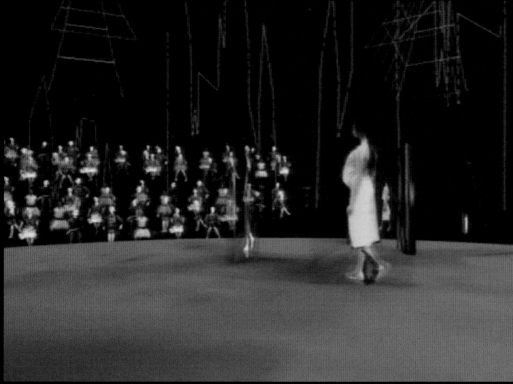

07

08

09

01

02

03

04

05

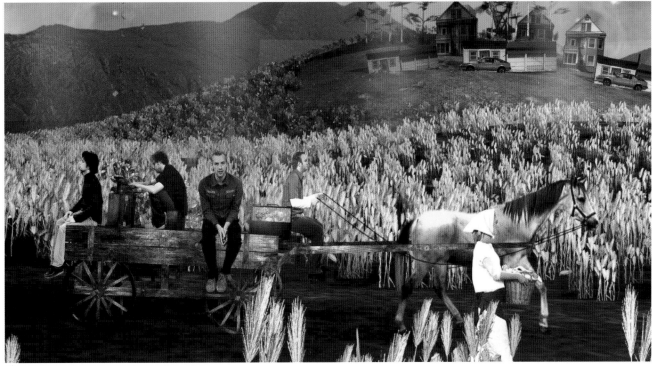

06

01-09 previous pages
Tim Hope explains his short
Jubilee Line as follows: 'I have
rebuilt the Jubilee Line to my own
requirements and added Shelly
Fox's clothes designs as figures
wandering around my millennial
architecture. It is a flawed
attempt by me to pay homage to
all that has gone on in the last
few years in London.'

01-06
Hope produced an outstanding
music video for Coldplay's song
Trouble. The band gave him
permission to re-edit the piece
and so go beyond the normal
'director's cut' by allowing Hope to
make a personal film with a new
soundtrack, Wagner's 'Liebestod'.

01

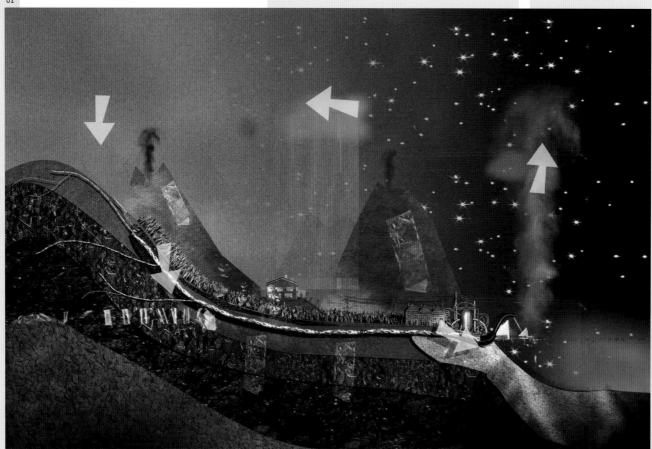

02

03

04

01–04
A beautiful world of domestic,
cut-out harmony is upset by
torrential rain in Hope's ethereal
and iridescent first music
video for Coldplay, Don't Panic,
with additional animation by
John Williams.

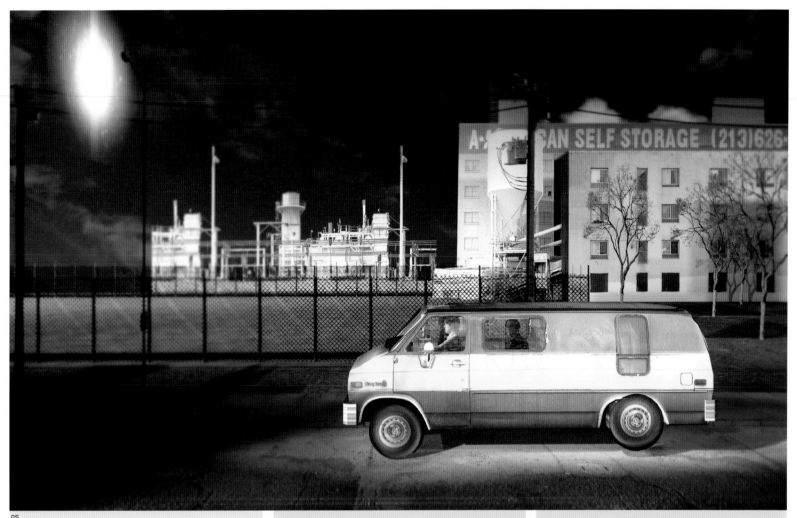

05

06

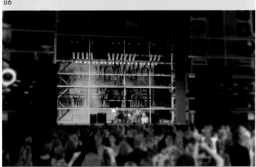

07

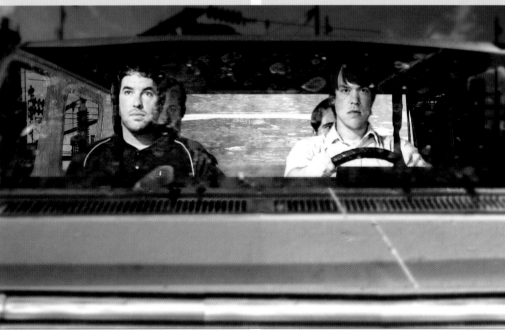

08

05–08
In the promo for Jimmy Eat World's track <u>Sweetness</u>, a performance video is intertwined with Hope's landscaped urban vision as he takes the American band on a city tour.

motion blur: onedotzero tim hope

kuntzel + deygas

Kuntzel + Deygas have produced some of Europe's most individual music videos, working with electronic music artists such as St Germain and Dimitri from Paris. But it is their love of character design that really sets them apart. This interest is reflected in their pet project, Winney, which is about an orange cartoon cow and stylistically marries Mickey Mouse with conceptual art. Character design is not much practised by European and US design teams, but it is very popular in the Far East; Winney is a markedly Gallic version.

01

02

03

04

05

06

07

08

01–08
Winney Tokyo Tour is a short film that was completed for and shown on onedotty. It shows a 'live' Winney going about typical Japanese activities and exploring different ways of life around the capital's zones. Activities include visits to traditional gardens, 'onsen' hot springs, shopping, etc. The project combines live action and cartoon animation inserts.

01–15
Winney is a cartoon character marrying Mickey Mouse with conceptual art — an orange cow who could be the next animated star out of Hollywood. Kuntzel + Deygas have created more than a character as Winney has a full history with black and white cartoons to document his early life. They have taken this conceptual media star to every level, producing a whole range of merchandising and exhibitions in his name. There have been notable collaborations with Baccarat, the Colette department store in Paris and Evian. Products have included clothing, crystal glass, water bottles, games and art capsule figurines.

09
Winney goes shopping, wearing an official Bad Winney T-shirt.

10
Eat My Life, a series of cakes sold at Colette in the winter.

11
A record, Sonata for 3 Fingers, has even been released featuring musician Bertrand Burgalat.

12–14
Winney at the 'Château de Baccarat'.

motion blur: onedotzero kuntzel + deygas

What attitude do you bring to creative work?

FD: Today, for creative people, even for people on the street, there is no frontier between character, reality, serious and non-serious things. Everything is part of the same world now. Every time Olivier and I do something, we think it through before we start, because every time we want to do something different. We are not specialists in one particular technique, so it's very difficult to define ourselves as directors or illustrators or graphic designers.

OK: We don't want to be part of a chapel or group. The chapel of animation, for example. When we've done animation, we have gone to certain festivals and, yes, for that moment we are part of that particular family. But at the same time we want to be part of other families. We love jumping between things, between music and fashion, for example. What we really want to do is to connect different techniques, different people and different countries. Our activities are not confined to Japan, or England, or anywhere else. We just want to connect different things.

Is this why you've been developing character design, because it's underdeveloped in Europe?

OK: I conceived the idea 20 years ago to have a character who became the President, perhaps a character a bit like Mickey Mouse. A citizen cartoon character. We had to develop the story and we created the character Winney.

A cartoon character can be perfect, more than human. But Winney has a past like a human. Perhaps Winney may eventually be stopped in his career as President because of this past. In the 1920s he may have done some bad-taste cartoons or that kind of thing. We have imagined a whole Winney company, driven like a big marketing enterprise. In the Winney company there are rules, just as there are in real big-company cultures. But extended, like a secret society.
FD: Yes, with its own special vocabulary. We've conceived Winney as leading a human life. So it's a life with mistakes, with happiness, felony and everything else. We don't have a set goal. We just say, 'Okay, we want to go in that direction.' We started the Winney project for it to be open, not just to follow a certain preordained track. We don't know where he will go but we will follow him. You have to be open to things. For example, before going to Japan the image I had was that of a very disciplined country where men and women were very wise and never went to extremes. Afterwards I realized that the Japanese could be as extreme as we are here. It's difficult to generalize.

With the St Germain music video you seem to have attempted a move away from straight animation.

FD: Rose Rouge was done only with photos of Paris and the main shots of a girl. We had the idea to take still photographs and morph them to create her movements and to produce the bits in between, as in classical animation. It removed any dynamic effect and made you concentrate on the movement.
OK: Sometimes I feel it doesn't help really to find new ways or techniques of doing things. I feel we have — or the artist has — to be a little lost. You have to make some mistakes along the way. If you know exactly where you want to go, your journey is problem-free, but sometimes what is created is less pure because it contains no mistakes. It means there is no adventure in a way.

09

10

11

12

13

14

15

i ♥ Baccarat

01 overleaf
Sketches of dogs for Vogue Nippon 2002 by Florence Deygas The similarity to the style and technique of the Catch Me If You Can titles is unmistakable.

02–12 overleaf
The main titles for the film Catch Me If You Can for Dreamworks really steal the show. It was reportedly the first time Steven Spielberg had used a non-US design company for the main titles for one of his films, and K+D did not let him down, winning a raft of awards for their work. The inspiration apparently came from the Pink Panther cartoon and the work of Saul Bass, the master of opening titles. John Williams' theme song was fully integrated into the sequence, with the letters and images producing a flowing narrative. K+D designed the characters in the sequence to resemble flat, highly stylized cutouts.

IIIIFR
interviewed:
Olivier Kuntzel
Florence Deygas

The K+D atelier is situated on the outskirts of Paris in a building which was formerly a glass factory. This is home to their work on both commercial and personal projects, including the fast-growing celebrity that is Winney.

06

07

10

11

motion blur: onedotzero

kuntzel + deygas

Catch me if you can

A Steven Spielberg
FILM

04
05

Nathalie Baye

Leonardo DiCaprio

08
09

Amy Adams

01–05
A sparkling space fantasy for the
video <u>Reaching for the Stars</u> by
Japanese jazz-funk outfit
Fantastic Plastic Machine.

01

02

03

04

05

motion blur: onedotzero kuntzel + deygas

06

06–08

06–08
K+D are often asked to create very stereotypically French work for international clients, a kind of commission that they usually avoid or manage to reinterpret. Collaborator Dimitri from Paris gives them free rein with his projects. One was a full-on pastiche of all things Parisian. For Stylish Fille, however, they decided to play on the Sixties theme in a highly stylized and fitting promo. 'Dimitri was very happy with that,' they remember.

07

11

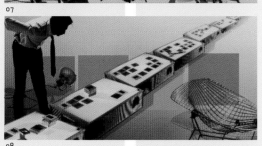

08

11–15
The Rose Rouge promo for St Germain was created entirely from digital still photography. The movements were all achieved through morphing techniques that provide a unique sense of motion, removing any dynamic effect. The colour palette, movement and tone perfectly match the smoky house music.

12

09–10
The video for French lounge musician Bertrand Burgalat's The Sssound of Mmmusic deploys subtle CG effects visualizing the organic sounds of the music using choreographed natural flora.

13

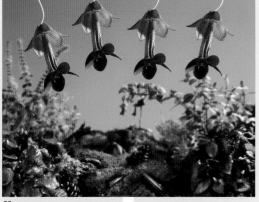

09

14

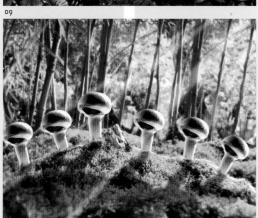

10

15

le cabinet

01-07
A onedotzero commission for
onedottv, Streets is a standout
piece exploring the fragile trajec-
tories of the skies and streets of
our endangered cityscapes. Here
Le Cabinet turn up the motion
graphic heat in a deft display of
oven-hot reds and burnt oranges.

Le Cabinet's design double act of Marc Nguyen Tan
and Benoit Emery typify France's new generation of
chic designer-directors. With clients ranging from
Parisian high fashion houses to European sports
channels, they create highly distinctive visions
across all media. Their conceit of using signals
and impulses, rather than direct copyline-focused
messages, for primary communication in their client
and personal work makes absolute sense when
viewing their vivid colour palette for Kenzo and
Arte or personal work such as Streets and Routine.

01

02

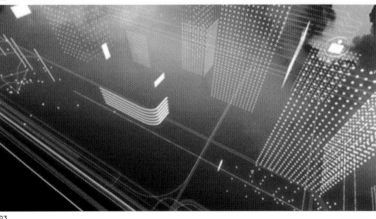

03

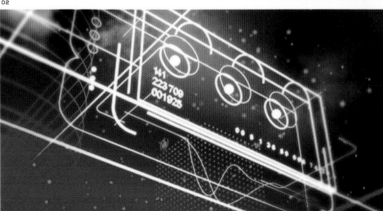

04

How did you get your name?

MNT: Le Cabinet can be a funny word in French, but it can also be taken to mean something a bit more serious. As a funny word, it means toilet, but in its more serious meaning it is a place to work and to have a very specific vision of that. We find it very hard to define ourselves because we are not like graphic designers or art directors or movie directors. We are a bit of everything.

Would you say you have a contemporary French visual style?

MNT: I don't know if what we are doing is something that you can call a French style because it's something that we don't do consciously. I remember when I was in England they used to say, 'Oh, your work is very continental', but I never understood what it meant. But maybe the things that I understand about our work — the way it's very focused on the

impact of something, of the images — creates this impression.

BE: Most of our clients come to see us because they know that what we are going to give them is going to be different from all the usual advertising or design agencies.

Are you concerned only with 'look', or with the deeper issues attached to the work?

MNT: We are not changing the world; we are just trying, at a certain level, to do nice things and do something a bit more personal. There are many very talented people worldwide, so we're just one drop in a big ocean. So we don't feel that on top of that we have to act or take ourselves too seriously.

BE: We are most concerned with the design process. Most of the time, if we are working on a multimedia project for example, we try to push it a bit forward and develop it.

→

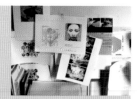

IIIIFR
interviewed:
Marc Nguyen Tan [left]
Benoit Emery

The Paris-based Le Cabinet work in art direction, new media and print design, as well as motion graphics. Marc Nguyen Tan also records music under the name Colder.

05

06

07

01–08
Promotional video for the
Honda car company.

Why did you start creating personal moving-image work?
MNT: I did a piece called 1:23 as a way of exploring my interest in science and trying to express that in graphic design and designed images. It was based on scanner images and tried to reveal an inner view of 'normal' things. It was just a kind of test for me.

Can you tell us about your newer personal films, commissioned for onedottv?
MNT: In the beginning we were really interested by something called 'number stations'. They are a network of radio transmissions which exist worldwide that you can still listen to with really big satellite dishes. They are just like spoken radio broadcasts but with voices of people saying words in a random order. When we heard about that for the first time we thought it sounded really spooky and weird. We thought this was

maybe a way to express the relationship human beings have with their natural environment — and the way they feel about science. So it was a good starting point from which to create a series of films.

Could you highlight your differences and how you work together as a team?
MNT: Benoit is much more into doing things without a computer, whereas I am completely lost when my computer is shut down for some reason. He is much more into drawing things and painting, or working with different kinds of papers and materials.
BE: I'm fascinated by the way Marc approaches different media, including music. It's not his technical skills that I am interested in, but more the sensitivities he's able to bring to them. He applies these sensitivities to everything he touches. That's why I was fascinated immediately by his work when we first met.

01

02

03

04

05

06

07

08

motion blur: onedotzero le cabinet

10–15
Title sequence for French TV
music series <u>Jazz 6</u>.

16–19
Broadcast titles for Eurosport
Channel ATP/WTA.

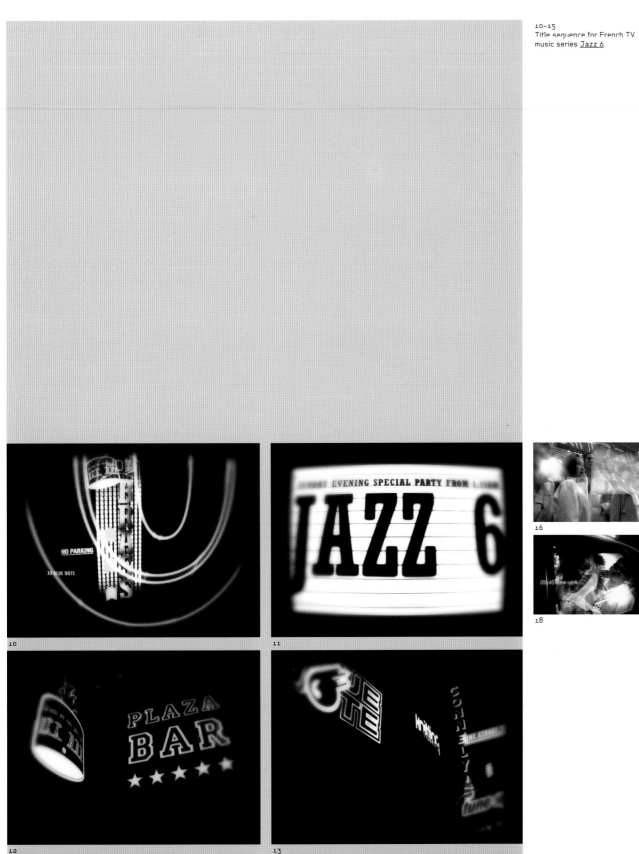

10

11

12

13

14

15

16

17

18

19

motion blur: onedotzero

le cabinet

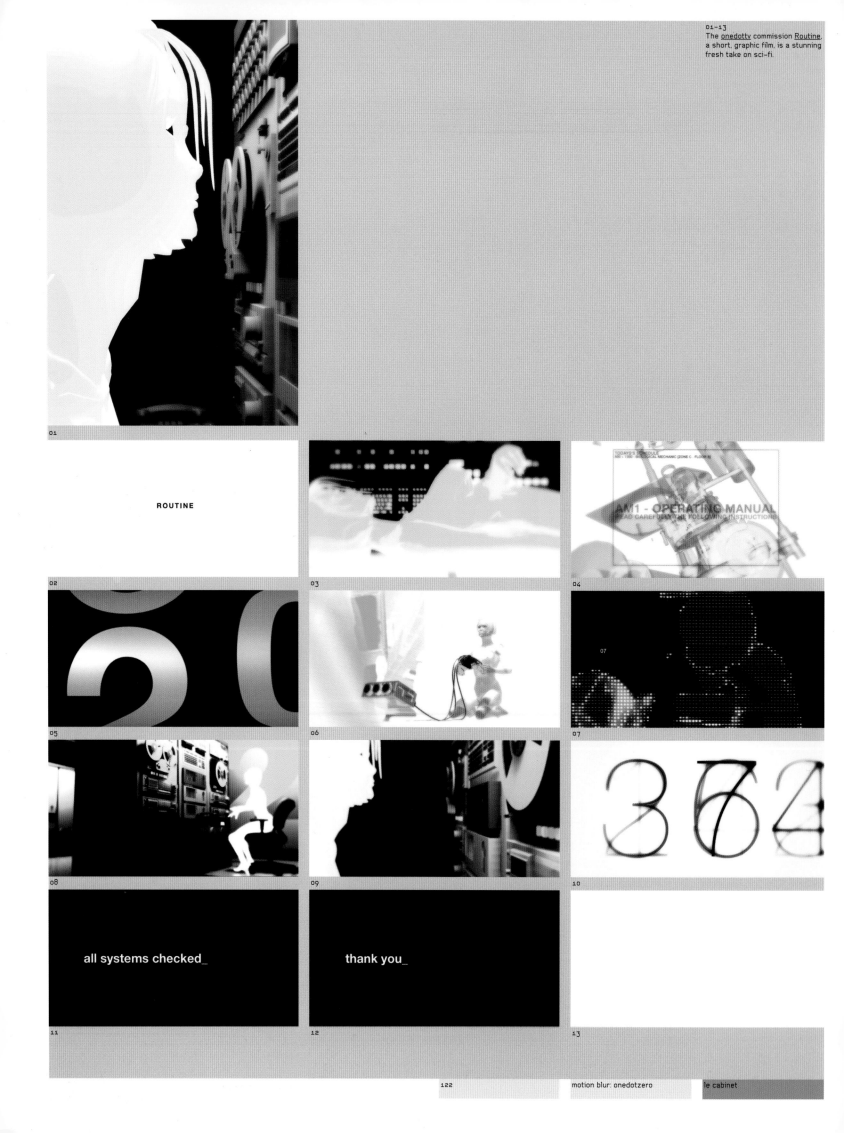

01

ROUTINE

02

03

04

05

06

07

07

08

09

10

all systems checked_

thank you_

11

12

13

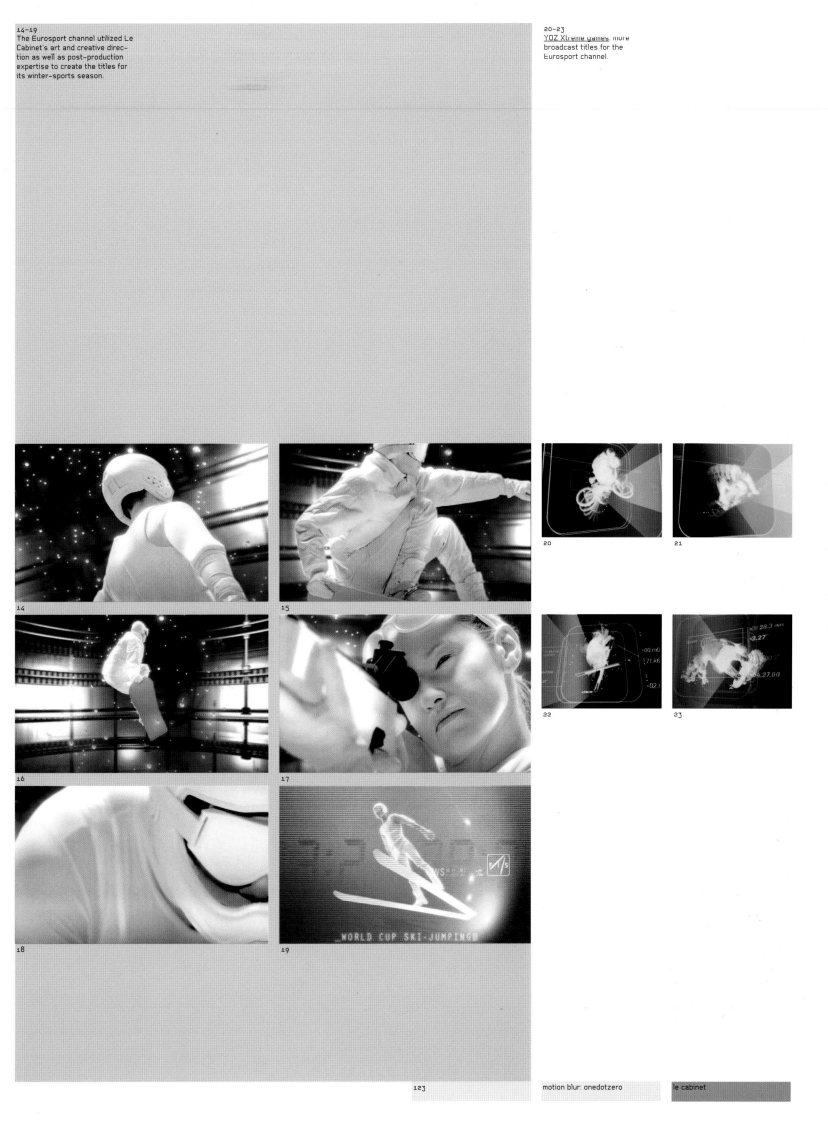

The Eurosport channel utilized Le
Cabinet's art and creative direc-
tion as well as post-production
expertise to create the titles for
its winter-sports season.

YOZ Xtreme games. more
broadcast titles for the
Eurosport channel.

14

15

16

17

18

19

WORLD CUP SKI-JUMPING

20

21

22

23

motion blur: onedotzero

le cabinet

logan

Logan have fast become of one of the hippest design groups in the US. Operating out of the former offices of the Beastie Boys' defunct label, Grand Royal, their standout work for clients including Money Mark, Jurassic 5 and DKNY reflects the sense of displacement that seems to be inherent in Los Angeles life. This is a city of foreign objects, and Logan's Alexei Tylevich and Ben Conrad, who come originally from Minsk and Okinawa respectively, have assimilated this feeling into their motion work, honing a signature style that juxtaposes live action with vivid graphic elements. This displacement and a unique set of visual inspirations set Logan apart in the American motion-design landscape.

01
01 overleaf
01–12 page 128
Information Contraband for Money Mark, aka Mark Ramos Nishita, is a loving tribute to the graphic-and-type orgy of Thai film posters, with cops, villains and heartthrobs literally bursting off the billboards in a feast of colour and movement. The video takes you on a visual vacation, prising out startlingly original influences to wondrous effect. It won best directorial debut, best electronic music video and best video under $25,000 at the MVPA awards.

You seem to be in a state of constant change, with your group name, work areas and styles.

BC: I think the problem with a lot of commercial designers is that their clients are wanting something that they feel safe with, that's already been established, that's already been in a film or in another commercial. So it's the duty of designers to keep going forward and hopefully getting the client to see that their own vision is better, to grow with those ideas.

AT: And that can only come from personal work. I always look towards films and filmmakers who use particular approaches in film in a more real, personal and graphic style.

BC: Like Stan Brakhage.

AT: Or even like Suzuki Seijun. His film Branded to Kill is amazing. Of course, it was a pretty large production, but it's so personal and even his use of real simple graphics, to imply rain for example, just blew me away. It's one of the most influential things I've ever seen.

Do you deliberately seek out external sources to inspire your work?

BC: Well, lately we've been looking at a lot of Jodorowsky's films and Verner Panton's interior design from the Seventies.

AT: We've gone from rational modernism to absurd kitsch in the current phase.

Tell us about the early MTV title you worked on.

BC: The MTV piece has a combination of two elements, a sort of psychedelic, sinewy background in combination with real flat vector-based people that we shot, composited and built, with 3D elements around the characters.

AT: I had a lot of preconceptions of what film production is about. To me it's always been a group enterprise and I never saw a way to actually work with film as an individual. The exposure to digital tools really opened up a world of new possibilities.

How did you first get involved in motion graphics?

AT: After graduating from school I was invited to come to LA and work for Channel One News as their company art director. That proved to be the most demanding assignment I've had in my professional career so far. It's a direct TV news programme broadcast daily to hundreds of thousands of classrooms around the US. There's about eight million people that watch it every day, but most of the people who don't get Channel One have never heard of it. I didn't want to go the easy route and just borrow visual language from other mediums popular with teenagers, such as music videos or candy commercials. So the idea I had in mind was to elevate the factual information to the level of a narrative. To expose the fictitious nature of news.

BC: I did a lot of work trying out animations in the darkroom, exploring analogue techniques. But they ended up in a digital format. I like approaching it using really archaic and simple techniques that eventually turn into digital form. I think exploring these older techniques allows for a lot of interesting things to happen. During school, at the time I got into animation I was feeling frustrated with the still image, just the idea of one still. That idea mutated itself into something called the Pinhole Camera Suit I created, which is composed of 135 pinhole cameras that take a picture almost, but not quite, simultaneously. It's interesting because it's time-based, but it's slow. It captures my breathing and it reflects on the exposure of the film.

That interest evolved into multiple frames, and I thought, 'There's a life in these frames,' and began to animate phonograms using really traditional pinhole photography – the most basic form of photography. I created composites within a darkroom, scanned them into frame-by-frame animation and created videos out of them. Based on that idea was a film that I managed to acquire from a drugstore in Minneapolis called Butler Drug. It was a 16mm record of people cashing cheques. The security corporation had no idea of the sort of amazing thing that happened when you played it, they were just using it for stills, just to print for identification purposes, but once you run it in a film projector it's amazing.

Logan has a really varied array of clients. How do these come to you?

AT: A lot of the projects that we've been getting have been through word of mouth or through things that people see in magazines, books and publications that catch their imagination.

BC: The reality of commercial work is that clients often ask for it to look like something else, which is unfortunate. But there are other times when they find stuff that we've done for ourselves and ask us to make it look like that. With any project we try to tweak it and take it a little further than the client is thinking.

Can you explain the ideas behind your personal project Murmurs of Earth?

AT: It's an idea for a brand that we developed, a kind of a side project for us, but we are spending more and more time on it. It's influenced in large part by the Voyager programme carried out in the Seventies. The purpose of that programme was to contact extraterrestrial intelligence. NASA sent a gold-plated disc out into space carrying images, voice recordings and samples of music that were an attempt to describe our planet to aliens. We were just mesmerized by the material when we saw it for the first time. It was such an incredible collection of random bits and pieces that didn't really quite fit together, and that gave us an idea of developing a collection of marginalized outsider data. We wanted to come up with a term to describe the style of this visual journey, and for want of a better term we came up with 'psychedelic constructivism'.

≡ US
interviewed:
Ben Conrad [left]
Alexei Tylevich

Logan are located in the former offices of Grand Royal, the Beastie Boys' record label, in the Atwater neighbourhood of Los Angeles.

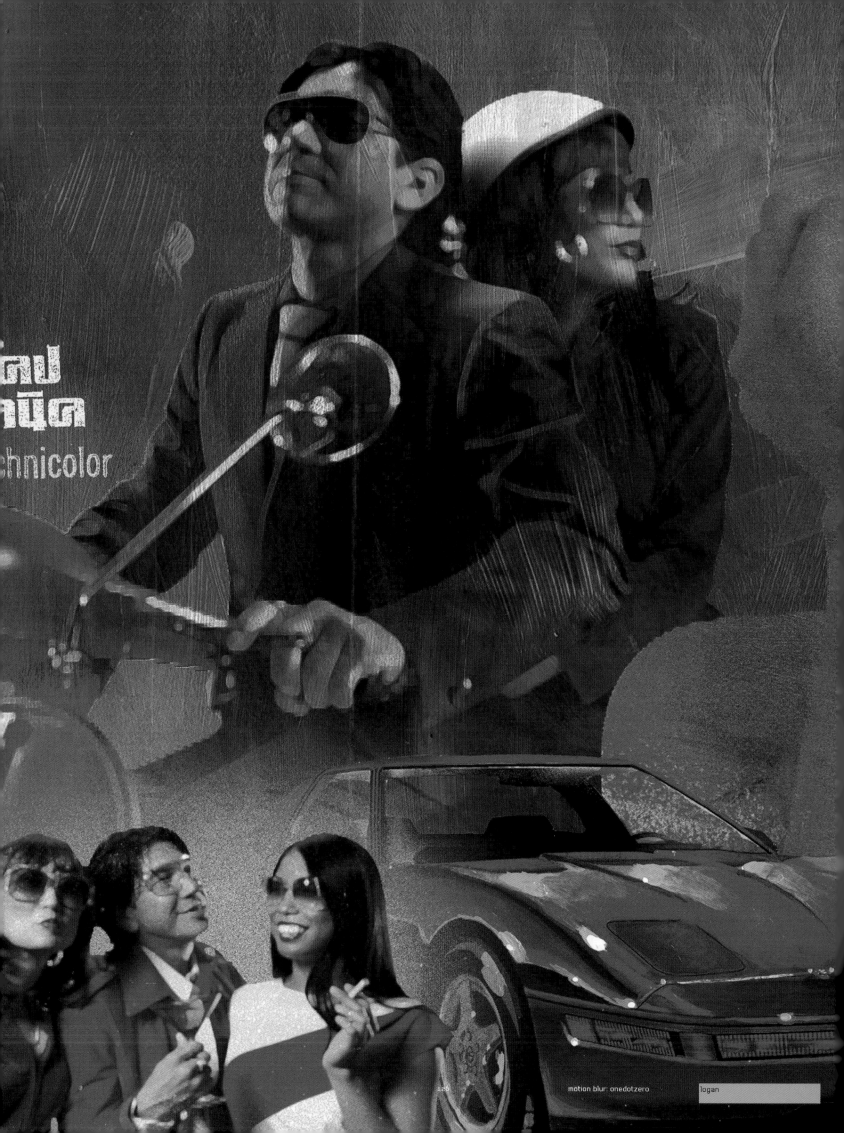

chnicolor

motion blur: onedotzero

logan

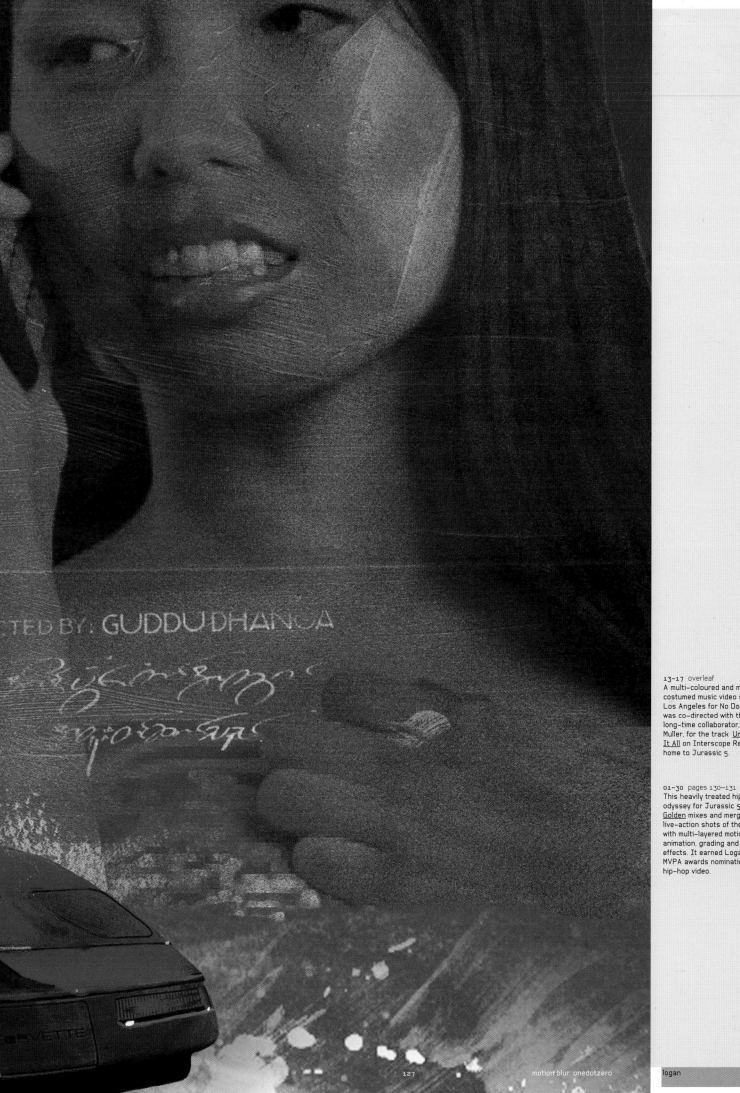

CTED BY : GUDDU DHANOA

13-17 overleaf
A multi-coloured and multi-costumed music video shot in Los Angeles for No Doubt. It was co-directed with the group's long-time collaborator, Sophie Muller, for the track Underneath It All on Interscope Records, also home to Jurassic 5.

01-30 pages 130–131
This heavily treated hip-hop odyssey for Jurassic 5's What's Golden mixes and merges dynamic live-action shots of the rappers with multi-layered motion graphics, animation, grading and special effects. It earned Logan another MVPA awards nomination for best hip-hop video.

01

02

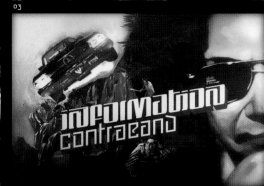

03

04

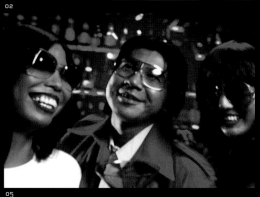

05

06

07

08

09

10

11

12

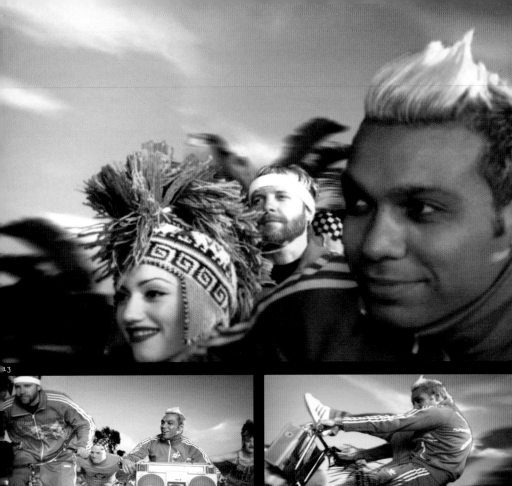

13

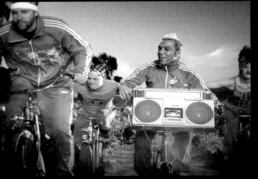

14

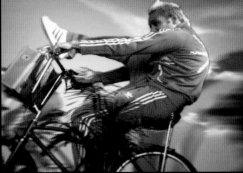

15

6

17

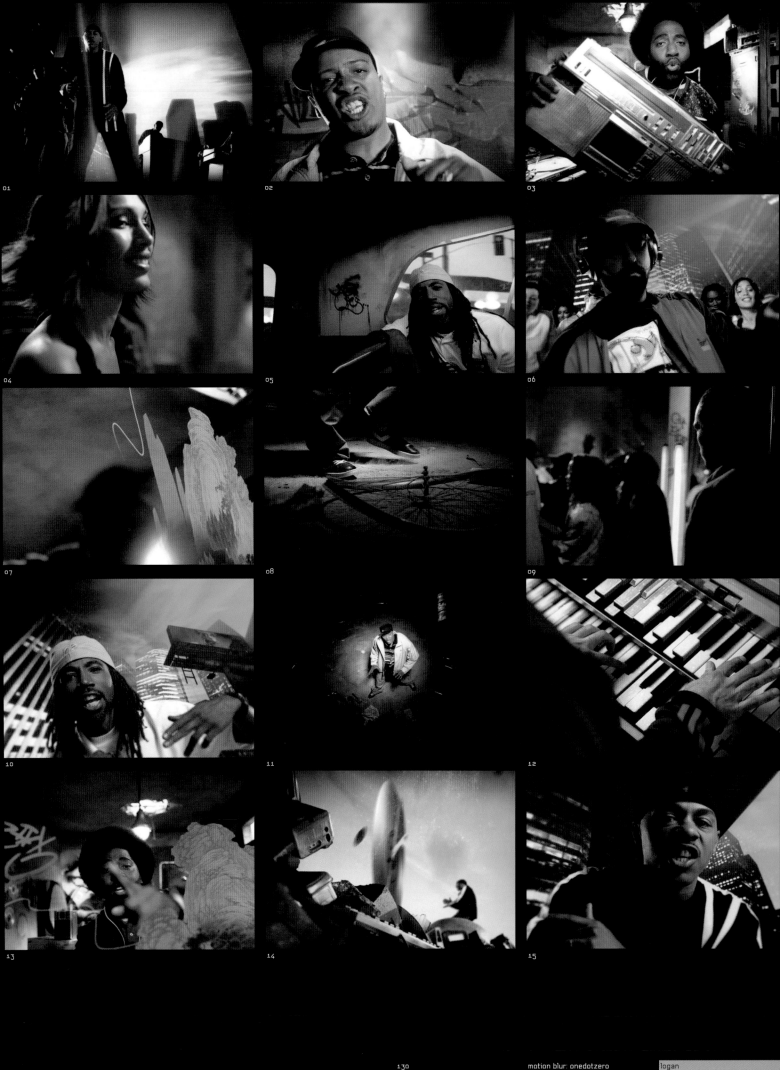

01 02 03

04 05 06

07 08 09

10 11 12

13 14 15

motion blur: onedotzero logan

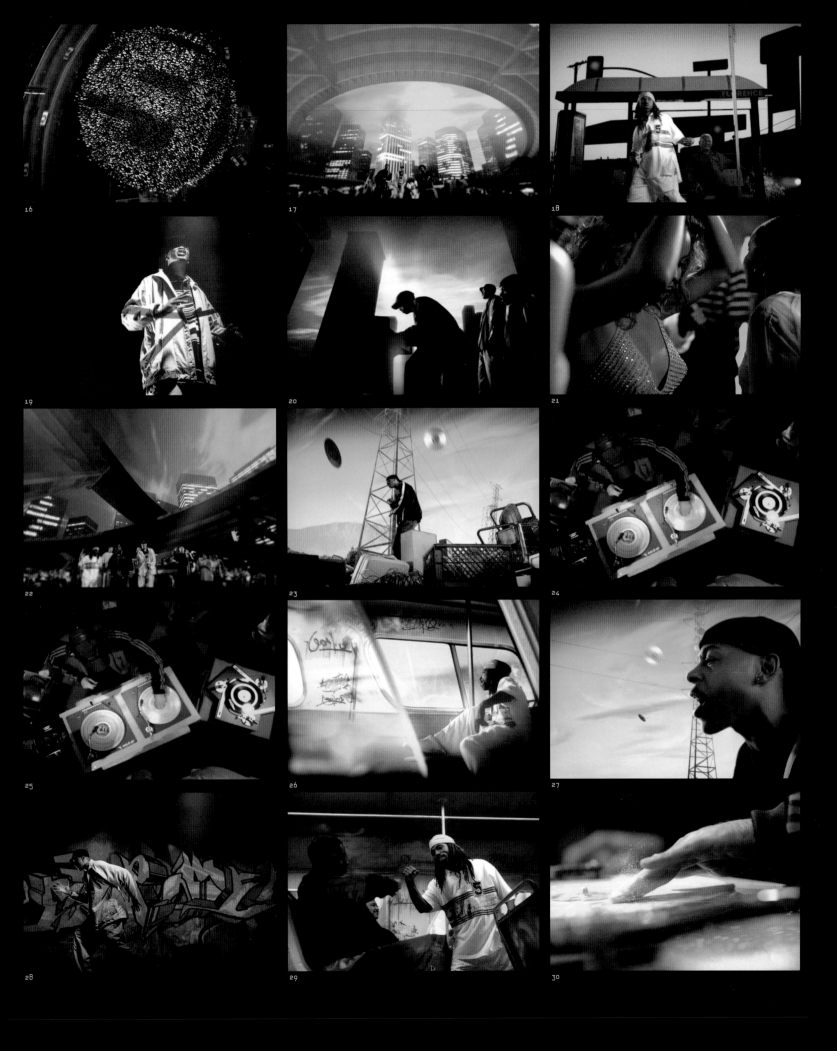

16

17

18

19

20

21

22

23

24

25

26

27

28

29

30

motion blur: onedotzero

logan

01

02

03

01–10
A moving-image piece completed
for <u>onedotty</u>. <u>Murmurs of Earth</u> is
a Logan side project influenced
by and responding to the 1970s
Voyager programme that sent
a disc into space containing
media artefacts, etc, in the hope
that aliens would be able to
understand it. 'We wanted to
come up with something to best
describe the style of this visual
journey,' say the creators.

04

05

06

07

08

10

09

geoff mcfetridge

Developing out of a languid lo-fi skate-style tradition, Geoff McFetridge's work has become progressively less about subcultures and more about intimacy. With the inherent simplicity of its direction and animation style, it speaks volumes compared to the frenetic eclecticism of many of McFetridge's contemporaries on the US graphic scene. He combines working out of his graphic design studio, Champion Graphics, with directing work for The Directors Bureau.

01

02

01–10
The success of McFetridge's graphic and illustration work naturally segued into titles and motion graphics. He not only created the posters for Sophia Coppola's The Virgin Suicides, but also the film's main titles which used a schoolbook graffiti style of handwritten typography. A refreshing doodle-infested style suggests the teenage rebellions and angst of the story, capturing not only the Seventies-nostalgic feel, but also the desire to escape authority and the perceived lack of freedom to be who you are when you are an adolescent.

03

04

05

06

07

08

09

motion blur: onedotzero

geoff mcfetridge

Your work commonly segues between live action and animated illustration. Is this the best way you could make sense of being a graphic designer and director at the same time?

I suppose. I really like doing animation and am very comfortable doing it, so most of my treatments involve graphics in some way. I love graphics, I even do graphics about graphics.

The graphics in your <u>Citizen Cope</u> video are refreshingly naïve. Was this due to the restraints of the format for you at the time, or something more to do with your inherent style?

It was created in seven days, from getting the song by courier to going online. But it looks rough because I wanted it to look that way. I shot myself drawing things in stop motion with my digital camera. Almost all the graphics are shot that way. Simplicity interests me, and so does roughness. There are enough slick graphics on TV already.

Your moving image is at its most crude, simplistic and sadistic in the ESPN X-Games spots. Can you tell us about how ideas for these developed?

The campaign was based on a series of posters I did. Most of the characters I had already created. Wieden + Kennedy [agency] had the concepts for the sequences, which we then worked on together. The only moment that we toned down was when I wanted the bear to cut open his stomach and have his bowels spill out. Other than that, it just felt like making an art piece. It was really fun. I have done a lot of commercial work that is based on material that I have created for art shows. Like the Burton Snowboards forest spot, <u>Big Foot</u>. I would never have thought that would happen.

Can you tell us more about the Simian video?

I always loved that song, I actually had it on my graphics reel for a while. So I was excited to write for it. The basic premise is that a white monolith lands on earth, and sends out visions to people to de-evolve. It

→

▤US

Geoff McFetridge is a graphic artist and director currently working in Los Angeles but originally from Canada. He set up his own studio, Champion Graphics, in Atwater Village, California, and his creations have appeared on magazine covers and clothing, as well as in exhibitions of his work from the USA to Paris and Tokyo.

10

01–36
The music video <u>One Dimension</u> for Simian is an unassuming, comic lo-fi piece whose deceptive simplicity belies its cutting-edge sensibility. The live action is interwoven with motion graphics riffing off Eighties T-shirt designs, political placards and camouflage. Gangly, carefree students, balaclava-clad revolutionaries and ballet dancers in combat gear are masterfully integrated into the seemingly Sixties-set narrative.

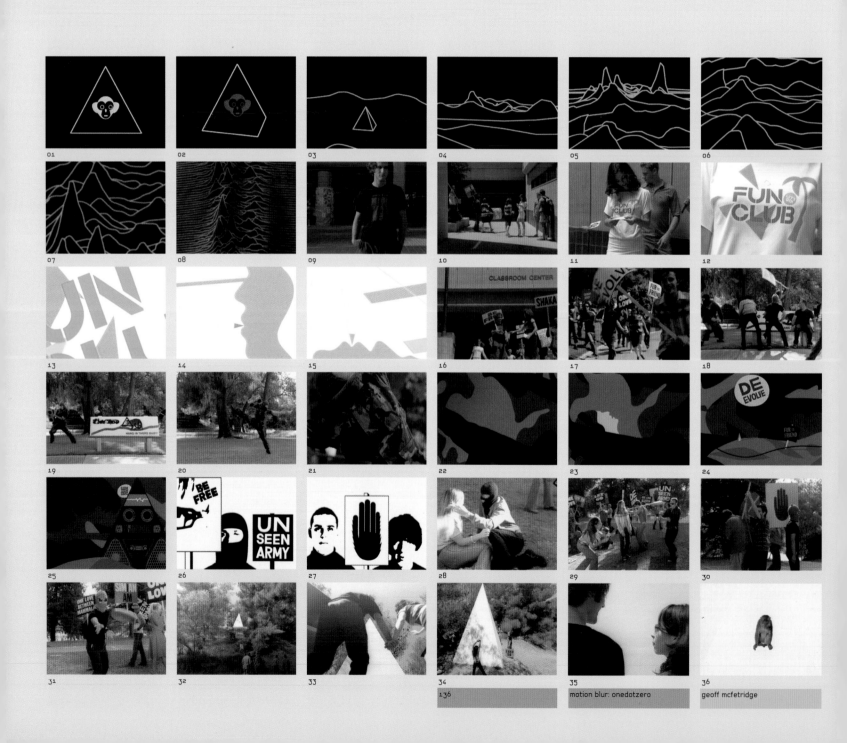

01 02 03 04 05 06
07 08 09 10 11 12
13 14 15 16 17 18
19 20 21 22 23 24
25 26 27 28 29 30
31 32 33 34 35 36

motion blur: onedotzero

geoff mcfetridge

is a reference to 2001 — A Space Odyssey, where a black monolith lands on earth and triggers evolution and aggression in early man. The white monolith teaches love. How trippy. The graphics are meant to be 'one-dimensional' visions that the people are having.

Can you expand on how your work for Marc Jacobs and your other print work at Champion Graphics feed into other areas?
It all works together. A lot of the same ideas will show up in different aspects of my work. If it didn't work that way I think I would lose my mind.

The Plaid Itsu video feels like a real departure for you.
I wanted to make something that was created in the editing rather than in the animation. Animation can be exhausting. I never want to stop doing animation, but I am really interested in telling stories with film. I am still working out how I want to be doing it.

The Virgin Suicides title doodles feel like the most 'all-American' thing you've done compared to your

other work, which is not typically in the super-slick US style.
That is interesting that you think of the Virgin Suicides sequence as slick. I also think that it is interesting that you describe it as all-American, and I agree. Like many motion-graphics projects I have done, it is a visual solution that came out of a creative process. Outside of the video work I have done a lot of different title work for film and TV. My graphics reel is really eclectic. Most of the work has a rough, found or hand-done feel.

As for American graphics trends, I have never been interested in creating the 'slick' look of most graphics seen on TV. Even so, technically, I couldn't do them if I tried. I have tried to have the graphics I have done be solutions to specific projects, rather than stylistic moves. It is crazy to watch animators and designers scramble to create the next look. For me, interesting and influential work usually comes about as a visual solution to the demands of a project — images that develop out of larger ideas.

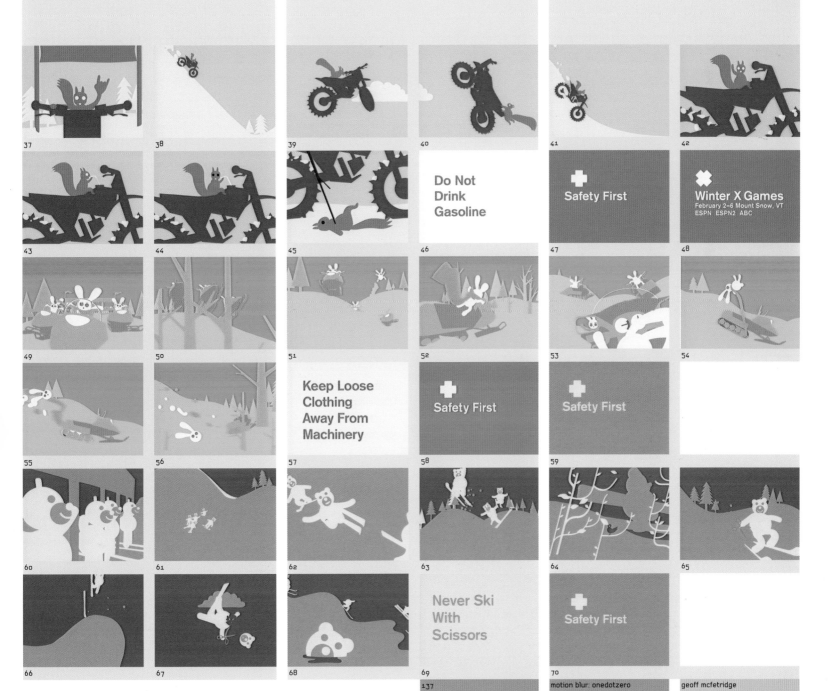

37 38 39 40 41 42
43 44 45 46 47 48
49 50 51 52 53 54
55 56 57 58 59
60 61 62 63 64 65
66 67 68 69 70

Do Not Drink Gasoline

Safety First

Winter X Games
February 2–6 Mount Snow, VT
ESPN ESPN2 ABC

Keep Loose Clothing Away From Machinery

Safety First

Safety First

Never Ski With Scissors

Safety First

motion blur: onedotzero geoff mcfetridge

01-09
McFetridge's work always seems
to have personal elements.
Forests [and yetis!] often feature,
possibly as a nod to his roots
growing up in the Canadian
countryside. The animation Big
Foot, for Burton Snowboards,
features his beloved forest
setting complete with a yeti
wandering through the snow.

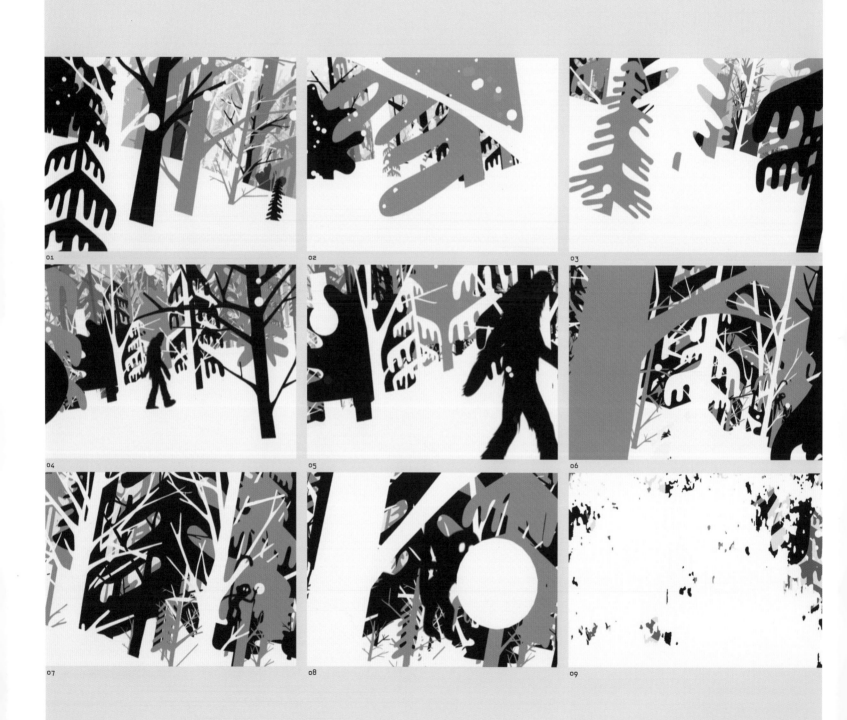

01

02

03

04

05

06

07

08

09

10

11

12

13

14

15

16

17

18

19

20

21

22

23

24

10-24
McFetridge's visual sense and
humour feed into his motion-
graphics and moving-image
works, as well as his music videos.
For The Avalanches' Frontier
Psychiatrist video, for instance,
he uses mainly live action with
still images and transitions to
animation.

psyop

There's a Lower East Side subversive quality to Psyop's polished graphics and innovative visuals. However, corporate clients including Volkswagen, AT&T and Starbucks are more than happy to buy into their conspiracy theories and paranoid delusions in order to be associated with this young motion-design boutique's edgy and distinctive style. While Psyop have heavily commercial instincts, they bring the same sense of sublime finishing to their propaganda pieces Personal Power Pathways and Brasil. Satirizing an industry that they are part of is a tricky business, but they carry it off with an offbeat sense of humour and dashes of Situationist-style theorizing.

01

02

04

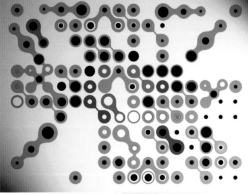

05

03

Can you tell us about the premise your group is based on?

TM: A while ago I found a field manual for psy-ops — psychological operations — which was published by the military on this waxy paper. It's indestructible; made of weatherproof and waterproof paper. It's about 200 pages, and inside it describes exactly how to create strategic propaganda to convince the population in the country that you're entering to side with you.

We apply this approach to the commercial realm. Through consumerism you will achieve ultimate success in life, and so we're creating everything from Personal Power Pathways to prescriptions and products. The idea is duping the system at the same time as feeding off it.

What's your working process?

TM: In practical terms, wherever possible we do a great deal of conceptual work first. We write our own work or we help the process by working on clients' scripts and refining their ideas. We then try to identify a visual approach that would be complementary to the concept of the piece.

KM: Within the digital realm we've explored a variety of different approaches, some being really clean vector-based graphic looks, others having that sort of textural, watery, bubbly quality. I think that, even though our work is quite embedded in technology, there's still a huge diversity within what we do.

TM: We try as much as possible to enjoy the collaborative effort of working with agencies and client creatives, and it's very possible to do that. We don't shut the door on them and try to isolate our process,

→

01–09
Psyop utilized an abstract, flat illustrated style throbbing and pulsating with high-speed motion graphics for the AT&T campaign for a newly proposed broadband division. It translates the telecommunications company's business into a series of modern spots, highlighting connectivity and a sense of community, and merging curvaceous shapes and sensual circular movement to a banging soundtrack.

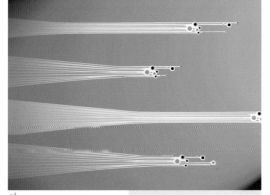

06

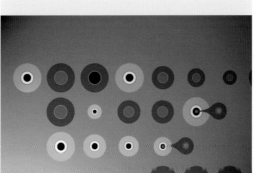

07

US
interviewed:
Todd Mueller
Kylie Matulick

Psyop's slogan is 'persuade — change — influence'. This Lower East Side powerhouse was founded by Marco Spier, Eben Mears, Marie Hyon, Kylie Matulick and Todd Mueller [pictured left–right] in New York in 2000.

08

09

because we want to do what's best for the project. Also, because there are five of us, we have a fairly critical and energetic approach to things which are not commercials — artistic endeavours where it's just more purely self-defined. We're trying to do more and more of that because I think we are more inspired by the self-delineated adventures.

Your signature fluid approach was first seen in the Company Flow music video directed by Todd.
TM: The band Company Flow is a very grassroots hip-hop band based in Brooklyn. End to End Burner is about a train that is completely covered with graffiti

from the front of the train to the very back end. I just sort of conjured up this idea of gravity moving like a subway train. If gravity could somehow move like a hip-hop beat, or an MC's hands through space, through the subway system, how could that be visualized?
KM: It's not so much about technique as about ideas, and technique following those ideas, and keeping the approaches to these techniques as fresh as possible.
TM: When you do work for yourself, the brawn of the work is just inventing the crystal. Like, what is it going to be? What do we want to do? I guess I find that such a slow, enjoyable process of, you know, oh, it's this, and in this shape there's 15 ideas, and then you bring

→

01–14
My VH1 Music Awards was developed from the previous year's branding, also created by Psyop, but throwing in more narrative elements and environments and using black and white, flat, line-drawn people. They used 'ghetto motion capture', taking video footage as a reference for the animation. This allowed them to create simple but recognizably living characters, who were capable of conveying narrative ideas and who could be used to break the standard mould for displaying infographics. A completely 3D environment was created that would give the illusion of unlimited space that could hold the 50 modelled figures — who could swell to represent more than 2,500 characters, appearing and interacting seamlessly, thanks to the creation of a motion library. This simple yet stylish work soon attracted other commissions from brands such as Volkswagen and Starbucks, keen to sample Psyop's successful approach.

01

02

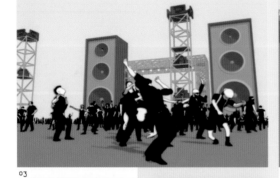

03

04

05

06

07

08

09

10

12

13

14

motion blur: onedotzero

psyop

15

16

17

15-19
Come for Brasil is a personal
piece created for Nando Costa's
Brasil Inspired book and DVD
project. Psyop's love for the
country shows through in this
lustily animated, wet and sexy
motion graphic short which spurts
off the screen and lives up to the
term 'graphic'.

18

19

it down and bring it down. Then you find you've identified precisely what it is you want to make.

How do you make sense of the way you engage with the overall capitalist process, as opposed to the creative process?
TM: One of our ideas, or paranoid delusions in an entertaining way, is that there is a government controlling all ad agencies and the ad agencies are controlling our appetites for everything from weight-loss clinics to olestra, to whatever.
KM: Where everything's feeding off everything else. It's like a pyramid of consumerism and even desire. So we just play on that whole theme of changing the minds of the masses. Using that as a simple tool. From that we created our own list of Personal Power Pathways. It's all based on that whole concept of the more you consume, and the more open you are to consumerism, the better.
TM: How to be a more willing target for advertising.

01–04
A superb early music-video work made for Company Flow, <u>End to End Burner</u> featured live video footage and animation set in New York's subway system. The live-action shots of the band are interspersed with animated, 3D strings of graffiti tags literally flowing dynamically through the underground tunnels over walls and tracks.

05–07
The distinction between film and animation is blurred in <u>Arrow</u>, a 30-second TV spot for Lugz Footwear that blends the look of live-action film and hyper-real animation. It followed on from earlier experiments with graffiti in motion (the Company Flow video) and is set in a sketched cityscape tinted with an orange and black palette based on the Lugz brand colours. It is here in the gritty Lugz City that realistic b-boys set to the beats of DJ Funkmaster Flex bust their moves on rooftops and city streets, all virally connected to each other via an animated, textured 3D arrow that is integrated with the dancers' moves. Director/designer Marie Hyon states, 'The challenge was to keep the arrow from feeling like a ribbon and to have it take on the integrity of the designed tags.'

01

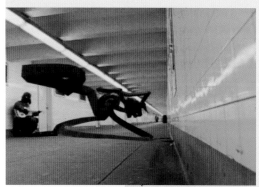

02

03

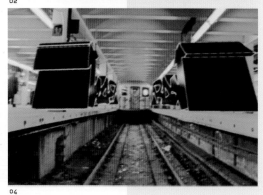

04

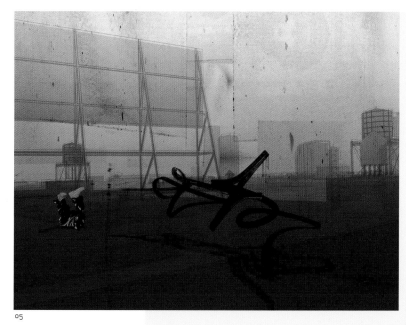

05

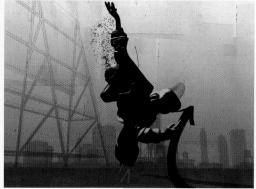

06

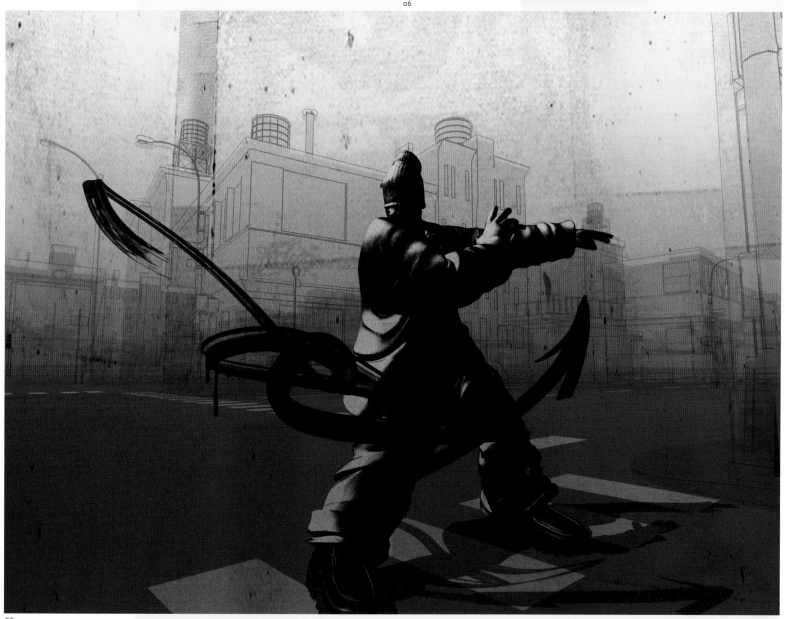

07

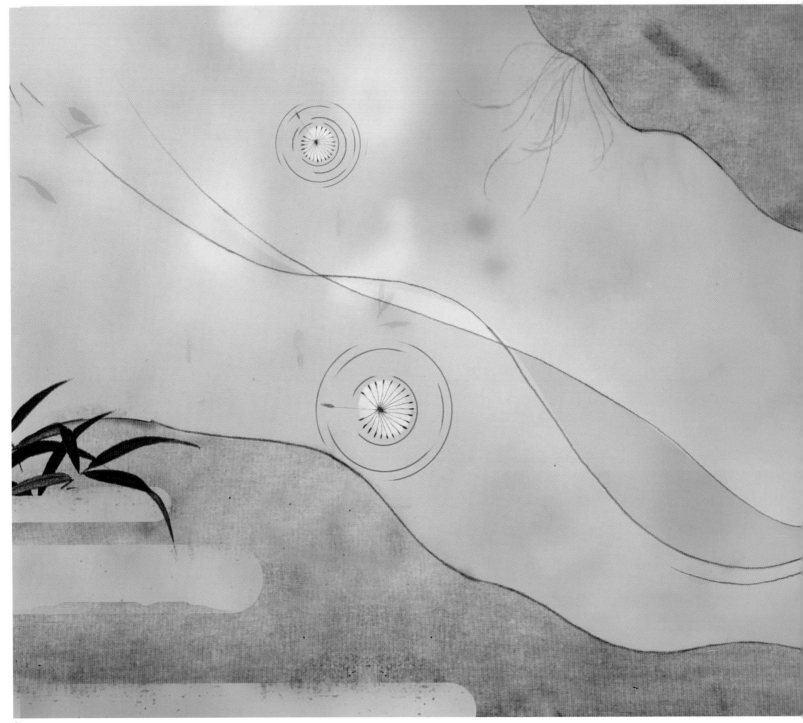

01

motion blur: onedotzero psyop

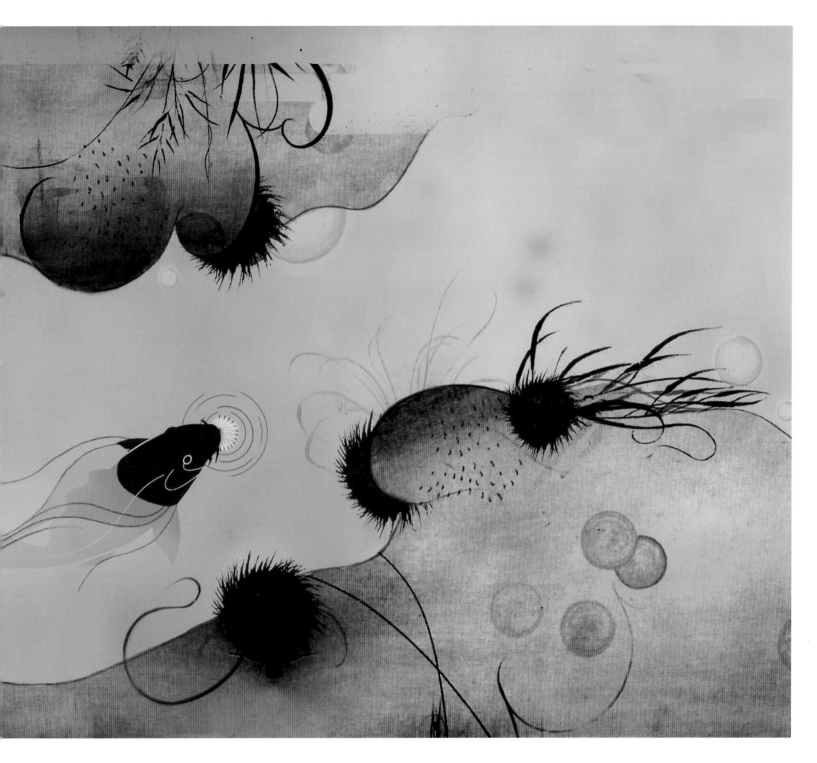

01

01–04 overleaf

<u>Drift</u> is somewhere between a personal short film and a commercial for Bombay Sapphire gin. Psyop were given creative freedom with the project but, as it was essentially a branding film, elements of the Bombay Sapphire brand — alluring spirit, style, complexity and depth — were infused into the design, which also drew on traditional Japanese screen painting. It is a beautiful and sensuous short that uses the natural world in undulating blues to motivate the narrative, a simple love story in which a man and a woman have a connection but never meet. The woman sets off a poetic set of occurrences by gently blowing a dandelion. This triggers a cause–and–effect chain of events that carries the viewer off on a mysterious and emotional journey through wisps of air, encountering fluttering moths, centipedes, blue lagoon waters, soft light and darkness. The dream–like and organic jour-ney ends as the drifting dandelion seeds softly land on a man's palm and a wish is granted.

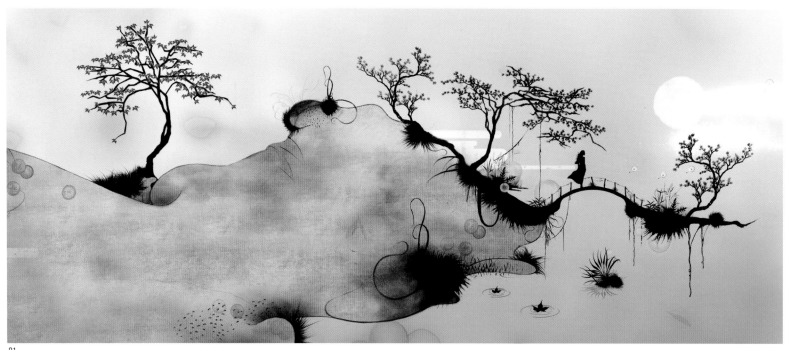

01

02

03

04

motion blur: onedotzero psyop

05–08
Psyop's style and range continue
to evolve. They refuse to be type-
cast despite being associated
with some stand-out motion
graphic approaches. For this
cinema commercial for Merrell
Footwear, for instance, they turned
to 2D animation. Run Wild uses a
stencilled, stop-motion animation
style as the backdrop to a simple
view of a rabbit taking his morning
jog that rapidly transforms itself
into an epic adventure and a
mighty contest with the other
forest animals. It is a humorous
slapstick narrative that Psyop
co-designed and animated from
an initial concept from agency
Jager Di Paola Kemp Design. The
accompanying driving percussion
track is by Jack Livesey.

05

06

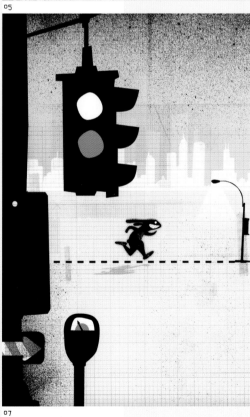

07

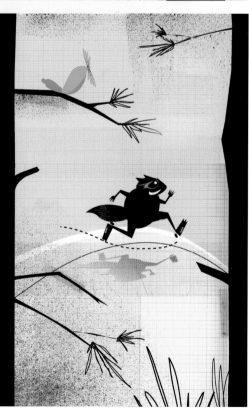

08

alexander rutterford

With his extraordinary attention to detail, and an ultra-synched approach to moving image, Alexander Rutterford immediately came to prominence in 2002 with his first major music video, Gantz Graf, a mind-twisting sound and visual experience. But with his extensive experience of motion and infographic work, and an impressive array of experimental moving image under his belt, Rutterford has been creating his own particular uncompromising vision of the future for some time now.

01–06
3space was a self-initiated short film based on music from Mozart's 'The Marriage of Figaro'. It was made for and premiered at one-dotzero. Rutterford explains: 'It was designed, constructed and animated just using 3D software. The film is a short, concise visual exploration of a complex architectural environment in which there is no direct relationship to humanity or earthbound physical properties. The camera jerks and spins to the music. I would have loved to have done it in one take but I only had two weeks to complete so had to edit it.'

01

02

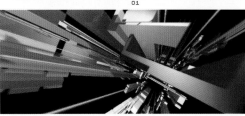

03

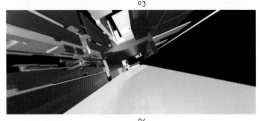

04

05

Can you explain how your involvement in 3D-orientated and intricately detailed motion design developed?

I trained in graphic design, and had an interest in 3D and mechanical things even as a child, but 3D animation was not on my agenda as a student and through my early working career. When digital technology made it more readily available I saw I'd been missing out. I started applying my graphic-design aesthetics to the world of 3D animation, and received a great deal of pleasure from it. It was a vehicle to get across the way I saw graphics and images in my head when I shut my eyes and thought. The detail is just my way of seeing things in the structure of whatever it is I'm doing. I think it's pretty funny that people think my work is detailed, as I see it in very basic terms, as almost childish, like something by Fisher Price.

<u>Gantz Graf</u> seems the zenith of an approach you've been pursuing for a long time, with a direct antecedent in <u>Sound Engine</u>, which you made a few years before.

<u>Gantz Graf</u> was a breakthrough exercise for me in animation and sound sync; <u>Sound Engine</u> was supposed to do that, and in a lot of ways some of the basic elements of <u>Sound Engine</u> were stolen for <u>Gantz Graf</u>. It was an idea I wanted to do many years back, but it took a long time for me to get to grips with CG and what it was capable of. <u>Sound Engine</u> was a second test that was getting close, but it was completely retarded in synchronization terms, although it conjured up a sense of sync, and the dynamics were there. As far as <u>Gantz Graf</u> being the zenith of an approach, I don't think it is, but it does get really close at times. There's nothing really special or new in the

→

✳UK

Although Alex Rutterford is represented by the prestigious RSA/Black Dog Agency in London, he mostly works from his North London flat.

01–04 overleaf
'Music and sound to me are very important, especially music – it's the seed from which a lot of my personal work stems,' says Rutterford. <u>Gantz Graf</u>, a music video for Autechre, took Rutterford's previous forays into hard-synched 3D motion and sound such as <u>Sound Engine</u> and <u>Monocodes</u> to a new level. He had to animate and render each frame individually to get the synchronization frame-perfect. It took Rutterford three months to finish and he admits that when he first heard the track he had a shock: 'My heart was racing, I was thinking, Shit, how am I going to do this, what could possibly work with this?'

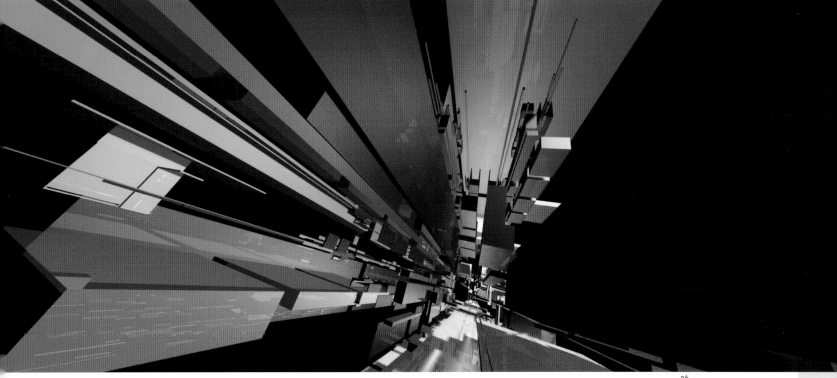

06

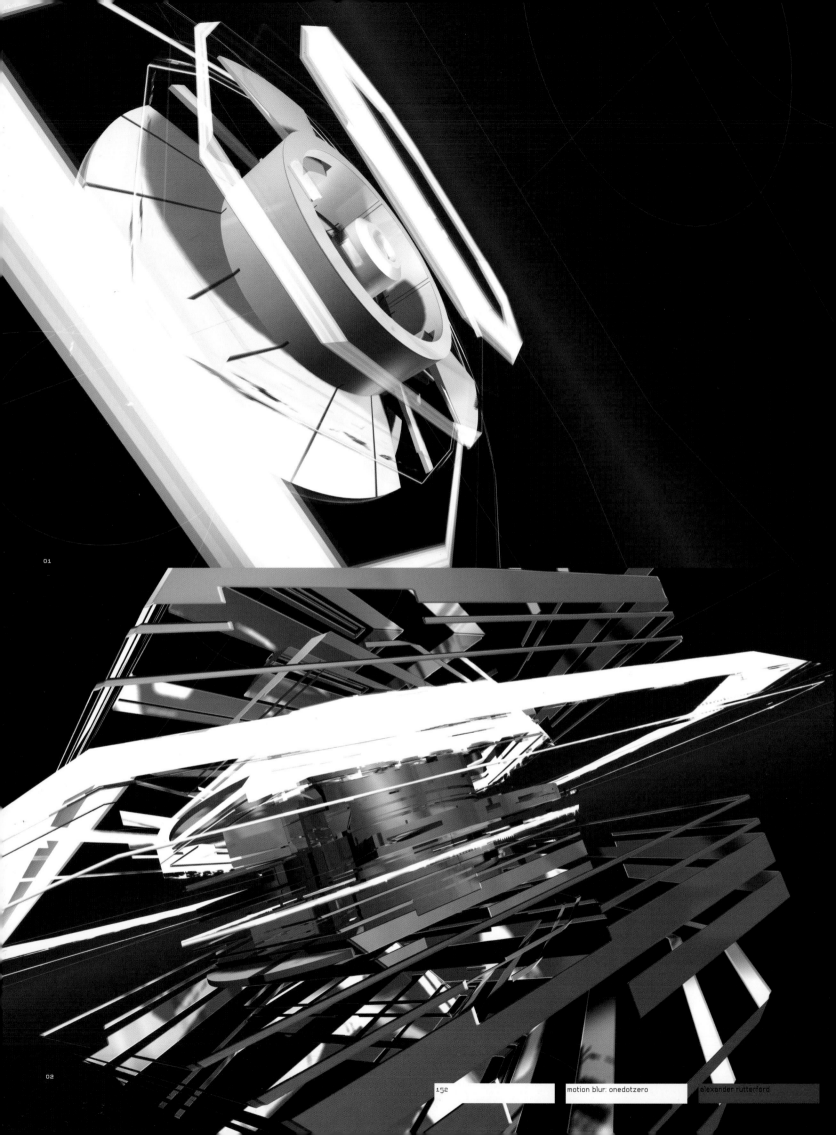

01

02

motion blur: onedotzero

alexander rutterford

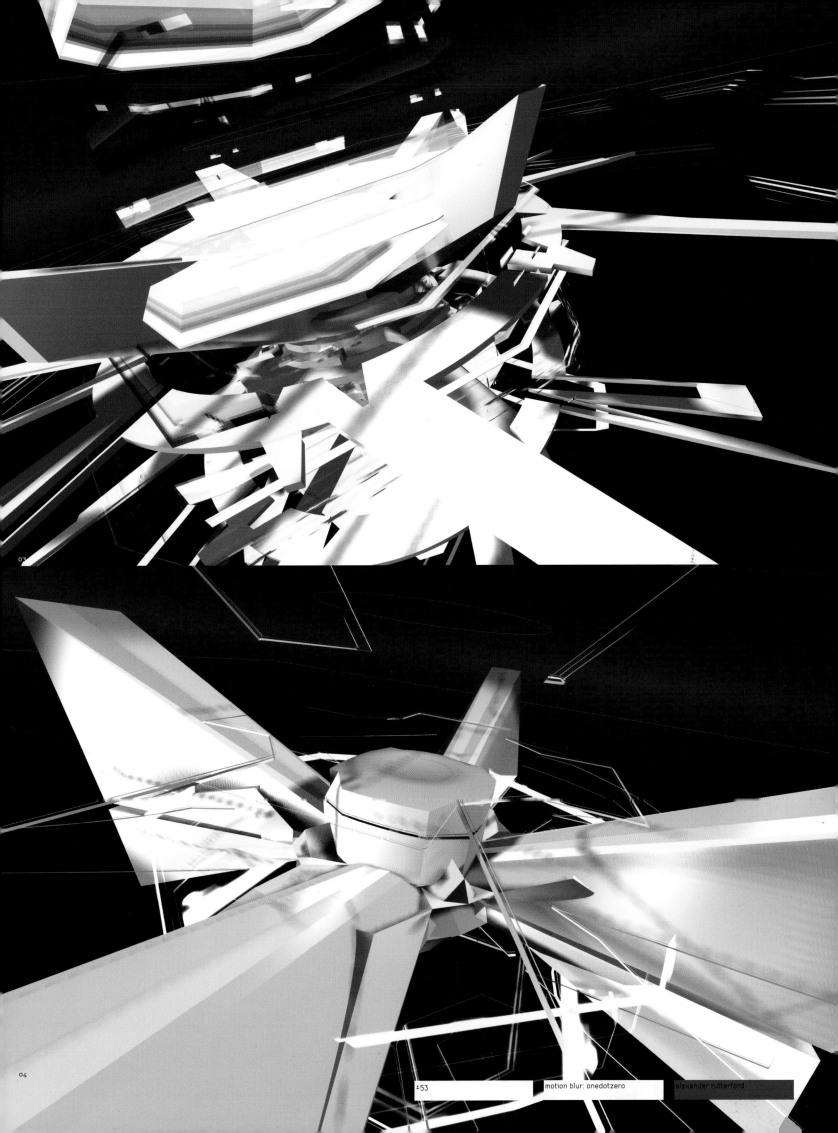

03

04

motion blur: onedotzero

alexander rutterford

01–06
Rutterford created the info-
graphics for Squarepusher's
Come on my Selector music video,
directed by his old friend Chris
Cunningham.

01

02

03

04

05

06

01–36 overleaf
Rutterford was in top gear for Verbal, a Ninja Tune promo for Amon Tobin. The synching of sound and image serves to create an extreme car chase featuring a chameleon–like car, whose impressive multi–colour, oscillat-

ing bodywork throbs and pulsates in time with the infectious beats. It has all the thrill of the chase but at triple the speed. Rutterford had to create and crash a virtual car over 40 times to get the effect he wanted for one of the scenes.

01–36 pages 158–159
I Go to Sleep, created for the patrons of the music-video art form, Radiohead. Rutterford produced a full animatic and design style guides before taking his work over to a team at London post-production house The Mill.

The full range of lead singer Thom Yorke's facial expressions and quirky movements were motion-captured to provide the framework for the video.

software that created it, there's no special pop-down button that gives you Gantz Graf, it's just hard work.

I had been in conversation with Autechre in fits and starts for a long time over this video idea. When I finally felt confident enough to make a commitment to produce it, they sent over two tracks, one of which would be for the video. I nearly had a panic attack when I heard it as it was so encrusted on a granular level. I thought the preparation and experimentation had been moving in slow motion and this was a second learning curve to surf. I sent over a tape with about 15 seconds of half-completed footage on it, which confirmed the direction and level of work that was going into this thing, and had a positive response.

There seems to be a particularly strong relation-ship between sound and visuals in your work.
Music is the seed from which a lot of my personal work stems. It gives emotions that visuals can't deliver by themselves in silence. If I had the choice of watching a film with music or without, I'd choose 'with' every time. Listening to music really transports me into a different dimension. I mostly listen to electronic music, but only a handful of people are doing anything interesting with it. I'm open to other types, especially classical. It has to have an atmosphere and dynamic structure; film soundtracks have that vibe for me because they are written for a certain purpose. Extreme types of music have that effect too. I did the sound design for a personal piece, Monocodes, myself. It can't really be considered music in the traditional sense, but it was an interesting exercise in experimentation.

Can you tell us more about 3space as it uses classical music very effectively?
My view is, the more basic or simple you make things, the more timeless they are. A square or circle, cube or sphere will never be viewed as being of any period of design or fashion. It's what is done to those shapes and the composite forms they take that make them indicative of the time they are produced in.

When I listen to a piece of music, I have an intuitive feeling towards it, what the world looks like in

that sphere. With 3space, I listened to a piece of classical music, then played around with some very primitive 3D shapes, and the two just locked into place. There was no big plan. I imagined a cubic envi-ronment appropriate to Mozart's 'Marriage of Figaro'. People will still listen to classical music 100 years from now, and structurally I was attempting to show the visual equivalent of that music devoid of fashion. I would have loved to do 3space with one dancing camera move, like the viewer had some sense of being in the core of some self-conducting structure.

How did you come to supply infographics for Squarepusher's Come on my Selector video?
The director of that video, Chris Cunningham, is my oldest friend, and approached me with the concept, outlining his need for the infographics within it. He first drew me a sketch of the two heads, the dog with a large brain and the human with a mini–brain showing within the skulls. It had to have a certain sense of humour to it.

It was a commission of 'better the devil you know' from Chris, and it was a compliment to have the oppor-tunity to be trusted in your design aesthetic. I love doing infographics and this was an ideal scenario to have a laugh with them. I had seen a lot of the rushes, and had got a good feel for the style, so I went off and designed and animated them with a very slight manga edge. I also provided some large text and cursor drawing typeplates that were cut in. All the type that was integral to the plot as subtitles was translated into Japanese for the graphics. It all made sense and had a bizarre logic to it, even down to details of very small type on the screens that can't really be read. There's a lot of detail in there. The pace of the storytelling in the video was fast, and the graphics echo that.

Can you explain how you build up a project from conception to delivery?
For me it's a controlled freeform process. Sometimes I don't know what things should look like until I've seen them move or interact with something else. I like to fly blind for most of the time. I hate the concept of getting stuck down in a plethora of sketches and designs that

keep on getting more complicated but don't actually go anywhere structurally. I have an intuitive response to projects and then work on up-rezzing those ideas into a recognizable form.

What are your creative ambitions?
Visually, I just want to keep playing. I definitely want to try some narrative-based filmmaking with character animation in the future. I have found my voice, but haven't said much with it yet! I try not to think too much about the future, I just like to cruise. There are certainly ideas I want to pursue that are very specific.

It would be nice to be remembered for having some lasting influence on visual culture, but let's face facts, everything gets swallowed up and spat out at such an alarming rate now that it makes me wonder at times if it's all really worth it. We live in an age of super-sampling and remixing of the audio and visual.

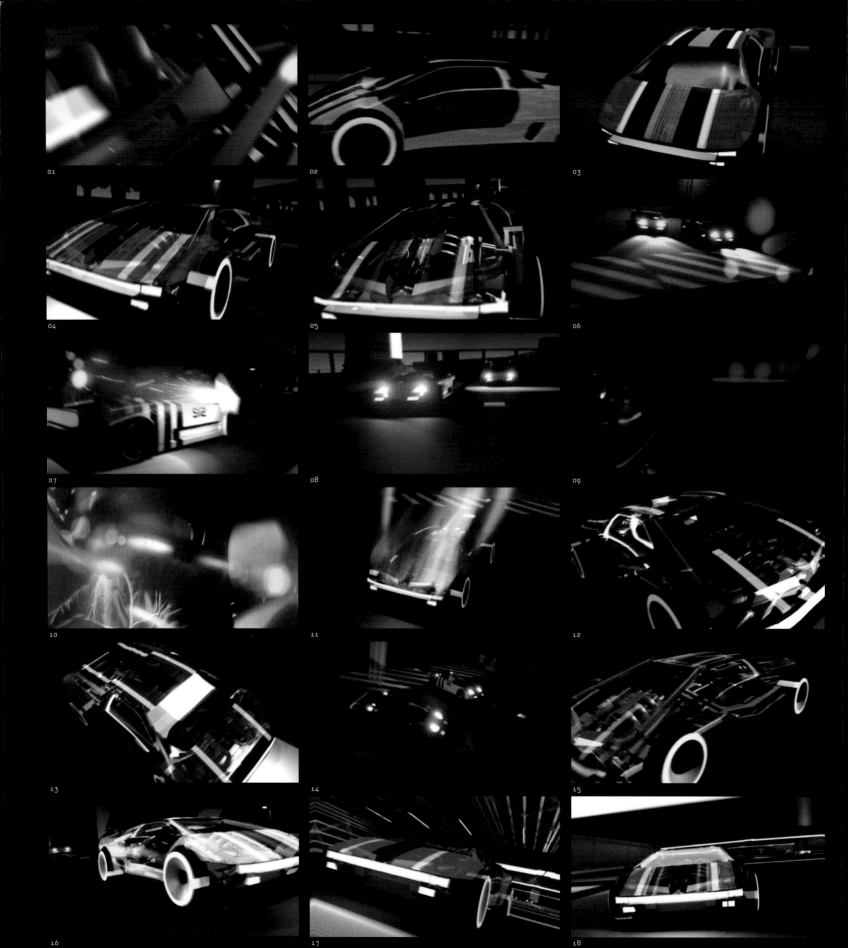

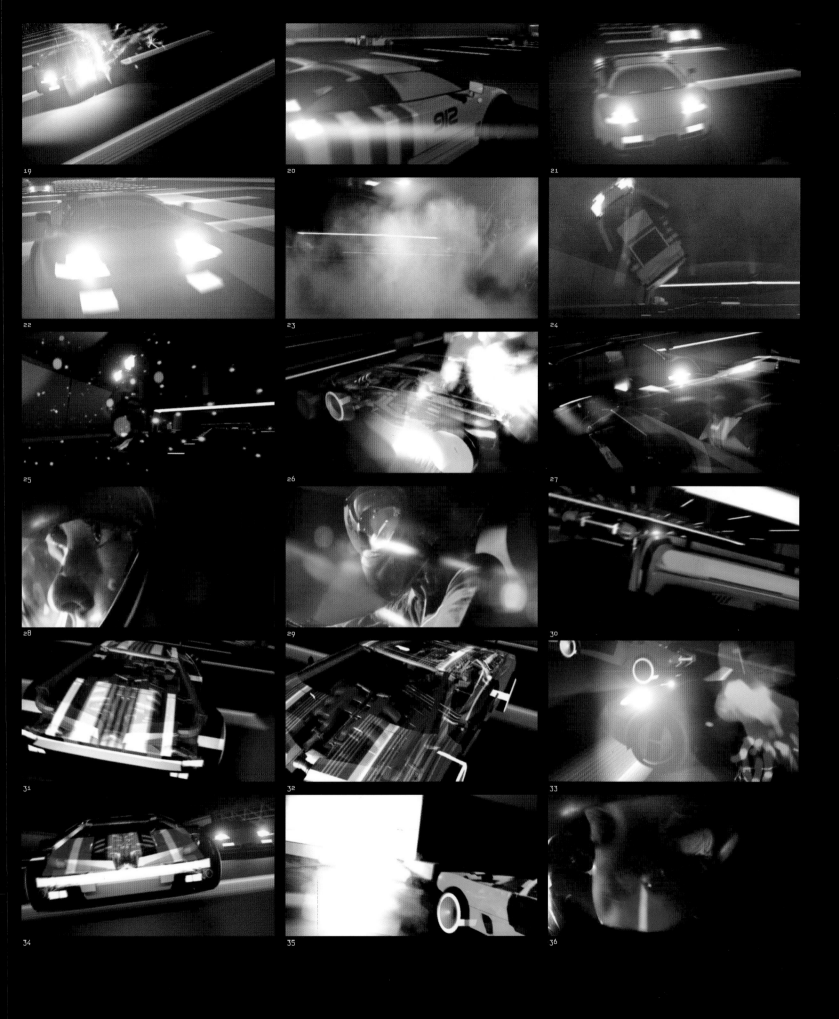

19

20

21

22

23

24

25

26

27

28

29

30

31

32

33

34

35

36

motion blur: onedotzero alexander rutterford

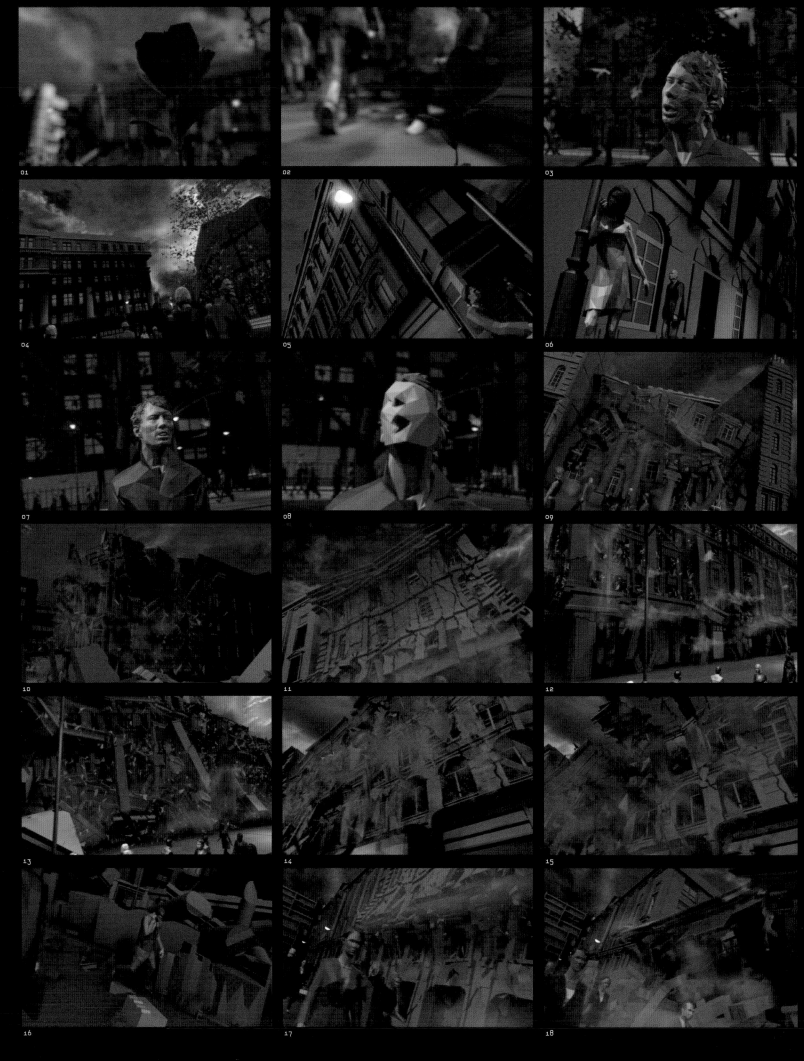

01
02
03
04
05
06
07
08
09
10
11
12
13
14
15
16
17
18

motion blur: onedotzero alexander rutterford

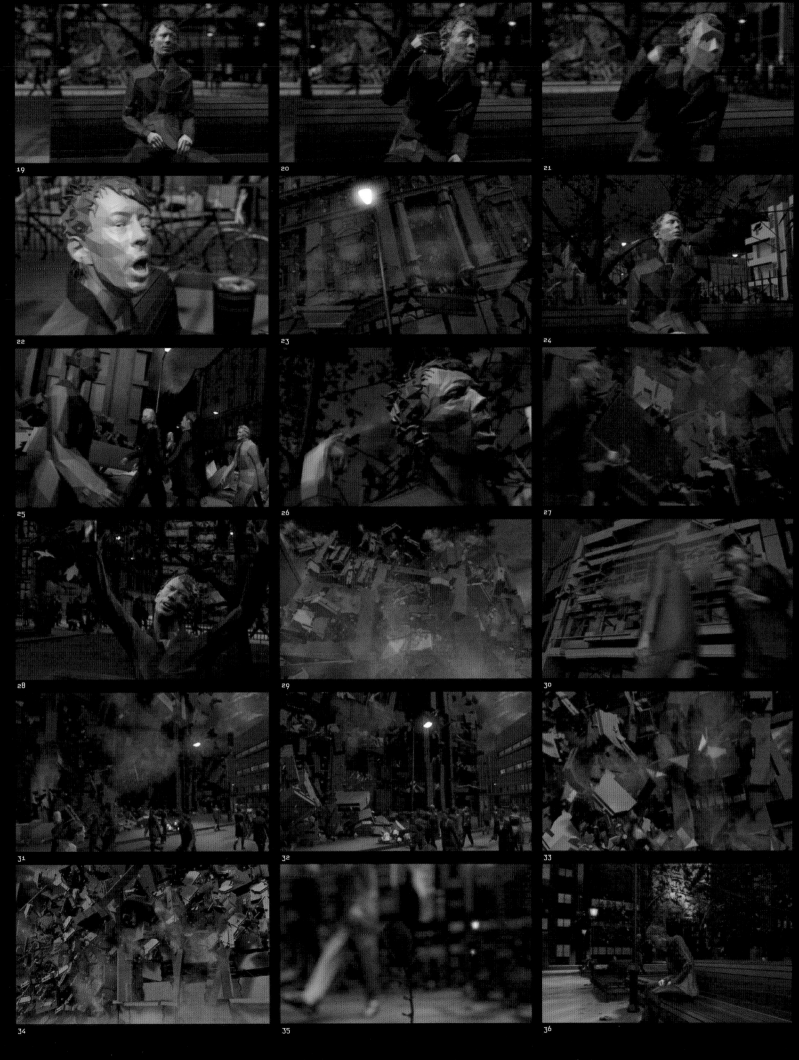

motion blur: onedotzero alexander rutterford

shynola

In a few prolific years Shynola have redefined what it means to be eclectic. They are a tight-knit creative unit, having managed to live, work and flourish creatively together since the group's inception. An initial hi-tech look, for their Quannum and Grooverider videos, has softened to include exquisitely fluid animation for Lambchop and Radiohead. Visually at the peak of the animation field, they are making a priority of extending their emotional and storytelling ranges. Shynola are Gideon Baws, Jason Groves, Chris Harding and Richard Kenworthy.

01

02

01–03
Character sketches, the simple starting point for many projects. 'Who doesn't like robots? It never really occurred to us that we had a robot "fixation", though people kept asking us why we put robots in everything,' comments Shynola's Gideon Baws.

03

From the dream-animations of Radiohead to the lo-fi pixellation of Junior|Senior, Shynola's animation ranges across a diverse array of styles. Do you have favourite looks and techniques?

GB: We don't have anything approaching a favourite look or technique. We aren't vicariously interested in animation. Our inspiration comes from many other sources: painting, film, comic books or whatever. We simply approach each job, at least in terms of music videos, with the intention of trying to marry something with the music. We just do what seems logical to us. All animation techniques are highly labour-intensive and painful to achieve, so to have a favourite would be like having a favourite type of surgery. Of course, the results are more than worth the effort, and since we come from a design and illustration background, it seems natural to us to think of ideas in terms of animation.

From your early pieces such as The Littlest Robo, you've had a fascination with robots.

GB: Who doesn't like robots? It never really occurred to us that we had a robot 'fixation', though people keep asking why we put robots in everything. Mostly, we all like sci-fi. We grew up with Star Wars and all the crap that came after it, so they are firmly part of our culture. I'm sure if we were older, we would all be obsessed with cowboys (as it is, only Jason is).

Robots are like a blank slate, which can be useful in storytelling, as it allows the viewer to see the story from their point of view. We used them in this way in The Littlest Robo and the Quannum piece. The only other thread we have spotted in ourselves is our black sense of humour. I have lost count of the number of videos we have made or pitched that end with the world blowing up, or everyone dying a slow and painful death.

Shynola's breakthrough work was the UNKLE Guns Blazing visuals. An Eye for an Eye takes this collaboration much further. Can you talk about how this was made and how you have progressed since then in your style and approach?

RK: Guns Blazing was practically the first commercial piece we had made and it very much reflects the sort of thing I was making at college at the time: short passages of experimental animation that were very graphics- and illustration-orientated. None of the shots really relate to each other, and the only thing that binds them together are the Futura and Drury designs and the fact that they are in sequence. The next piece we made was I Changed my Mind for Quannum, and we realized that it was much more satisfying to tell some sort of sequential story for the duration of the video. Since then we have been primarily experimenting and finding our way with storytelling, to the point that An Eye for an Eye plays more like a short film than a typical pop video.

How important is something like the continuing relationship with UNKLE and James Lavelle in particular?

GB: The main reason we returned to the UNKLE project was that we felt in some way indebted to James Lavelle and Andy Holmes at Mo'Wax who commissioned our first big piece. It is quite hard to get started in this business, and they showed great faith in our ability, for which we are very grateful. So this was a special project for us in that sense. Generally we like to try very different things from one project to the next. Each video we make is in an entirely new style, and we try to tell different sorts of stories too. In musical terms we have made videos for hip-hop, indie, country and disco songs. If we had made a Guns Blazing Part 2 for An Eye for an Eye, then we would be disappointed with ourselves.

What is on the Shynola 'to do' list now?

GB: We definitely want to develop our storytelling further. It is getting a little difficult to convince record labels that a dense, thoughtful narrative is what they want for the new Backstreet Boys video, though, so we should let off steam and make another short film.

Is there any client you feel you couldn't do work for?

GB: There is not so much any client we could not work for as much as there are individual projects we cannot take on. We have been offered the chance to make videos for lots of bands we love, but have been unable to think of a suitable idea, which either leads to us turning them down, or vice versa.

What is Shynola's mission statement?

GB: We have never really had any plan or long-term goal other than to be our own boss and enjoy our work. We don't want to change anything; we don't have an agenda; we have nothing to prove; and we reserve the right to be as pointless or as serious as we like. Does that count as a mission statement?

✳UK
interviewed:
Richard Kenworthy
Gideon Baws

Shynola are Richard Kenworthy, Gideon Baws, Jason Groves and Chris Harding. They are based in London.

04

05

06

04–08
The Littlest Robo follows the experiences of a boy isolated from his father in a desolate landscape. Featuring award-winning computer animation [Ottowa International Animation Festival], this is a stunningly inventive RCA graduation film directed by Richard Kenworthy. Additional animation was provided by Kenworthy's Shynola partners; narration was by Kurt Wagner of Lambchop and music was by Calexico.

07

08

motion blur: onedotzero

shynola

motion blur: onedotzero

shynola

01

The music video <u>Is a Woman</u> saw Shynola again working with Kurt Wagner, lead singer with alt.country band Lambchop. Once again they show their incredible visual range in a contemplative piece set in nature as the melting snow of winter yields to the optimism brought by springtime. Inspired by the delicate wood-block paintings of the great Japanese artist Hokusai, it's a subtle tale of a single red leaf's journey down a free-flowing river to the end of a flowering branch.

02

01

02

04

05

03

06

PILOT OF THE FUTURE

01–06
Alien invasions have never looked
so much fun as in these
programme titles for SF:UK on the
Sci-Fi Channel, which see Shynola
mix their distinctive, hand-drawn
animation style with multi-layered
references to classic sci-fi films
such as Star Wars, 2001 and The
War of the Worlds.

01

02

01-02
The Pyramid Song video came
after Shynola had created dozens
of anti-videos for Radiohead in
the form of the Blipvert series
[with Chris Bran] commissioned by
Dilly Gent. In Pyramid Song
Shynola show their ability to tell
stories in a completely visual way.
A lonely block figure retraces his
life by plunging to a modern
Atlantis below the surface of the
sea. The simple design of the
figure is contrasted with stunning
3D visual work underpinning
Radiohead's emotive and poignant
music.

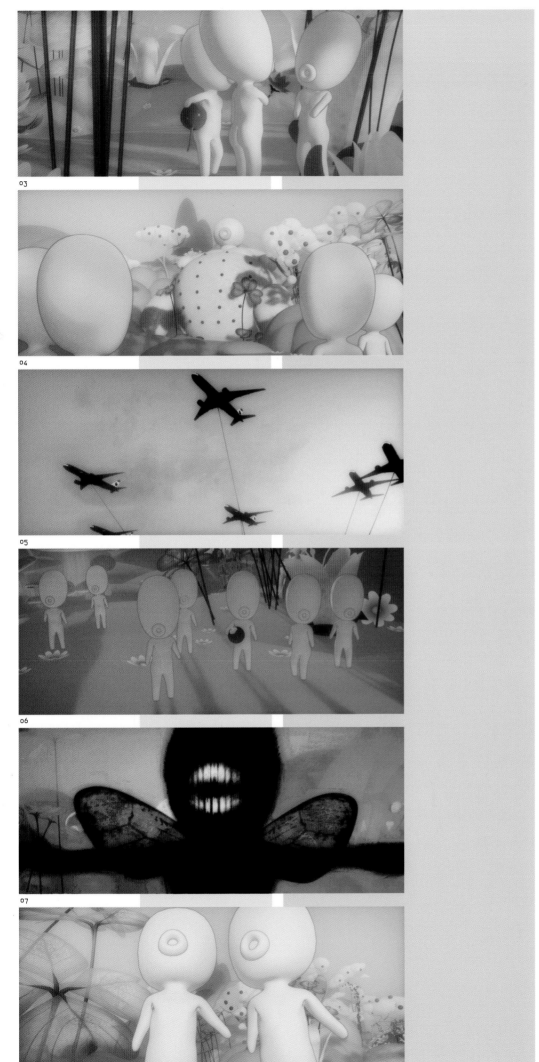

03

04

05

06

07

08

03–08
A showreel sent to Mo'Wax
resulted in a sequence set to the
UNKLE track Guns Blazing. Based
on the designs of Ben Drury and
Futura 2000, it was used as an
acceptance speech by James
Lavelle at the NME BRAT Awards
1999, and for UNKLE's live show,
incorporated into their visuals by
The Light Surgeons. Shynola
worked again with Lavelle on An
Eye for an Eye [shown here].
Conceived as an anti-war film, this
is a contemporary fairy tale with
references to Greek mythology
and the Japanese animation
studio Ghibli. A fleet of jet planes
disrupt a Garden of Eden idyll by
dropping into its midst what
appears to be a giant, blissful,
nipple-covered mother figure who
spawns very scary offspring. This
is beautiful, darkly charged work
with additional animation from
Ruth Longford.

motion blur: onedotzero

shynola

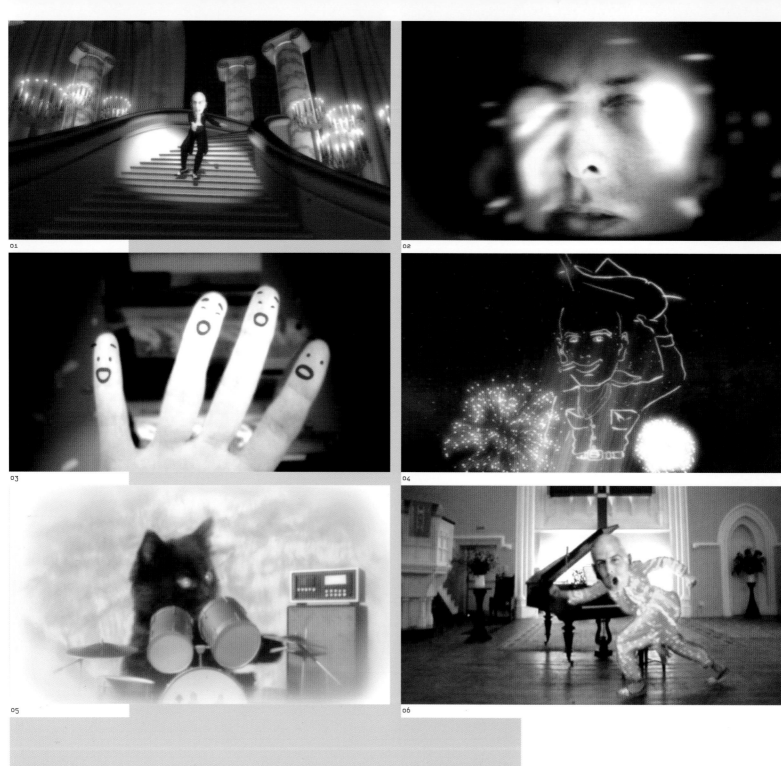

01

02

03

04

05

06

01–06
<u>Jo-Jo's Jacket</u> for Stephen Malkmus was an early foray into live-action directing for Shynola. Packed full of filmic references, finger animation and even a live kitten band, this is an inventive and unusual piece. The masterly animation inserts pitch Malkmus as <u>a Westworld</u> Yul Brenner in a range of scenarios from Atari-like computer games to <u>Raging Bull</u>.

07

08

09

10

07-10
The live-action/animation hybrid <u>Go with the Flow</u> for Queens of the Stone Age was a breakthrough video for Shynola, taking them into the lucrative US rock market. An acid-fuelled desert highway cruise, it features the band performing in the back of a pick-up truck, some face-painted villains and a handful of very will-ing showgirls. The band were first painted black and shot in live-action, then the resulting images were rotoscoped as flat comic-book figures.

stylewar

01–10
Graphic, live-action photography shot by Phillip Angström provided the basis for the title sequence for <u>Musikbyrån</u>, a music series for Swedish TV designed to bring 'pornography for music lovers' to the small screen.

From their base in the heart of Stockholm, Stylewar are mounting a guerrilla conflict with Scandinavian motion design. Drawing on influences as diverse in styles as science illustrations and old-school computer gaming, they are rapidly becoming the city's most highly regarded design hotshots. Stylewar have completed highly original music videos for The Hives and The Jon Spencer Blues Explosion, besides an impressive body of motion and print graphic work.

04

08

01

TRANS LOC 1 LOC START LIFTER CODE READY

◀ ▶ PLAY STOP REC

05

06

02

FM 88 90 92 94 96 98 100

PAUL WELLER

07

09

03

10

How much freedom do you have with what you do?

OH: It's never like we do a job and someone tells us exactly what we're supposed to do. So in that sense all the work we do is free. That's also why you like doing what you do so much. You can get on the path you want to go, creatively. I think that's one of the reasons our work looks so different, it's not one defined style, because the ideas are based more on what kind of thing we want to do at the time that will fit the particular job.

How structured is the work process?

OH: When someone asks us to do a job, everyone gets involved in gathering ideas for what we could do for this one. We might just sit on the sofa, and the person who comes up with the best idea gets to work with it. Then everyone is involved in giving input as it develops, like 'this is fun', 'you could do it like this or that'. It sort of just happens.

→

11

12

13

14

15

16

17

18

19

20

21

22

23

24

25

26

27

28

29

30

+ SE
interviewed:
Gustav Dejert [top]
Oskar Holmedal [above, left]
Martin Sjöström [above, right]

Stockholm is a breeding ground for moving-image talent and Stylewar certainly epitomize this. The collective constantly delivers work showcasing a dazzling array of styles and approaches in title sequences and music videos. They started out in a former petrol station in the heart of the Swedish capital before moving to a larger studio to cope with the huge demands being made on them by international clients.

01–09 overleaf
Stylewar favoured a 2D cut-out, lo-fi animation style for the Sweet and Sour promo for rockers The Jon Spencer Blues Explosion. A duotone newsprint graphic style that was explored in an earlier video for The Hives [Main Offender] is used throughout, though with different animation and effects.

10–24 overleaf
Media mayhem for favourite European punk rockers The Hives: produced with newsprint graphic direction and a simple black, white and red palette, Main Offender is an urban fable of sorts, following the band's heroic skulduggery as they set out to unseat their nefarious rivals The Negatives.

11–30
Stylewar have an international outlook, which is reflected in the range of music artists they work with. The two promos they have created for Moby both have strong narrative plots and follow the escapades of a group of aliens landing on earth.

11–23
The first promo, for In This World, sees the intrepid aliens leave their dusty planet and head to earth. Landing on the US east coast, they are completely ignored despite the tiny 'Hello' banners they wave at anyone and everyone they see. It ends with them departing for space again, with a new plan for a return visit. 3D animation is seamlessly combined with live action in this piece.

24–30
Sunday follows the style of the earlier promo and sees the return of the alien adventurers, who land on the west coast this time. Armed with a huge banner, they attract more than just a passing glance. They are soon on their way to major celebrity status and all the trappings that the high life brings. It is all too much for the visitors, however, and they soon head back home for a detox.

01

05

02

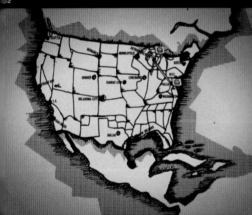

06

03

08

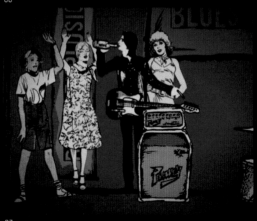

07

04

09

motion blur: onedotzero

stylewar

-There are some new cats in town looking for treble
and we got to bring it to them.

10

11

12

13

14

15

16

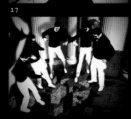

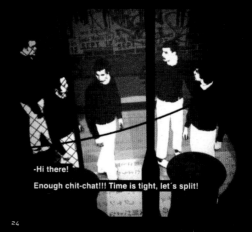

17

18

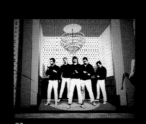

-Hi there!
Enough chit-chat!!! Time is tight, let´s split!

19

20

21

22

23

24

05

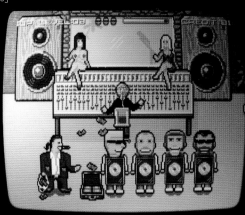

06

08

You've done many title sequences. How do you typically conceive them?

GD: For example, we did a sequence for Musikbyrån, which is a music programme. We made it like it's supposed to be porno shots — pornography for stereo lovers, music lovers. A friend called Phillip Angström had already shot some photography which we thought could work with it.

OH: Yeah, the pictures were actually already shot, but we modified it to have a guy walking around in them, and we just cut out the parts that didn't have anyone in them. We just tried to find a way to integrate the graphics with the shots already taken.

MS: First you must have the idea, of course. After that you can start thinking about ways of achieving it.

The Teddybears promo used a sprite-based, old 2D computer-game look, before many people started emulating that style. How did that come about?

OH: That idea actually came from one of the guys in the band. On their CD they had a little computer game. So they wanted to do a full video like it.

GD: I was not supposed to do this. In the first place it was going to be Oskar. But he left for Fiji for a month, and I got it just thrown in my face a week and a half before it was supposed to be done. It was a pretty intense creative exercise because there were five or six people working with the illustrations to get it done. When I got all the Photoshop pictures, I was supposed to animate them. They were two metres wide and I don't know how high, just big scenes with a lot of stuff, and it had taken five or six weeks for five people to do. This was for four scenes in total. I worked pretty hard those one and a half weeks.

What is the background and approach on the Terrain piece?

MS: The piece I made for onedottv is based on a big company trying to collect customers for their project in an area somewhere in the world. Then the project overruns everything else, so we try to show that with business-style graphics.

OH: All the tools we're working with are just regular computers, so there's no extremely big expensive machines that you need to have or something. Anyone can do it. Try it.

01–08
Rock and Roll Highschool, a music promo for Swedish group Teddybears STHLM, sees pixel power come to the rescue as Stylewar fuse Donkey Kong with Spinal Tap. This is a rock and roll caper in which the band are rendered as old-school video-game characters doing what rock stars do: sex, drugs, drink are all included, along with the now standard sight of a TV being thrown out of a window. It was only a matter of time before Commodore 64, sprite-based animation came back into vogue. The video was produced in late 2000 with character design by Stylewar and Kingsize.

theoretical
this could be your new home

09

terrain tomorrow...
hi-tech and stylish living
on an exclusive
foundation

10

each landowner gets their material transported by special made terrain-security vans

TRN//LOT#14b

11

task:
to build an extremely rich soil for an exclusive living area. the soil is made of the finest materials earth can offer

12

13

14

15

16

09–16
Terrain was a commission from onedotzero for the onedottv series, which saw Stylewar respond to a brief of 'territory and terrain'. The short utilized a business presentation model — PowerPoint has never looked so good — to comment on the state of the world's resources and how much some people will pay for them. The message is delivered in a straight but humorous, obviously graphic way. Martin Sjöström says of the treatment: 'This graphic short is a sort of anti-Disney community comment. The plot was to build a place for those who want their bathroom interiors made of more than 24-carat gold. The excess will take dramatically different forms at the end of the short. The story is told as a corporate project presentation in a Swiss/German style, with three colour-coded sections.'

motion blur: onedotzero

stylewar

sweden

01–07
Sweden's promotional film show-
casing all of Stockholm Records'
new acts featured the character
Alo, who leads viewers on a tour
of the label.

Graphic studio Sweden is a high-profile symbol of the cool but left-field attitude of Stockholm's burgeoning creative community. Having built an underground repu- tation with work for mainly Swedish-based firms such as Hennes, Diesel and Stockholm Records, they are now gaining increasing international exposure, commu- nicating the studio's self-deprecating humour world- wide. Staying true to a diverse but distinctly illustrative style in print and on air, Sweden seem immune from passing creative fads, ploughing their own particular creative furrow, tongues firmly planted in cheeks.

01

02

03

04

05

06

07

How would you characterize the studio's attitude?

We chose the name Sweden five or six years ago, when it suddenly felt like being from Sweden — the country Sweden — was not a drawback any more. You felt that people were a bit more interested generally in stuff coming from Sweden. The name for our company sort of summarizes something you could call a natural characteristic of Swedish people. We are a bit shy, and we are a bit humble, but at the same time we think we're really good.

We, as people who work here, are a bit like that. We have very high opinions of ourselves but we don't want to tell anybody about it.

Why do you think so many designers have moved into the motion arena?

It has a lot to do with software. It's sort of a desktop world, whatever you do nowadays, and this has democratized the process. We've seen that happening to music over the past maybe ten years, and now we're seeing it happening with film. And not only animation, but also with DV cameras and, of course, the editing process.

I don't do so much montage now as I used to, such as in the Diesel work. That was very much based on stuff I had already seen being done in the '60s. I wanted to put my own hands on that, and wanted to explore it. After a while I took away the photos and there were some specific elements I continued to work with. The bold use of colours, movement, things like that.

Where do you find your inspiration?

A lot of times you see an old poster or some record cover or something and you think you know what it is that makes it good. Then you try to use it for yourself. At first, you actually sort of copy it, to put it bluntly, and then you end up with just the colours, just the contrast, or just something in the composition which has been influenced by that original work. You can end up doing something purely graphic, though you may have actually been inspired by a photograph, or photographic image more accurately, from the beginning. To be able to go on until you feel that you've done something of your own out of what you're influenced by is probably what separates the leaders from the followers.

How do you find working in a commercial environment?

I think a problem facing graphic designers, or any type of commercial creative person, is finding good clients and good people who don't interfere too much in the process. Those projects are hard to find because you're solving somebody else's problem. You always have to be aware of what the aim is with your stuff. What problems it is supposed to solve. Of course, this means you can't be deaf to the client's wishes or wants.

Unlike many design studios, you steer clear of multimedia work, but your website seems important to you.

On our website we publish almost everything we do. It becomes sort of a litmus test. If you feel a bit wary about publishing something on the net, where you know people are going to look at it, then you know it has been a bad assignment.

We mostly work with clients in Stockholm, and the stuff that we do, the actual physical stuff that comes out of it, is, more often than not, only published within the physical boundaries of Sweden. So the website means it can be seen more internationally. I don't think our clients in the small world of Stockholm are aware that we probably have a bigger impact on the design world through our webpage than through the work that gets published and that we actually get paid for.

If somebody takes the time to write an email about something that they've only seen in a small size on screen, telling me that they love it, then I know that I'm actually doing something that people like.

01–12 overleaf
<u>swedotzero</u> was a moving-image commission for <u>onedottv</u>. This road trip takes viewers through picture-perfect fields and villages but also manages to incorporate difficult issues such as national pride and reminders of war in an ultra-flat graphic treatment. It features music by Silver Bullitt.

+ SE
interviewed: <u>Nille Svensson</u>

Ironically named after their country of origin, Sweden are based in Stockholm where most of the studio's design clients are also resident. A large amount of their output is in illustration.

motion blur: onedotzero

sweden

Onedotzero asked us (▦▦Sweden)
to think about...

territory...

hmm...

01

02

05

06

09

10

03

04

07

08

11

Please remember:

Nationalism is a lie, told to create conflict without reason, and unity without purpose.

Thank you for your attention.

Sweden

12

tanaka hideyuki

One of Tokyo's most versatile and imaginative visual creators, Tanaka Hideyuki is a veritable one-man creative powerhouse. He works in the heart of Shibuya, where the vibrant neons and bright young fashionistas of the district infect and influence his designs. His Frame Graphics studio outputs short films, cute character animations for television and computer games, and designs for his brother's hip fashion label Super Lovers, as well as a myriad of print work. As if that were not enough, Tanaka has also VJed with members of Japanese group Denki Groove under the name Prince Tongha. The hypersaturated colours he employs belie the subtlety of emotion and visual sophistication of his work, rare qualities in pieces infused with such raw fun.

01

02

01–04
Tanaka has a gift for creating characters not just for his brother's fashion label Super Lovers but also for commercials, computer games and television. His primary-coloured, children's animated television series <u>Super Milk-chan</u> has been a big hit in Japan.

03
<u>Super Milk-chan</u> has also now spawned a manga comicbook, which Tanaka's Frame Graphics company also produced and designed.

04
The making of a character: twelve stages in the design of <u>Super Milk-chan</u> as featured in the pages of the manga comic.

motion blur: onedotzero

tanaka hideyuki

Are you conscious of being involved in the current Tokyo scene?

I've not been so conscious of it, but recently I've heard many people talk about the Tokyo scene. I think it all started with the development of digital tools and personal computers, when creators became able to do all forms of expression easily.

What are your intentions with your work in different fields?

Well, I regard myself as a designer and director because that's the way I create, both designing and directing work at the same time. I've been doing many things, from cute character designs to live-action films, using many forms of expression and styles, but I think of them as the same thing. Regardless of the production style, I just want to do original and varied work. I never think that the style of expression is my personality. I'm sure that people who see my work understand what I mean. I use characters or images to communicate what I mean. I try to make a connection between the viewer and my work.

Where do you usually get your inspiration?

I've liked animation and moving images since my childhood, so I've been influenced by many works. Sometimes, I suddenly remember scenes which I saw a long time ago. It's natural that what I see in my imagination is different from the original in some way, but I always try to create and express things like that, as I experience or remember them.

I always start with a sheet of paper and a pencil to get an idea. This process hasn't changed for a long time. I guess if I started with a computer, it would be completely different.

→

101JP

Tanaka Hideyuki spent four years at TV station NHK before establishing the multi-disciplinary company Frame Graphics.

03

Why do you think the characters you create make such a strong impact?

I've read the works of great Japanese cartoonists like Osamu Tezuka and Fujio Akatsuka, and have been influenced by them since my childhood. So I think it's because I already have those experiences inside when I create and design characters. I want people to experience something different from their everyday lives.

How did you start designing for the Super Lovers clothing label?

Super Lovers is a fashion brand run by my younger brother, and I've been doing the character design and art direction for them for about ten years. Recently the characters I created have been becoming popular in London and Hong Kong, which makes me feel a bit strange.

The main reason I created the Super Milk-chan or Super Lovers characters is because I originally want-ed to create something entertaining for young Japanese people in Tokyo. I was not aware of an international market at all when I created them, so I'm happy with the result.

How did you get involved in music video?

I first got the opportunity to do music videos when I was VJing at clubs and was asked by a member of Denki Groove to create the visuals for their live performances. After that, I was commissioned to do their promo videos, and other musicians who saw that work commissioned me to direct.

Can you tell us more about your VJ group, Prince Tongha?

Prince Tongha is a music and visual unit which is made up of Pierre Taki of Denki Groove, DJ Tasaka and me. We don't define or limit the areas in which we work. We want to create something purely entertaining, whether it's playing live in clubs or making video clips for TV

→

03

04

05

03–05
Tanaka pioneered VJing in around 1992 at the legendary club GOLD. There he met Denki Groove and Ishino Takkyu. He developed his act into performances with the VJ outfit Prince Tongha. They play irregularly mainly due to the individual success of the three members — Tanaka himself, DJ Tasaka and actor, director, Denki Groove member and media personality Pierre Taki.

01

02

01–02
Spectre 21. Tanaka's first foray into longer-length narrative work, is a poignant yet madcap caper produced by Sou Maejima for a series of films under the banner of Bakuha [Burst the Earth]. Dave [actor Dave Spector], an announcer for a near-future online shopping programme, is feeling uncomfortable in his role. Meanwhile, a UFO sent by the outer-space federal police department heads to earth to arrest the violators of laws which only exist in outer space. The aliens communicate to others of their species who have already infiltrated earth society by utiliz-ing Dave's on-air body gestures. While broadcasting, Dave suddenly makes a strange robot-like action, inducing hysterical laugh-ter in the audience and bringing about a huge boost in his personal popularity.

06–09
Nothing's Gonna Change is a beautifully rendered 3D fantasy animation featuring a slinky singing siren, hybrid insect-like humanoids, spacecraft and a bizarre live-action insert of a fake J-Pop TV show with interviews with Denki Groove's Pierre Taki and Ishino Takkyu.

programmes. Of course, each piece has a unique concept, but mainly we create visuals and sounds simply to enjoy ourselves.

Almost all my other work is created by myself from my own ideas. Prince Tongha is different, so it's very exciting to collaborate.

How did the short film <u>Spectre 21</u> come about?
When a new digital satellite TV station launched in Japan, they developed a project that aimed to do something out of the ordinary: a short-film series featuring work by promo directors who had never directed drama. I hadn't done any ordinary dramas at that time, so if I had simply been asked to do a drama, I perhaps wouldn't have done it. But I was interested in the project itself, so got involved. I have a friend, Suzuki Osamu, who is a director of TV variety shows, and I thought it would be interesting to do something with him. So we collaborated on ideas for the story.

Do you get any inspiration from Tokyo?
What I find inspiring is the amount of information. All kinds of info is available in Japan from Europe or America. I can even buy techno records released by very minor European labels at a record shop in Shibuya. It's really exciting and I like Tokyo in that way.

What kind of audience do you target?
I don't target any particular generation. It's not like I only want younger women in their 20s to see my work. People of different generations from kids to 50-plus like the Super Milk-chan. I want to create without being self-conscious about age.

Can you tell us about the <u>Polynasia</u> video you directed, which has been voted one of Japan's best-ever music videos?
<u>Polynasia</u> is a music clip for techno artist Ishino Takkyu. When I was commissioned to do the video and

first listened to it, I got a strong impression that, rather than the detail, the overall composition and rhythm of the track were the best things about it. I think it's because he's also a DJ. I thought it would be cool to do something visually dramatic, making the best use of the beat and rhythm. That was the initial idea. After thinking carefully about the budget and schedule, we decided to do a live-action shoot. There's no special theme or story. I just wanted to make something that had a strong impact, that could expand the imagination of people who see it. That's all.

06

07

08

09

183

motion blur: onedotzero

tanaka hideyuki

01

02

03

04

01–04
Another Denki Groove promo collaboration, Flashback Disco is an explosion of colour and dancing puppets.

05

06

07

08

05–08
The pumping mesmeric beat of Anna by Japan's techno super-star Ishino Takkyu is matched visually by Tanaka's looping episodic story. The lives of a handful of Tokyoites are twisted and entwined on a street corner to dramatic effect, mingling B-movie horror with wit and humour to deliver a wonderful video that established Tanaka as Japan's very own Michel Gondry.

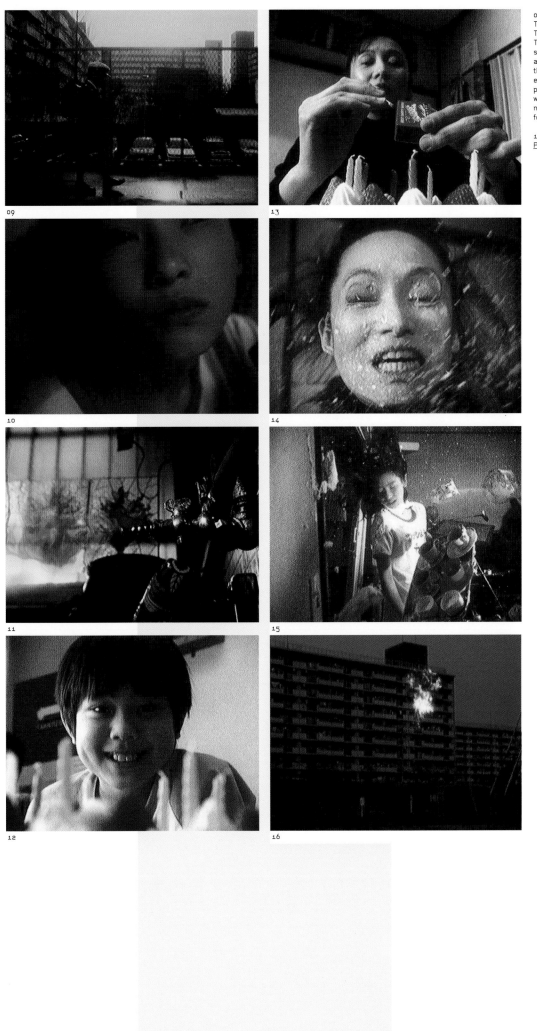

This live-action promo for Ishino Takkyu's <u>Polynasia</u> drew on Tanaka's VJing and directing skills rather than his awesome animation ability. It was chosen as the best Japanese music video ever on MTV Japan. The suspense of the action builds in time with the beats of the track — a near-perfect audiovisual marriage for Ishino Takkyu once again.

17
<u>Polynasia</u> storyboard.

17

tanaka noriyuki

Tanaka Noriyuki has blazed a trail for a new generation of Tokyo creators, working fluidly between a myriad of visual-art disciplines. As such, a strong case can be made for saying that he's the father of this movement, in one of the world's most visually competitive and innovative cities. At Alternative Space, his concrete studio located on a corner of Setagaya in Tokyo, Tanaka Noriyuki produces visual work across the whole spectrum of media. The moving image he creates is uniquely intriguing because of the way it fuses different artistic disciplines and a sense of scientific curiosity.

01

02

03

04

05

01–05
The Japanese band Brahman's music video <u>Arrival Time</u> combines beautiful live action and subtle effects.

01–07 overleaf
Before the computer-game aesthetic invaded music videos, Tanaka employed it in a hyper-kinetic celebration of the style in the video for Ishii Ken's track <u>Game Over</u>. Characters harking back to the 2D fighting sprites seen on the ZX Spectrum are rendered into 3D and set to work. The tour continues through scrolling platformers and Galaxians via 3D Breakout and live-action inserts. The photography is by Kitajima Akira and the CG work by Tanida Ichiro and Tanaka Makato.

08–17 overleaf
Tanaka's work is defined by the exploration of illusion and perception in both personal and commercial projects, from music promos for Ishii Ken to his own personal <u>NTV Activity</u> project. 'Many visuals and edits we see in clubs can't be broadcast on TV, though it's sometimes OK for satellite TV channels. I've made moving image with fast flash-frame editing before which couldn't be broadcast,' says Tanaka.

What are your intentions when you create work?
It's hard to say, especially for me. There are some people who think I'm crazy because I use too many different media. I'm involved in visual art, or visual communication art. I do many different things, from graphic design and installations, sculptures, drawings and paintings to moving-image work and photography. In those various fields, I've collaborated with many different people, from musicians to scientists. I think the only thing I haven't done in the visual arts is make clothes.

How did you get involved in moving image?
I became interested in moving image as soon as I started making films. The way it usually works is that there's the medium, and artists regard themselves as sculptors or visual directors according to the medium they select. But for me, I have an idea first and then choose a medium to work within. I think it's totally different from the traditional way of creating art. It's natural for me, but seemed strange to other people. There were no personal computers or multimedia works ten years ago, so I was under a lot of pressure working that way.

At that time, the British film director Peter Greenaway was searching for creative staff for his film <u>The Pillow Book</u> and I was asked to do the art direction. When we worked together and I saw his way of filmmaking with my own eyes, I discovered that it was possible to make films with a great deal of creative freedom.

Greenaway was originally a painter and he makes sensuous films. He makes films in the same way that he draws a picture. After we finished <u>The Pillow Book</u>, I realized that my ability to use different media would be helpful in filmmaking. Moving images are influenced by everything that surrounds us, from music to photography and art. I found that it was the most suitable medium to allow me to combine my creative energies. I didn't know how to make moving visuals until I had worked on <u>The Pillow Book</u>. I found that I could do it too, so I bought a 16mm film camera and a Sony VX1000, and started shooting and editing personal films. Along with drawing and taking photos, it became a source of ideas like a diary. Then, about four or five years ago, a musician asked me to do his music video, so it became a professional project.

In Japan, there's an apprentice system, which means you usually have to work patiently as an assistant director for ten years before becoming a director. There used to be no one who worked within many different media. So what I had to do when I started working independently was to trust myself. During the '80s, when I started working, there were no personal computers, and the concept of art was limited.

Now, with the development of new media and technology, anyone can create music and graphics independently using a personal computer. But it was good for me to experience that pressure in the '80s to develop a strong will. It made me tough in my way of thinking and way of living. I think it was important for me to start creating before other people began working that way too.

You explore the idea of perception in your work. Can you explain where this has come from?
When I met Joseph Beuys, the encounter made me think about art in a broad way. I was already doing many things, such as painting, drawing, photography and sculpture, but after I met him my interests extended even further. I became interested in the mechanisms of human perception. For example, it's not possible to prove that the colour red I'm seeing is the same red colour you're seeing. I see this

object as red, but others may not. I'm working in the visual arts, so it's natural to be interested in the mechanism of perception. Visual art is related to seeing and feeling, that is, perception. I got on really well with Professor Shimojo Shinsuke, who researches cognitive and perceptual psychology at California Technical University, and we started to do collaborative projects with the theme 'What is the meaning of reality?' One of our projects, exhibited at the Science Museum in Tokyo and the Kawasaki City Museum, features a huge revolving cylinder about three metres wide. A striped spiral pattern is printed on it, and there's a viewing bridge installed at a height of three metres. When you look at the exhibit, even if you're a great athlete, you can't stop yourself from leaning your body to one side. You can't balance and stand on one leg.

There's also a project about visual frequency. It's like sound, or flickering flash frames. What rate are we able to perceive? There are different frequencies of sound that you are able to hear and perceive. It's like the <u>Pokémon</u> broadcast that caused epileptic attacks in Japan. After that incident TV stations had to examine every animation programme to see if it was dangerous for the viewer or not. However, the decisions aren't based on scientific facts. People who examine them make judgments on whether they're OK or not using only their feelings, without scientific evidence. Many visuals and edits we see in clubs can't be broadcast on TV, though it's sometimes OK for satellite TV channels. I've made moving image with fast flash-frame editing which couldn't be broadcast.

Would you say your approach is purely conceptual?
There are several parameters when I start making a new piece. The first is the medium itself. I try to confirm how it is constructed. It sometimes gives me a source of inspiration for ideas. The second is theme. I'm not interested in stories, but I'm interested in something like reality. Not necessarily linear stories, but layers of feeling. The third involves ideas on a creative and technical level. I start thinking along these three lines, though I don't know which comes first. But basically, I need all of them to give me inspiration, to make me feel like I'm doing something original.

The initial idea always comes from something personal and unrelated. There is usually some social influence. I meet some people, which then leads to something new and different. I've collaborated with designers like Issey Miyake and Takizawa Naoki, brands like Nike and Uniqlo, and musicians like DJ Tsuyoshi, Ishii Ken, Boom Boom Satellites, Brahman and UA.

What are the differences between your personal and professional projects?
The reason I started using diverse types of media is because I didn't want to be limited to one style. For example, in the world of filmmaking, if you are good at documentaries, that becomes your speciality. But it's no more than a method for me. I believe that even if your technique and style are destroyed, your originality should remain in your work.

If I have to change to do commercial work, I won't accept it. That's the originality, or the spirit. You can easily create moving images based only on technique, but I'm not interested in doing only that. Creativity develops in commercial areas, and has an economic value. I find an aesthetic quality in selling ten thousand copies of a CD to high-school students for ten dollars, rather than selling one sculpture to a rich guy for a hundred thousand dollars. Some people might say it's too commercial, but I believe it is part of the beauty of my aesthetic.

lolJP

In a striking modern concrete studio, which sits on the corner of Setagaya-ku, Tokyo, in the midst of more traditional dwellings, Tanaka Noriyuki has his Alternative Space. From here he concentrates on producing visual work across the whole spectrum of media surrounded by his personal effects and objects.

Do you have a favourite way of working?
No, after collaborating with other people I usually react and feel I want to do something alone, like drawing. It's important to keep that balance. Taking photographs or drawing pictures doesn't need the help of others, but I can't really do installations or make a film by myself. I always combine these ways of working. If I feel lonely when I'm drawing a picture or when I'm taking a photograph, I then start to think about how I enjoy collaborating with people. Essentially, I think we need to know loneliness to be creative. An idea or theme sometimes comes from my imagination that can't be put into words. I try not to think which medium I like most. It might limit my imagination. If you define your favourite medium, whether it's graphics or moving image, you easily become stereotyped. I think imagination is something primitive. It can't be put into words.

What are your most important influences?
I've been more influenced by the people I've collaborated with, rather than by books, visuals and music. There's a proverb: 'Treasure every meeting, for it will never recur.' I have learnt a lot from people I've worked with or met. When I meet great creators I respect, it's not their work that influences me, I'm more inspired by their way of living. So when I face challenges or problems, I always remember their way of living and persevere.

01

02

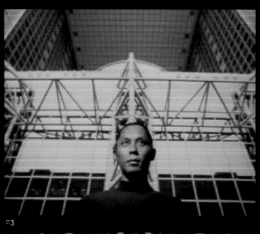

03

04

05

06

07

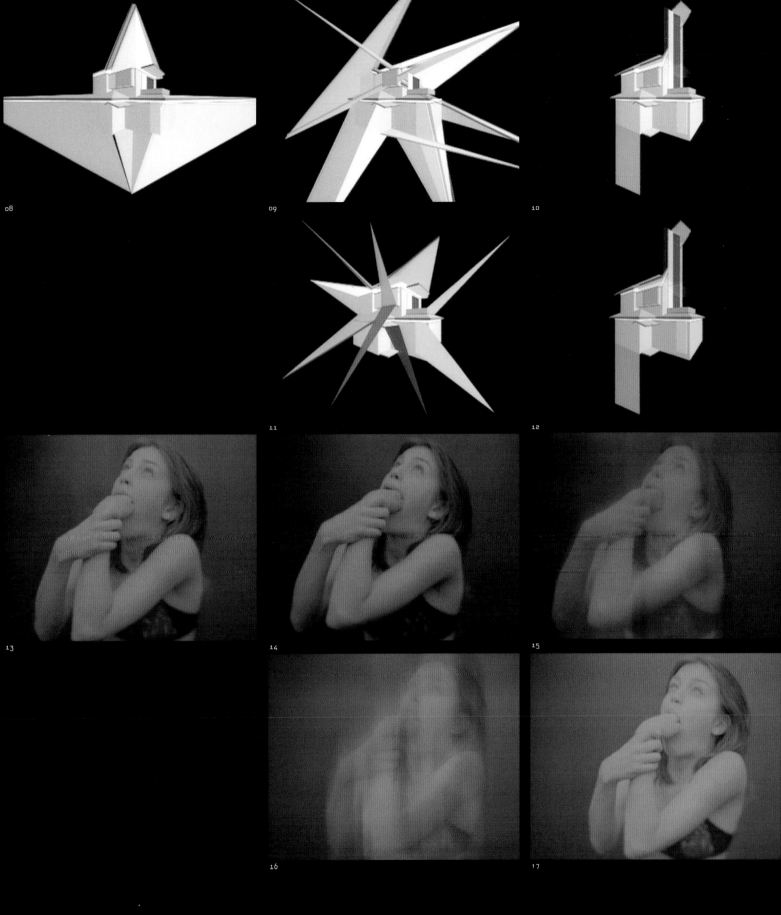

08

09

10

11

12

13

14

15

16

17

motion blur onedotzero

tanaka noriyuki

tanida ichiro

01-03
Tanida seamlessly manages the transfer of his character designs from illustrations to moving image and back again. Many start out as illustrations before finding their way into his motion work. Shown here are illustrations commissioned for BIG magazine's Japan issue — each issue is produced in a different country — including the cover image.

Tanida Ichiro's graphic work has evolved from illustration and 3D imaging to animation and film. Based in a studio in the chaotic Tokyo suburb of Roppongi, he's one of Japan's most stylish directors, constantly in demand from fashion labels and music artists. His JJD studio produces an eclectic mix of work, from refined 3D models for fashion spreads to line-drawn haphazard animation for music videos and oddball comic live-action shoots. This sophisticated visual fusion of ultra-modern and traditional Japanese graphic styles is delivered with a deliciously offbeat humour.

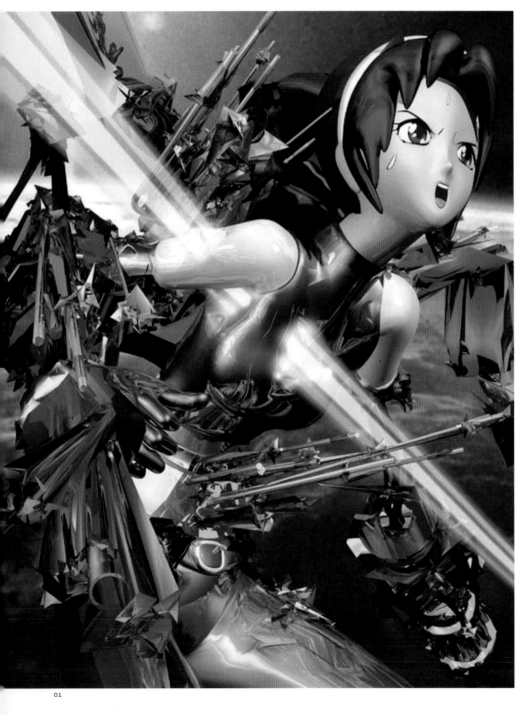

01

02

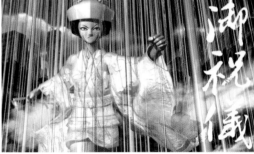

03

Why do you do what you do?

Each person has different reasons for creating something. Some are political and others are artistic. There are also some people who create as a consequence of thorough research of one subject. For me, the most important aspect is how I can enjoy myself. My life has changed, I've got married, had a baby and got a dog. Nothing is sweeter than them, even though I sometimes take things too seriously. You see a child and think that she or he is cute. I just wonder if there's any point in creating a 'cool' artwork with a lot of serious thought behind it. It's an instinctive thing. No one can create against their instinctive feelings or interest.

Your company's name is JJD or John & Jane Doe, Inc. What does it mean?

I made an A-to-Z of slang words for a CD-ROM about seven years ago. I produced it under the name John & Jane Doe, Inc as a joke, and it became my company's name. It's the mark written on the bottom of unidentified dead bodies' feet. It's just like 'Nanashi no Gonbei' (Mr Unknown) in Japan.

What influences do you have?

The first influence I had was Pop Art in the '60s, when I was a naïve student and didn't know anything. I've been greatly influenced by fine art as well. I don't know why I'm a director now. I recently started to get interested in films and motion graphics. I didn't like 3D that much at first, but I got interested in it naturally before I was even aware of it.

Of course, I have Japanese influences, but thanks to the internet we can get information from many different cultures simultaneously in Japan, especially in Tokyo. We can get almost everything we want. It's inevitable for me to have a mixture of influences, not only Japanese ones. Previous generations were conscious of foreign countries. But our generation

→

[o]JP

Maverick designer, artist, illustrator and director Tanida Ichiro heads up his JJD company based in the lively Tokyo district of Roppongi.

04–10
Da Pump is a boy band with their own TV series, for which Tanida produced a trio of whacky and hilarious opening titles. He had complete freedom and wanted to make small horror films, live-action vignettes with his trademark twisted humour. He featured the lovely 'Nicole' and a range of cute toys that turn evil on her. From rooftop attacks from soft-toyed monkeys to killer frogs in the bath and frenzied dogs, he managed his desired response from the audience: laughter underscored with fright.

11–12
When Tanida produced an in-store video for clothing company PPCM, he created his first middle-aged character. The archetypal 'Salaryman' moves and behaves in a very traditional manner to reflect the store's clientele in a very humorous way. It was produced for MAWS, a design company that mainly works in fashion.

04

05

06

07

08

09

10

11

12

motion blur: onedotzero

tanida ichiro

01–16
The warped logic and playfulness of Tanida's previous 3D work is further developed in this action-packed combo produced for the popular SM Station anime TV programme. They are enhanced by more sophisticated character modelling, cinematic editing and camera moves.

01–08
In Run, a 3D film noir, a young girl is seen being pursued through a series of corridors and class-rooms until she finally comes to rest. Cornered and exhausted, she begins punching and twisting her leg until it finally comes free to reveal the SM logo within.

09–16
Tanida's trademark feisty female character, Jane Doe, reappears in Akiyama to battle with an ex-lover atop a Tokyo skyline. Power struggles are not usually played out like this with beachside flashbacks and absurd comedic turns that end with the SM logo appearing on the ex-lover's knocked-out tooth.

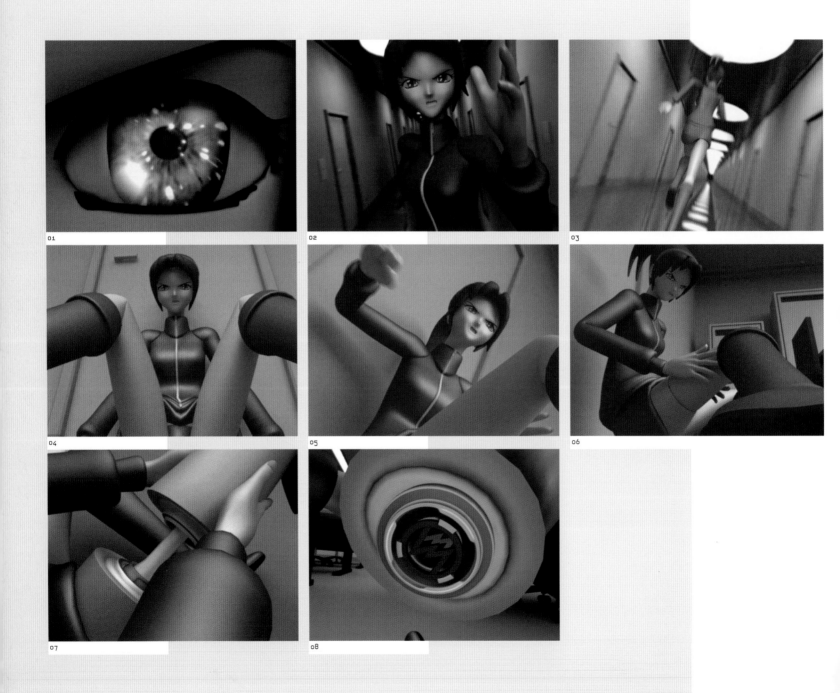

01

02

03

04

05

06

07

08

has created work inspired by and imitating foreign styles, which we know isn't necessarily our style. Each country creates different things depending on its native street culture and environmental surroundings. There should be some differences like that.

Do you see things in terms of individual elements, such as concept, visuals, story, psychology, etc, or as a whole?

I usually see both the whole and the details of a piece at the same time when I create something. When I draw a picture of a woman, if I get interested in the back of her neck, I draw that part first. I always begin with what I'm most interested in. Next I sketch her hands and legs. It's OK to ignore elements on paper. I draw what I want.

When I do computer graphics, I usually make a rough sketch by hand first. It's important to have a definite image in mind, so when I create a graphic I can then build a scenario around it.

Do you already have characters in mind when you start writing your stories?

I usually have a certain character, often a strong woman regardless of the story. I think the world would be more peaceful if women were portrayed in a stronger way. Every character in my stories has considerable presence, though the figure itself may sometimes be small and slender.

What is your definition of success?

I always aim for every piece to be successful, but I think there's not such a big difference between my definition of success and others'. A TV commercial becomes a big hit when hundreds of thousands of people see it and spread the word, not when only five great creators appreciate it. My definition of success is not so far from that of the client's and agency's.

Tell us about your characters.

I usually create strong women characters, both in animation and live action. But each character is different. I'm conscious of emotions when I create both female and male characters. Not just their facial expressions, I also attach importance to their poses. I always try to create emotions with their bodylines and a delicate nuance. A clenched fist has a totally different meaning from an open hand.

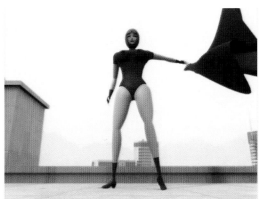

09
10
11
12
13
14
15
16

01-07
Tanida originally created his Jane
character for an art exhibition,
'From Tokyo to Tokyo', organized
by the store Beams. An art direc-
tor for Laforet spotted his work
and this became his first commer-
cial work. Tanida was happy his
character had been chosen and
went on to produce a number of
campaigns for the Tokyo fashion
department store from 1996
onwards. Tanida's John and Jane
characters feature heavily in his
work. Other than Laforet, they
have been used for other projects
such as opening sequences for
late-night post-club music
programmes.

01
Laforet Grand Bazaar Winter '99,
based on previous illustrations for
BIG magazine, which were art-
directed by Tycoon Graphics.

02-03
Laforet Grand Bazaar Winter '96.

04
Laforet Grand Bazaar Spring '96.

05-07
Laforet Grand Bazaar Summer '96
campaign. This was based on the
Japanese punk schoolgirls,
'Furyo', who hate school and
prefer bad behaviour such as
drinking and smoking.

01

02

05

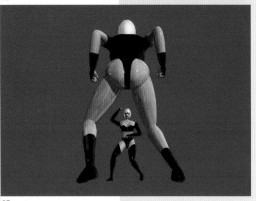

03

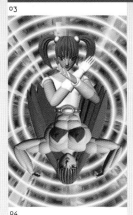

04

06

07

08-15
Tanida first worked with Tei Towa
VJing and DJing as part of a
regular club night. Both men are
intimately linked with the Tokyo-
based Graphickers collective.
They have gone on to work
together on commercial projects
such as the opening TV campaign
for Tower Records. They have a
strong, ongoing collaboration for
Tei Towa's music videos, from
<u>Technova</u> in 1995 onwards.

08-10
Tanida used a more illustrative
and collage style for Tei Towa's
<u>Fly</u> music video.

11-15
Tanida's music video for Tei Towa
references the classic Toho films'
Godzilla movies, with their cheesy
special effects. <u>Mars</u> showcases
Tei Towa and his evil twin battling
in a dwarfed cardboard cityscape
with gently comic consequences.

08

09

12

10

13

11

14

15

motion blur: onedotzero tanida ichiro

teevee graphics

Teevee Graphics, one of the elite motion-graphics studios in Tokyo, create highly original work to appeal to the endless variety of local youth cultures. With <u>Video Victim</u>, first exhibited at the Japanese department store gallery Parco, they made their mark as distinctive motion-graphics experimenters who could move seamlessly beyond the bounds of music videos and commercial films. For such a metropolitan production house, their work is uncharacteristically suffused with a wry humour.

01

02

03

04

05

06

08

07

motion blur: onedotzero

teevee graphics

What was your original vision for Teevee Graphics?
KJ: I started Teevee Graphics because I wanted to create visuals using graphics, but today there are so many visuals that use motion graphics. In the future, we would like to establish an independent structure which would allow us to be our own client and publish a collection of works by ourselves.

How do you describe what you do, and what are your intentions with your work?
KY: It depends on the people I meet. When I went to an estate agent recently, they asked my occupation and I said I was a commercials director. If I had said a visual director, they would have thought I meant a director of porno films or something like that. When I talk to my friends, I sometimes introduce myself as a music-video creator. It depends on each individual case, and I think it will change in the future. I don't want to define myself.
SM: Basically I'm an animation director, but I'd love to do live action as well. I define myself as a visual creator, but I sometimes introduce myself as a music-video creator to people who are not familiar with this field. It's easier for them to understand.

What is the reputation of Teevee Graphics in Japan?
KJ: We basically create visuals that have motion graphics. We never communicate through stories. When clients want a creator to communicate via graphic design, they think of us. What we create unconsciously has a very Japanese or Asian style which I think would appeal to people in other countries.

How did you get involved in moving image?
SM: My first encounter with moving image was TV. Animations have been the strongest influence, like the work of Hanna-Barbera broadcast on TV Tokyo, or Japanimation like Space Battleship Yamato. When I first saw them on TV, I was really inspired and wanted to create animations myself.

What are your influences?
SM: I'm interested in contemporary expression. It's quite natural to be influenced by cutting-edge work if you spread your antennae. I like digging up old ideas from 10 or 20 years ago that have been forgotten by everyone, and reproducing them in my own creations. Like '80s optical effects. It's like sampling a vintage wine. Digging up old forms and mixing them with the new.

What aspect of your work do you like best?
KJ: The River is a good example of what I want to do the most. I wanted to pursue the balance of black and white colours like in an old Japanese monochrome painting, and it was good to be able to do this. I'm pretty satisfied with the result.

How do you feel about your more commercial projects?
SM: Commercial work never inspires me. Usually clients propose a concept, meaning my input is limited. After I get a brief, I try to get ideas, but when the client proposes concepts or images at the next meeting, I lose interest. Especially if their proposition is concrete.

Is there much difference between the digital and analogue domains from a creative point of view?
KY: I think everything is based on analogue. Digital is no more than a convenient tool. The idea itself or the way of thinking that makes us feel like creating something is analogue. In order to express the idea, we use digital tools for convenience. They exist together, but there's no digital thinking in my expression when I make something.

How did your collaboration with Sugiyama Hiro of Enlightenment on Video Victim begin?
KJ: A magazine suggested we create an experimental motion-graphic project in collaboration with Sugiyama. Then we started thinking about the theme, since we couldn't create anything without a theme! I had an idea of distance or time. The final theme became the distance between man and woman.

Tokyo is very exciting. Is it necessary to your work?
KJ: To tell you the truth, I don't want to live in Tokyo. But there are so many interesting people who create great work here, it's a good source of inspiration, so it's difficult to leave. If Teevee Graphics went to New York or somewhere, I don't think there would be the same sense of competition. There are so many interesting people around us in Tokyo, so it's easy for us to work this way.

|◦|JP
interviewed:
Kojima Junji [top, third from left], studio founder with team
Kakegawa Yasunori [above, left], director
Savini Mizuhiro [above, right], director

Teevee Graphics, based in the heart of Tokyo, are a small industrious unit of creatives who turn out an exquisite range of work under the creative direction of Kojima Junji.

01-08
Teevee Graphics have played with abstract multi-coloured blocks in their personal and commercial work to great motion-graphic effect. Here they provide the visual elements for the Strobe Enhanced music video for Ishii Ken.

01-06 overleaf
Japanese Tradition short films directed by Kojima Junji and featuring Japanese comedian Kobayashi Kentaro, aka Rahmens.

01-03 overleaf
Sushi: Teevee Graphics poke fun at Japanese traditions in this hilarious take on the ritual of eating sushi. It stars the comedic double act Rahmens [Katagiri Jin, Kobayashi Kentaro] in a marvellous mix of studied live action and sharp graphics that highlights the humour.

04-06 overleaf
Room Service: a well-to-do woman has trouble packing her shopping bags into her trunk. To the rescue come the special powers of the hotel porter extraordinaire. His mathematical knowledge of ergonomics and spatial dynamics allows Kojima Junji to use a graphical overlay as a witty addition to the cinematic live action.

07-15 overleaf
Un Homme et une Femme is film number 13 in the Video Victim series. It is a monochromatic animated piece with hand-drawn illustrations by Sugiyama Hiro and music by Sasaki Toru.

motion blur: onedotzero teevee graphics

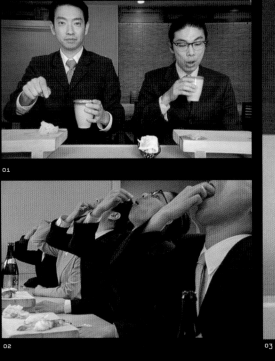

01

02

03

04

12cc

06

07

08

09

10

11

12

13

14

15

motion blur: onedotzero

teevee graphics

朝、とる、栄養が、あなたを変える。

protein 6.7g vitamin B₆ 0
minB₁ 0.6mg vitaminB₂ 0.6mg sodium 25m
vitaminD 50I
calcium
nesium 50mg potassium 60mg
dietary fiber 2g
min A 900IU folic acid 100µg

protein 6.7g
vitamin B₆ 0.8mg
vitaminB₆ 0.8mg sodium 25mg
niacin 8.5mg vitaminB₆ 0.6mg
vitaminD 50IU
calcium 200mg
magnesium 50mg potassium 90mg
vitamin A 900IU vitaminE 4mg
folic acid 100µg

01 02 03
04 05 06
07 08 09

01-09
Commercial work for Calorie Mate
Jelly.

10-21
As well as commercial and broad-
cast work, TVG produce a large
number of music videos for the
Japanese market.

10-12
This music video for Aco, directed
by Kojima Junji and Savini
Mizuhiro, used a range of tools
including After Effects, Lightwave
3D and Inferno.

13-15
Element of Rhyme is South Park
filtered through Japanese
sensibilities. This unadulterated
homage was produced for the
band Audio Active and features a
story of drugs, drugs and drugs.
It was directed by Kojima Junji
and Savini Mizuhiro with animation
by Sano Moriyo and Liling Lu.

16-18
A further video for Audio Active,
entitled Psychobuds and directed
by Kojima Junji, had a more
treated live-action approach.

19-21
A motion-graphic, typographic
music video entitled Love Beat
by Yoshinori Sunahara featured
design by Sano Moriyo, Takagi
Akihisa and Liling Lu and 3D work
by Hirotaka Watanabe.

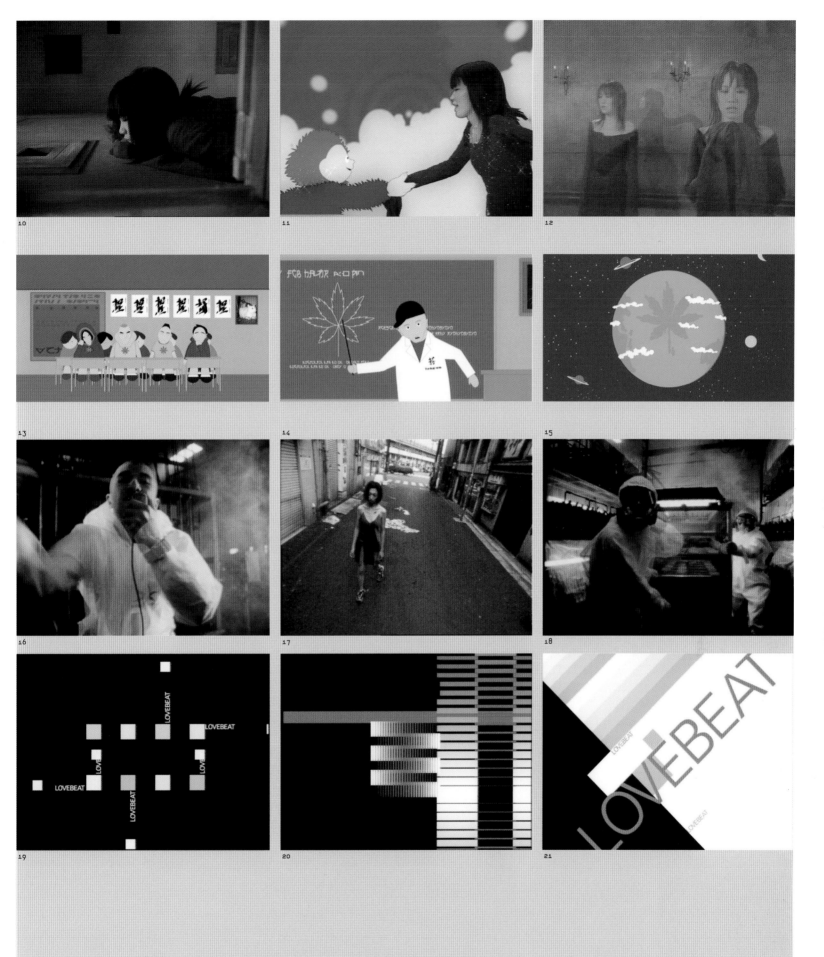

10

11

12

13

14

15

16

17

18

19

20

21

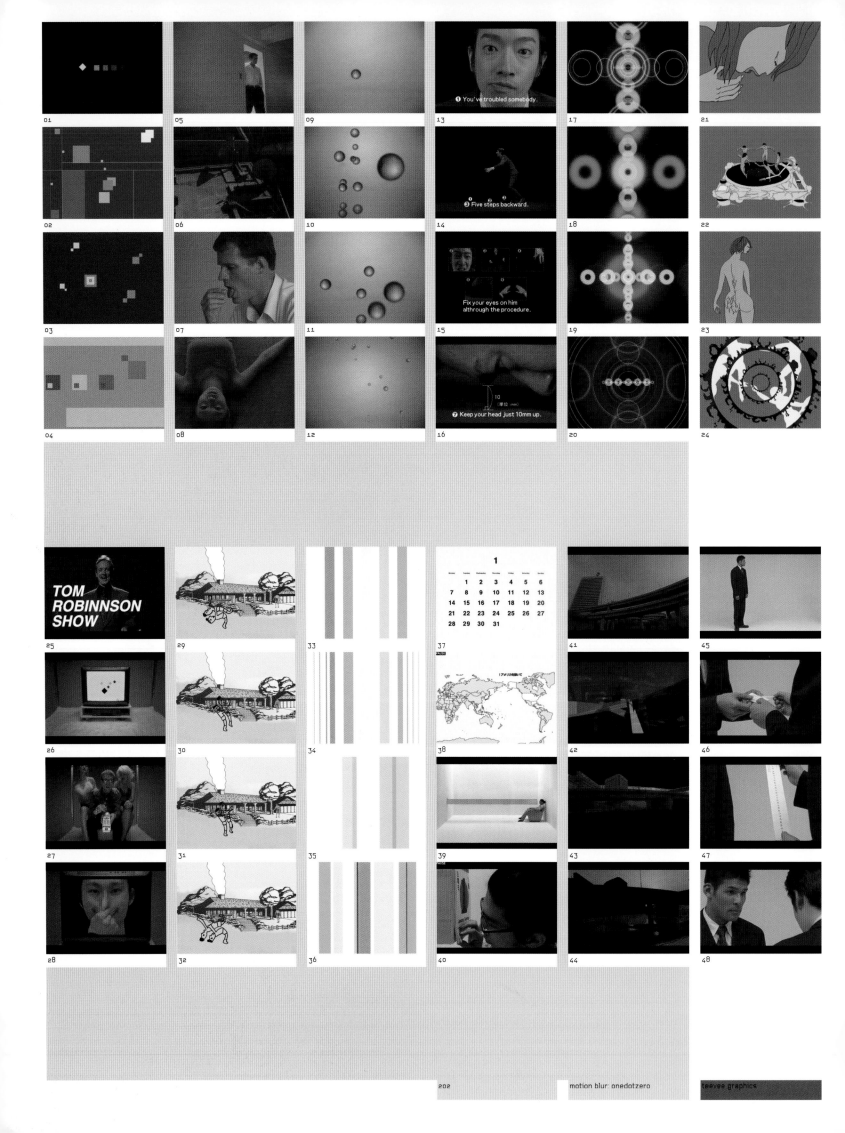

01
02
03
04
05
06
07
08
09
10
11
12
13
14
15
16
17
18
19
20
21
22
23
24
25
26
27
28
29
30
31
32
33
34
35
36
37
38
39
40
41
42
43
44
45
46
47
48

01-92
The Video Victim series was an exhibition and DVD release containing over 20 pieces of short personal work from the TVG team. The series shows their humour and immense talent in disciplines from moving image to live action and multiple styles of animation from CG and hand-drawn to motion graphics.

01-04: square, 05-08: grape, 09-12: landscape, 13-16: the japanese tradition, 17-20: ripple, 21-24: pulse to pulse, 25-28: video victim, 29-32: backdrop, 33-36: 5s, 37-40: new world calendar, 41-44: river, 45-48: business card, 49-52: un homme et une femme, 53-56: morse, 57-60: matt, 61-64: future, 65-68: colour, 69-72: science, 73-76: psychological game, 77-80: hui brothers, 81-84: pencil, 85-88: 12 sec, 89-92: rainbow

the light surgeons

The Light Surgeons have been producing defining moments since 1995. As prime movers in advancing the UK club visuals scene, they've seamlessly transferred their analogue innovations and 16mm looping and layering activities to a multi-layered, multi-source digital approach that combines their own sourced graphics, photography, filmmaking and sound. In the process they have reinvented them-selves as experimental filmmakers, creating live and pre-recorded graphic cinematic experiences to complement their VJ exploits.

01

02

05

03

04

motion blur: onedotzero the light surgeons

How did The Light Surgeons come about, and your distinctive style evolve?

I founded The Light Surgeons while studying design at Portsmouth University along with a few friends. I began back in '92 doing visuals at a club night called Steps Ahead that my brother, who now records as Dynamic Syncopation on Ninja Tune, began DJing at. That was at the Gardening Club back in the days of acid jazz. After leaving Portsmouth I teamed up with another guy called Andy Flywheel and we founded our own night along with DJ Rob Da Bank called Sunday Best. We then moved to Hoxton, East London, and contributed to Ninja's Stealth nights and other events in the now-defunct Blue Note club.

At the moment The Light Surgeons consists of myself, as director and founder; Jude Greenaway, who records as Scanone and performs audio, editing and animation duties; James Price, who cuts video and runs productions; and Rob Rainbow, who comes from a more 2D print-based background. Becky Gates manages The Surgery, and helps produce.

Our style initially began through sampling and referencing visual culture in general, using looped visual samples to create a fusion of graphic and moving images designed to work with and illustrate the music. We discovered new ways of assimilating both old and new technology into a single process as we went along. Our style is about approaching film and visual expression in a more free and musical way. More recently it's also been about adding a narrative, creating our own form of documentary dance music, AV with a message, which entertains and makes people think.

What do you find the most enjoyable aspect of your work — live performances, club VJing, print or short films?

Personally, I enjoy being able to express my ideas in many different media but I think live performance is the most enjoyable. I love having a direct contact with an audience and taking over a space. VJing is also a lot of fun and allows for experimentation, but putting down our ideas in a more tangible format as films has been a lot more rewarding. I enjoy photography; I love the happy accidents that are created with multiple exposures.

You were integral to the early UK VJ scene. What are your views on its progression and current state?

In the early days it wasn't really VJing as it is now, it was more graphic- and moving-image installations that happened to find a home in nightclubs. The new laptop generation of VJs performing and creating 'visuals' has made it more accessible. It has its own aesthetic, though personally I think it seems less creative. It's all about what material you put into the programmes. I think VJing will continue to develop as a major part of club culture and become more audiovisual in its nature. Hopefully it will not become the next DJ-type craze and spawn a wealth of glossy magazines and a crowd of over-hyped minor celebrities. The form's value is in its freedom from the established forms of communication and its countercultural perspective.

What is your favourite piece of work to date, and why?

It's hard to pick one project, but I would say the APB [All Points Between] performance because it draws on all aspects of our work. I think it's a groundbreaking project that is redefining digital cinema and multimedia performance. APB came out of the Electronic Manoeuvres show commissioned for the onedotzero4

→

01–05
<u>Thumbnail Express</u> was the first in a series of documentaries debating the social and political state of the United States of America. It introduced for the first time the character Robert Alan Weiser and his travels across America, and marked a new direction for The Light Surgeons in the use of digital tools and direct narratives in a linear film.

✳ UK
interviewed: <u>Chris Allen</u>

The Light Surgeons conduct operations from their base in a Shoreditch warehouse in East London.

01

02

03

04

05

festival. It was a really important turning point for us, moving from VJs to filmmakers. We became more of an act in our own right, while also premiering our first short film. It was the testing ground in the form of a club night that started our move into what has become the APB performance, a live documentary fusing club culture with cinema.

APB presents other people's points of view, often those without a voice or on the margins. The message has grown organically out of these people's stories. We had filmed and recorded a lot of stuff in the US, in Vegas, San Francisco and New York. Post–September 11 we felt that we had to make the shows reflective of the current political situation. We wanted to create something with more meaning, something that was more socially aware, rather than the endless abstraction that seemed to be happening in both music and VJ culture.

You have also created original sound to your moving image. How did this come about?
Taking on the sound to our own work has allowed us to explore many new things and it really developed out of Jude becoming part of TLS and his interest with making music and my own wish to move more into storytelling and narrative. We did an installation project for an event called 'Exhibit B' which involved us travelling in the States for a week and collecting footage and sound material that we later edited into our first film, Thumbnail Express, for the festival. It was the first time we had gone out and recorded sound for a project and we happened to do a load of interviews with people because I thought it would be cool to introduce some narrative and spoken word. We ended the week-long trip in LA and recorded an hour-and-a-half monologue with this old travelling street dude in Venice Beach called Robert Alan Weiser. I think that was a seminal point for me. We are still working on his stories as a digital film project.

What future developments can we expect from TLS?
We still intend to finish the short digital film series, following on from Thumbnail Express and City of Hollow Mountains. I still think working with an act or band is really interesting as it is our interpretation of their music, and we've been working with Zero 7 on some stuff. We see our work developing through other platforms such as DVD and the internet. Overall we're focusing more on digital film production and motiongraphics work than VJing in clubs and providing creative production for events. We intend to initiate more of our own live performance projects and continue to pioneer collaborations that combine sound and image with architecture and the construction of total environments.

01-05
The City of Hollow Mountains was the second instalment of the documentary series Gilligan's Travels. Here Robert Alan Weiser draws us into his thoughts on the east and west coasts of the States while travelling from San Francisco to New York City, ruminating on the urban environment – full of skyscrapers, elevators and long urban canyons – as vertical trap.

01-11 overleaf
APB was a reincarnation of the live show Electronic Manoeuvres, spawned from a fragmented, freewheeling AV night where club culture collided with feature film via installation and sonic performance. It is an audiovisual investigation of latitude and longitude and people and places. 'My work has always traversed these different mediums, so I don't really view them as being that different,' says Chris Allen. 'They are all tools for communication and are traditionally presented in different contexts. I think there has always been a fascination with process in our work… Through working under the limitations of the medium and with the resources to hand, I discovered new ways of assimilating both old and new technology into a single process. These infamous light shows in clubs led me to produce work for many different musical artists and commercial companies through a diverse range of different media… As Chuck D said, hip-hop is the urban CNN. For me, hip-hop lives on in the new expressive mediums of multimedia and our own live AV performances. This IS the urban CNN, baby… for reel.'

01

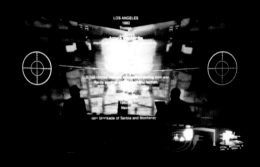

02

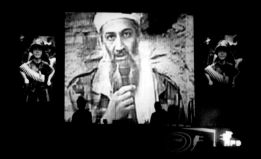

03

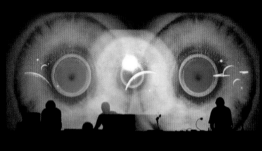

04

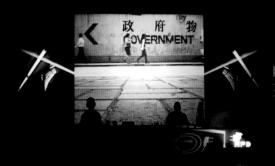

05

06

07

o8

09

10

11

zeitguised

Henrik Mauler and Jamie Raap assemble motion graphics that mediate between our need to make sense of an increasingly confusing world and the complex systems that comprise that world. They do this with pristine infographic meditations and architectural motion explorations. The duo comment on the proliferation of pre-visualization techniques and prefabrication, while creating stark and beautiful forms based on these processes, moving beyond image-led motion graphics to ones driven more by philosophies.

What is your general approach to filmmaking and motion graphics?
For some reason we want to adjust the 'pop feeling' that probably helps some people get up in the morning to artistic, scientific and philosophical thoughts. Jamie comes from an artistic background, graduating as a sculptor, but crossed over to fashion and painting during her studies. I thought architecture combined my interests in design and science well and would also serve as a good cover-up so my parents would think I do something decent and serious.

We like to refer to our process of designing as 'modelling'. Not modelling in a 3D-CAD sense, but in the sense of how a scientist creates, say, a mathematical model to stand in for and simulate a physical process. Motion graphics connect our bandwidth of interests.

Is your first love infographics or moving image?
It is probably something in the middle: time-based painting in the tradition of Max Ernst and Eva Hesse. We love traditional moving image and there is always a part of that in our infographics.

Your motion work — exploring the Boolean Camera, database cinema, and a city environment — is obsessed with process rather than narrative.
Our generation is more obsessed with the idea of 'becoming' than with a platonic 'fixed reality behind things'. Our work explores this. Popular Mechanics was trying to express processes with narrative elements,

→

01-04
Fluid abstract expression and architecture inform the motion-graphic work of No C No K, a lesson in spatial dynamics contained in a fractured yellow and magenta urbanscape.

01

02

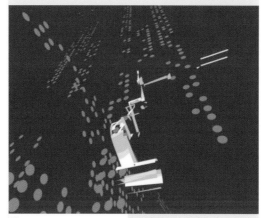

03

04

but the content, what the machines in the urban environment were doing, was a system with unpredictable outcomes. With the Boolean Camera in Kontaktschmelze, the process was on a different level. It emerged in its making, by downloading random objects from the internet, generated by armies of anonymous modellers, and generating a process, or machine, that would turn them into bastardizations of established and questionable forms. Now we are pursuing the purer modelling of processes, and we want to show that in our work.

Can you explain why you chose these themes, and what you want to explore?
To cross the gap between philosophical and scientific concepts — modelling — and the sensual experience, the excitement of perception — simulation. As 'designers', it goes without saying, we are interested in topics that deal with the perception of our world and strategies to trace the things that are excluded from this perception, as well as operations to give these hidden alternatives form. The limits are just to do with us. We are getting older and grumpier, which means we don't want to see the beauty in things any more.

What is your take on graphic moving image as opposed to 'mainstream' filmmaking?
Graphic moving image works with reduction of complexity, just like traditional science. It makes a good framework to synthesize the unseen. In

mainstream filmmaking you have to work hard to make something visible beyond the surface of the obvious. It is so full of conventions which are screaming to be taken apart.

Are architecture and environments areas that you wish to work in or just subjects that inform your work?
Our work wants to spread out at both ends. Taking input from 'a new reading of urbanism, architecture and space' for movie-clips means taking motion graphics as a base for creating physical environments, namely architecture. We can't really dissect the work into the two fields, but actually making architecture takes up a lot more time and energy.

Do you consider that what you are doing is 'different' or unique?
Sometimes there is only a minimal but important difference from comparable contemporary work. Artists don't think so much in terms of ingenuity any more. Authorship is highly overrated. Uniqueness and originality have a different meaning to us, it's more about how to combine the right things. Cedric Price, the secret British hero of Pop architecture, gave a lecture in Stuttgart in 1996 in which he said the unforgettable words: 'Always anticipate the unexpected!'

≡DE
interviewed: Henrik Mauler

Henrik Mauler and Jamie Raap came together in 2000 at a point when they were 'mixed up in private and academic chaos' to form Zeitguised, which is based in Stuttgart, Germany.

05

05–07
Kontaktschmelze [contact fusion] is an experimental piece in which the 3D models and sound effects all came from free databases on the internet. The work 'perverts both the supposed explicitness of graphical manuals and the conventions of the engineering drawing by animating boolean operations as The Boolean Camera'.

06

07

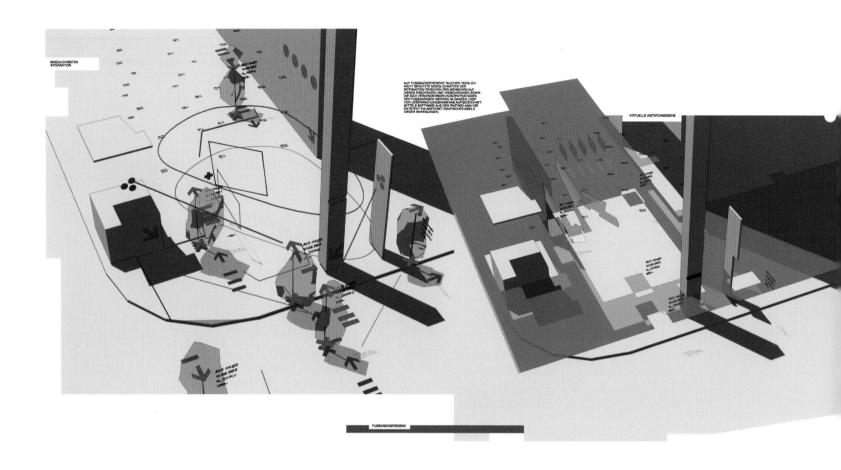

01

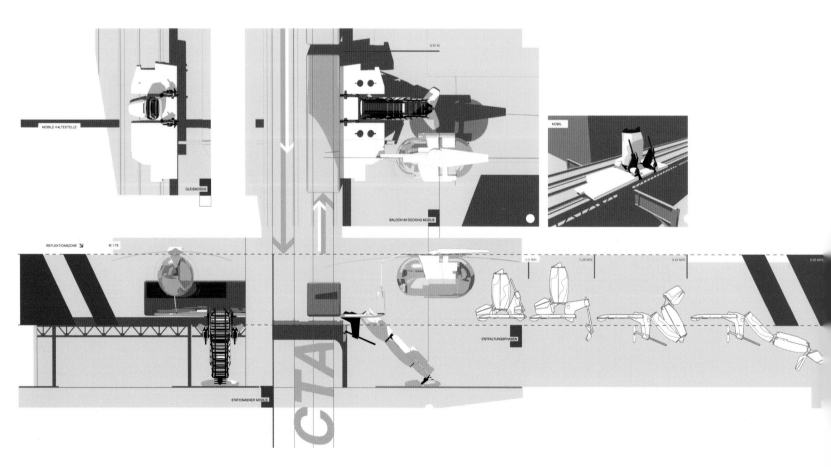

02

03

04

05

06

01–06
<u>Popular Mechanics</u> illustrates a minimalist world of mass transit. This elegant, clipped vector-graphic project is based on a design proposal for the Chicago Loop or El, examining previously unexplored possibilities where social interaction meets abstract graphical code.

07

08

09

10

11

07–11
<u>Syntax of Construction</u> is an experimental 3D animation describing the connection between built structures and their underlying principles. 'The film depicts how individuals move through spatial environments attempting to gather information about their surroundings and configure elements according to their ideas. In the end we see that the individuals themselves are constructed by the same structures and mechanisms they were scheming.'

01

02

01–10
A rebranding proposal for <u>MTV North</u>, featuring different logo animations for various genres of music. This treatment for electronic music features a twisting MTV logo, intersecting with golden speaker and pluglike abstract animated shapes. Produced with Lostinspace, London; copyright MTV Europe 2003.

11–16
<u>Fold</u> is an artistic interpretation of an intelligent textile research project at the University of Stuttgart [IGMA]. Adaptive textiles are used as part of the stage and prop to cooperate with the movements of dancers and actors.

03

04

05

06

07

08

09

10

11

12

13

14

15

16

　　　motion blur: onedotzero　　　zeitguised

appendices

motion blur: onedotzero appendices

the seduction
of moving image

Are we are entering an age of de-regulation of creative boundaries? Are tags such as graphic designer and filmmaker still accurate descriptions of what people do or are they approaching redundancy? Are digital tools transforming us all into image-making jack-of-all-trades and lost masters of none? Moving image is becoming a popular destination for those wishing to deviate from their chosen creative careers. And as more creators are attracted to the area, more are also encouraged to take moving image back into other disciplines.

onedotzero was very fortunate to start when it did, with the advent of desktop digital filmmaking and the reduction in cost of these systems. It was also a time when collectives were being formed, bringing together artists of differing backgrounds to work on the same project. For the first time a whole new range of artists could embrace moving image as a medium; illustrators and graphic designers could add a time line to their work and begin experimenting. This opened up the way films are both made and viewed. A new media-literate audience emerged and there was a resurgence of interest in short-form work.

onedotzero was not created to be a neutral showcase event. It was created with a clear agenda, and a definite motivation to push and promote a particular genre and range of styles of moving image. It's hard to define these styles; the programming is more instinctive and does not follow pre-ordained routes. Rather than simply picking up on the latest styles, onedotzero is more about predicting and shaping them.

onedotzero was set up to allow adventure and playfulness, and it purposely explored the grey area between art and commerce, client-driven and personal projects. It has striven to create a unique environment in which to experiment, with a democratic approach to those creators taking up the challenge. By being a producing festival and encouraging new work, it naturally became a catalyst and conduit for progressive production — a visual ideas lab.

It is particularly rewarding to see the cross-fertilization of creative disciplines happening more organically and from a wider area than it did when we first started. The buzz of convergence is still heard but it has now become a realistic way of working in today's creative landscape. The true excitement is not just the converging of areas such as graphic design with filmmaking, or photography with music, but what happens after they have blended. There is the thrill of

the collision, but the resulting fragments forge even more engaging trajectories to follow.

This intermixing is happening at an earlier stage of artistic development as a matter of course. Once rigidly fenced-off areas are being fractured and splintered; in some cases you're more likely to learn about moving image on a design or architectural course than one on filmmaking. Architecture is now enjoying a higher visibility and popularity, but compared to other areas of creativity it is perhaps much harder to straddle the personal/commercial arenas in architecture. Access to new tools has made it easier for a musician or a digital filmmaking Kubrick to explore their personal projects from a bedroom or a garage and make an impression. Although technology has had a huge impact on architecture, you still can't really build the South Bank in your spare time.

However, architects and designers today are sufficiently trained in software and emerging digital tools, armed with a conceptual approach to decide on a variety of artistic outputs. Making fly-throughs of unrealized dream projects opens the door to the seduction of other areas, such as moving image.

What does this fresh perspective bring to moving image? Used to the challenge of literally carving out a space in the real world, does the freedom of the virtual or screen-based world mean architects can finally get to play out their ideas, albeit in a different dimension? A sense of occasion, a spatial representation in a particular slice of time? It must almost seem like a decadent display after the barriers that architecture throws up.

Whether it's a creative or a financial choice, this crossover into moving-image production is certainly happening. Take the London-based company General Lighting and Power. Set up as an architectural firm, they now work exclusively on moving-image projects. After a stint at GLP [General Lighting and Power], the Lynn Fox collective is already creating a stir on the music promo scene. Their final project at London's Bartlett School of Architecture was handed in on a solitary videotape. Both groups, it seems, feel much more at home with their designs on a moving-image timeline than back on the drawing board.

So much for architects joining the digital moving-image domain. But what this also does is have a swing door effect, with motion makers filing in. It means those who are actually working on spaces and in

architecture are much more switched on to moving image and its possibilities in environments. This flow and exchange will lead to more hybrid projects where it is difficult to pin-point the contributor's origins.

onedotzero has always been interested in this opening up of boundaries which continues to infuse the moving-image area with fresh ideas and new directions. Creators from new hybrid forms of moving image now want a playground to exercise in and, interestingly, they are being courted. Companies such as interactive design consultancy Digit are creating installation experiences that are integral to the environment and are keen to work with architects at the planning stages. From 1997 to 2002, John Warwicker of Tomato was the 'media architect' for Melbourne's new cultural centre, Federation Square, working with Lab Architecture on a variety of architectonic forms that blur the distinction between architecture, programmable space, information and identity.

All this leads to the development of new visual languages and ways of expression. Graphic design is a great communication discipline that has brought an injection of vigour to the short-form areas of music videos, advertising and increasingly longer length films. In early onedotzero festivals the work had an abstract, experimental look. Artists then started to marry this with more ideas and stories, and fuse live-action filming with animation. Each edition of the festival has a flavour, whether it is highlighting the aesthetic and influence of new media tools such as Flash, or promoting the idea that computer gaming informs other areas of animation and film. Over the last eight years there has been a huge increase of these motifs and styles in the work we show and that has spread to other areas at an ever-quickening pace.

Adventures in moving image are what onedotzero is passionate about. As with all adventures, there are many routes and paths it can take, offering an exhilarating ride with no one correct course. As a visual ideas lab it should be the place for discussion and debate to drive forward not only moving image, but also those disciplines and areas it encounters. It certainly feels like an exciting time to be exploring.

Shane RJ Walter

First appeared in Creative Review magazine, May 2002 and onedotzero6 festival catalogue.

the end of celluloid

The End of Celluloid has long been predicted. With filmmakers from Hollywood to the East End embracing the new digital technologies, a sea change is taking place in moviemaking, whether it's no-budget, low-budget or blockbuster. With the advent of digital video tape and computer post production, the mystique of film production is slipping away. Splicing reels, developing negatives and processing opticals all make way for easier modern methods.

But while the mystique may fade, making a film starts to come within the reach of all of us. Just as samplers and synths revolutionized music production and produced whole new genres and sub-genres, desktop digital filmmaking has the potential to kick-start independent filmmaking worldwide. New ways of working with and processing images mean that film language and imagery will also be reinvigorated.

Beyond camcorder culture, creative talents from areas not necessarily associated with film get to slip over easily into moving image. onedotzero version 1 [1997] was an indication of this. Graphic designers, familiar with the tools necessary to manipulate images digitally, were the first to transfer their talents to this area. The results were far removed from the Hi-8 high jinks of lo-fi filmmaking that has represented the bottom end of independent film production in the UK.

When directors emerge from outside the cocooning confines of 'professional film', we see remarkable cinema — witness the vibrancy of Greenaway, an avowed 'painter of images' [and, uncoincidentally, one of the first group of directors to use digital imaging]. Even such a literate filmmaker as Wim Wenders, when toying with high-definition video images [in Until the End of the World, et al], uses them in a refreshing and engaging way [with that film's 'dream images']. As a century of cinema passes, so does the torch from Lumière to Méliès, from realism to illusion. But the way we can modify images is as likely to produce strange, unsettling unrealities as it is full-blown fantasy. Things are fused and altered by the processor, blurring the lines previously dividing these schools and their traditions.

The ability to morph, colourize and endlessly change the filmed image comes into its own if the footage is recorded digitally. Quality doesn't fade, as the picture was originally recorded in binary code, ones and zeros. The End of Celluloid shouldn't be mourned too long as this code enables a rebirth in innovation. We can play with the moving image in

surprising and subtle ways which haven't really fed through to modern-day cinema beyond the special effects spectactulars. It has been left to commercials and the pop promo to feed through these developments, but by their nature they are rarely accompanied by a complex narrative context. The inspirational and ambitious way in which cinema of the late '60s and '70s experimented with opticals, combining and clashing images on screen, is a route that can be returned to as the expense necessary to do this becomes negligible, and the tools come within the reach of anyone who can master a PC.

We are rapidly becoming a digital democracy, where more and more decisions are within our control through the decentralization and accessibility the technology allows us. It's taken for granted that in modern society imagemakers have power, but when everyone can produce these images, this becomes more enabling than disconcerting. The explosion in the number of digital channels of information [whether internet or television] creates the opportunity for a plurality of views and attitudes represented and available to everyone for the first time in history. Content and originality then become king, and we consumers of image and information start taking command. The desktop publishing [DTP] revolution of the '80s is mirrored by the revolution in desktop video [DTV] taking place today.

Digital video allows no excuse for poor quality production and brings the creation of broadcast images within everyone's reach. Control is transferred from a privileged few as the tools to record our passions become more readily available and easier to use. DV filmmaking jettisons a whole lot of bulky support rigs and crew, and is ideal for the kind of guerrilla filmmaking which carried American independent cinema in the early '80s through to its miraculous growth in the '90s. These talents have now matured into such iconic creative voices as Gus Van Sant, Jim Jarmusch and Hal Hartley. DV actually lends itself to this guerilla filmmaking model in a way which doesn't intimidate the user.

Of course, digital video isn't a panacea, and in terms of sheer quality it can't compare to 35mm or 70mm celluloid, but it's already catching up with super16mm. And while an older generation may rail against pixels as opposed to emulsion, there's a younger one who genuinely get a sensual pleasure or kick out of seeing blown-up video images. The time has passed when a film using any new form of effects

or editing could simply be dismissed as an MTV blow-up to fill a cinema screen. While the digital video field is currently filled with conflicting standards and expensive technologies, the near future promises low-cost, accessible equipment, delivering the quality of celluloid in a digital package.

The possibilities extend from production to distribution, always one of the main obstacles for independent film financing and exposure. As cinema chains look into the idea of piping films down fibre-optic cable straight through the projector from a single source [thereby saving millions on the costly process of replicating film prints for each screen a film is shown on], the possibilities pioneered by the open system of the internet become obvious. As cable with the appropriate fat bandwidth becomes available, video on demand becomes a reality. High-bandwidth networks mean independent filmmakers will be able to bypass the cinema chain cartels to become their own distributor. And just as the recording studio in the bedroom model has existed in music since the early '90s, so a film studio in your home could be the next model for the coming decade. The possibilities are endless, and onedotzero wants to be an enabling force in that. We are looking for pioneers in this new medium and if you want to follow that path or simply want to be informed about who these people are and the technologies and techniques they use, then you've found the right place.

'Now reference and reality disappear altogether, and even meaning — the signified — is problematized. We are left with that pure and random play of signifiers that we call postmodernism, which no longer produces monumental works of modernist type but ceaselessly reshuffles the fragments of pre-existent texts, the building blocks of older cultural and social production, in some new and heightened bricolage: metabooks which cannibalize other books, metatexts which collate bits of other texts — such is the logis of post-modernism in general, which finds one of its strongest and most original, authentic forms in the new art of experimental video.' [Postmodernism, or, The Cultural Logic of Late Capitalism, Frederic Jameson, 1991]

Matt Hanson

First appeared in onedotzero1 catalogue, 1997

biographical notes

caviar / tycoon graphics www.tycoon.jp

selected filmography

Nakamura Takeshi started working in video in 1991 and founded Caviar in 2000.
He has created videos for Giraffe, Fantastic Plastic Machine, 14, Boycott, Vibe,
Parco and Snickers. Caviar works independently as well as collaborating with other
artists such as Tycoon Graphics, transforming their designs into motion graphics
and animated work. Tycoon Graphics was established by Miyashi Yuichi and Suzuki
Naoyuki and creates work ranging from editorial, logo, print and packaging design.
Projects include identity creation for the Motion Element fashion brand and CD
covers for Tei Towa.

Caviar:

Mother, until we meet again,
animated series / 68, TV titles /
Kami-Robo, documentary project,
[c] 2003 Tomohiro Yasui +
butterfly-stroke inc. All Rights
Reserved. www.kami-robo.com /
Fantastic Plastic Machine, Take
Me To The Disco, music video

Caviar/Tycoon Graphics:

Tei Towa, Funkin' for Jamaica,
music video / Champagne Design,
personal project / Boycott, Iron
Tank commercial campaign /
Boycott, Industries commercial
campaign / Boycott, Layered Days
commercial campaign / Boycott,
Men's Rider commercial campaign

geoffroy de crécy

Geoffroy de Crécy is a Paris-based animator who, having worked in the games
industry, now makes music videos and commercials. He is currently best known for
creating music videos for his brother, French electro artist Etienne de Crécy.

Etienne de Crécy, Les Misérables,
music video / Etienne de Crécy,
Am I Wrong?, music video /
Etienne de Crécy, Scratched,
music video / Etienne de Crécy,
Tempovision, music video /
Rayman 2: The Great Escape,
video game, additional graphics /
Guinness commercial / Kellogg's
commercial

drawing and manual www.drawingandmanual.com

Drawing and Manual was set up in 1997 by Hishikawa Seiichi and Nagaoka Kenmei,
and specializes in motion graphics and websites. Based in Tokyo, its operations also
comprise the D&Department recycled furniture shop and café, which is expanding to
open in other cities. Hishikawa and Nagaoka also create experimental work and
curated the 'Motion Graphics' exhibition in Tokyo in 2000.

Airline, personal film / Prelude,
personal film / Grand Prix, per-
sonal film, commissioned for one-
dottv / Sonic Temple, YKZ, music
video / Honda, SMX commercial /
Hotwired Japan, PR video / Sony,
VAIO505 typeR, image video /
Sony Design Center, PR video /
Apple, Final Cut Pro 3, PR video /
DyDO, Real Black, commercial
motion graphics / POLYSICS bites
Viewsic, broadcast / Adobe
Dynamic Media Collection, motion
graphics / Electric Dragon
80000V, film title sequence /

Viewsic Live, opening sequence /
Viewsic, Countdown TV show,
opening sequence / Viewsic, Café
Viewsic TV show, opening
sequence / Viewsic, 1999 + 2000
Specials, TV show opening
sequence / Viewsic, LiveUK, open-
ing sequence / Apple's Creators
Portfolio, opening sequence /
Sony Ericsson, global brand
moving-image sequence

eyeballnyc www.eyeballnyc.com

EyeballNYC specializes in live action, graphic design, editorial, concept development
and original music/sound design. Commercial clients include Excite.com, Duracell,
Sprint, Lycos, McDonald's, Comedy Central, Nike and Canon.

DJ Tiga, Hot in Herre, music video
/ Disc Jockey TV series / NBA on
DirecTV / McDonald's, Really Want
commercial / IFC Fridays on Bravo
/ Summer Movie Megaplex / Lycos
commercial / Comic Remix / MTV
Hits ID Package / Comedy Central
2003 ID Package / McDonald's,
McRib commercial / Liberty Bank
commercial / MTV2 Sucker Free
Sunday / IFC Pulp Indies / MTV
Made promos / American Express
commercial / MTV Free Ride /
Nike, Made to Move commercial /
MAC Cosmetics commercial /

Tape [directed by Richard
Linklater], film titles

felt www.feltfilm.com

With a background and training in graphic design, directing and design team Richard
Carroll and Dominic Bridges set up Felt in 1998. In addition to their short film work,
they have created commercials in the US and UK. They are based in Clerkenwell,
London.

Underdog, documentary / Centre
for International Forestry
Research in Sumatra, Indonesia,
Spirit documentary / PlayStation
2, Gran Turismo 2 spots /
careerbuilder.com, TV spots /
Nissan, Primer GT spot / Fox
Sports Net, TV spots / MTV Base,
TV idents / Fifth Wheel, ident /
Crussh, TV idents

richard fenwick www.richardfenwick.com
www.refpnt.com

Richard Fenwick started his career as a broadcast designer at Static 2358 before
co-founding OS2, a film and design company where he made his first films: States,
People, Centre of Gravity and Fractions. After disbanding OS2 he turned to directing
music videos full-time with work for Death in Vegas, Teenage Fanclub, Sander
Kleinenberg, Timo Maas and Warp's Chris Clark. He also has an experimental
studio called ref:pnt [reference point], for his graphic-based film work and his
self-initiated art project RND# which will build into a series of 100 short films.

RND series [nearing 20 shorts]
States, personal short /
Fractions, personal short /
People, personal short, commis-
sioned for onedottv / Centre of
Gravity, personal short / Chris
Clark, Gob Coit, music video / In at
the Beep End/P.P.Roy, music video
/ David Guetta Vs David Bowie,
Just for One Day [Heroes], music
video / Timo Maas, To Get Down,
music video / Death in Vegas,
Dirge, music video / Timo Maas,
Shifter, music video / Lights,

Doom, music video / Teenage
Fanclub, I Need Direction, music
video / Bent, Magic Love, music
video / Lisp, Flatspin, music video
/ J Majik, Sacred Spirit, music
video / The Servant, In a Public
Place, music video / All Saints,
MTV trailer

motion blur: onedotzero biographical notes

furi furi www.furifuri.com

Widely known for the cute characters Furi Furi kun and Yoshida kun, Furi Furi design studio focuses on character design and animation for print, web and video. Set up by Tei Ryosuke and Sadaogawa Miho in 1998, the studio is also involved in exhibitions, VJing, merchandising [with the Electronic Virus figurines] and book creation. Clients include Honda, Capcom, Betty's Blue, Abahouse and Sony.

No.9, Mushi-no-ne, music video / Kagami, Valsimicos [Frogman Records], music video / Furi Furi kun and Yoshida kun, character animations / Betty's Blue promo video / Laforet motion ident / Girls Power Manifesto, fashion brand in-store video / What a Happy Life and Death, book / Electronic Virus character designs and figurines

groovisions www.groovisions.com

Founded in 1993 by Hiroshi Ito, Groovisions came to prominence through producing live visuals and music videos for cult Japanese music act, Pizzicato Five. Moving from Kyoto to Tokyo in 1997, they have balanced commercial work for clients with promotion and product releases of their own digital idol character, Chappie. Chappie has been part of many art projects and exhibitions, as well as commercial ventures including releasing a music CD, Welcome Morning, product endorsement, and a huge range of merchandising.

Pizzicato Five, Catwalk, music video / Fantastic Plastic Machine, Dear Mr Salesman, music video / Pizzicato Five, Ready Made TV / Volume 2: Hear a Symphony, music video / Chappie, Welcome Morning, music video / GRV113 / GRV1778 [GASDVD] / GRV1257 [New Chappie album] / GRV1756 – Nike Presto [Wieden + Kennedy Japan], commercial film / Pizzicato Five, live visuals

h5

H5 currently comprises animation duo Ludovic Houplain and Hervé de Crécy [one of the original members, Antoine Bardou-Jacquet, embarked on a solo directing career in 2002]. H5 made their name producing graphic design and CD covers for French music labels Disques Solid and Source. They have created music videos for acts including Air, Röyksopp, Playgroup, Ben Diamond, Alex Gopher and Zebda.

Alex Gopher, The Child, music video / Playgroup, Number One, music video / Alex Gopher, Use Me, music video / Röyksopp, Remind Me, music video / Massive Attack, Special Cases, music video / Subaru, The Ride commercial / Audio Bullies, The Thing, music video / Zebda, Oualalaradime, music video / Ben Diamond, Into Your Arms, music video / WUZ [Alex Gopher + Demon], Use Me, music video

johnny hardstaff www.johnnyhardstaff.com

After graduating from London's Central Saint Martins College of Art and Design, Johnny Hardstaff did not immediately enter the directing and motion graphics arena, but spent time developing a distinctive sculptural and infographic style. He later applied this style to great effect in his video work. Following an early exhibition animation for Letraset, his PlayStation 2-backed short films The History of Gaming and The Future of Gaming catapulted him into the spotlight.

The History of Gaming, short film for PlayStation / The Future of Gaming, short film for PlayStation / Freestylers, Phenomenon One, music video / Super Furry Animals DVD, Rings Around the World, music video / Radiohead, Push, Pulk / Like Spinning Plates, music video / FC Kahuna, Hayling, music video / Resfest 2003 title sequence

hexstatic www.hexstatic.tv

Stuart Warren-Hill and Robin Brunson formed Hexstatic in 1995. Based in London, they tour regularly throughout the world on VJ and DJ duties. Work includes collaborations with Coldcut, visuals for numerous event launches and title sequences and video remixes for MTV USA, the BBC, and cult Japanese anime series Cowboy Bebop. They produced the UK's first audiovisual album, Rewind, in 2000, and have released a number of records with Ninja Tune's Ntone label.

Rewind, AV album release [2000] / Bass Invader, music video / Vector, music video / Communication Breakdown, music video / Robopop, music video / Deadly Media, music video / Coldcut/Greenpeace, Timber, music video / Coldcut, Atomic Moog, music video [1996] / Lisbon Expo visuals collaboration with David Byrne [1998] / Sensurround Tour, The British Council / Channel Five, launch party visuals / Channel 4, Filmfour launch visuals / Casio, GSHOCK flag store

launch party visuals / Coldcut, world tour visuals / Channel 4, Vinyl Tap and SWEN, title sequences / MTV USA, 'video remixes' / BBC, Tomorrow's World, title sequence / Cowboy Bebop TV series, opening titles remix / Ninja Tune, Stealth club night, VJing / Listen and Learn, album release with accompanying live synchronized visuals / Coldcut, Christmas Break, music video [1990]

jeremy hollister www.plusetplus.com
www.jeremyhollister.com

New-York based Jeremy Hollister worked at post-production outfit R!ot Manhattan [formerly Manhattan Transfer] on a long list of commercial projects, including MTV US Movie Award idents and work for the Sci-Fi Channel, Sony Ericsson, Laforet and Nike. In 2002 he set up his own design company, Plus et Plus, to focus on a balance of commercial and personal projects. Self-initiated work includes the Peacekeeping video, and the Espiritos da Capoeira video for the Brasil Inspired project.

Peacekeeping, personal short commissioned for onedottv / Mulher, personal short [for Brasil: Inspired] / Espiritos da Capoeira, personal short [Judy Welfare for Brasil: Inspired] / Flips 4 [idN], personal short / Music for Eighteen Musicians, Steve Reich [Coldcut Remix], music video / 2001 MTV Movie Awards packaging / MTV2 camo motion graphics / MTV2 hip-hop motion graphics / Sci-Fi Channel ATM / Sci-Fi Scinema feature / Laforet,

commercial campaign, Japan / Peacekeeping exhibition, Zakka Gallery, New York

motion blur: onedotzero biographical notes

tim hope

www.passion-pictures.com

From creating personal animated greetings cards for his family, Tim Hope's animation career rapidly took off. His short film The Wolfman won the Edinburgh Film Festival McLaren Animation Prize in 2000, and was eventually converted into a PlayStation 2 commercial. His 'flat 3D' animated music video work for Coldplay cemented his reputation as a director, and resulted in a nomination in the best director category at the MTV music awards. Other work includes music videos and commercials for Jimmy Eat World, One Giant Leap, Hewlett Packard Computers and Robinson's Juices. His background as a stand-up comedian is evident from his short films and TV pilot for The Pod.

Birthday cards: Mum, Dad, Elizabeth, personal shorts / Jubilee Line, personal short / The Pod Techno Dawn TV pilot / The Wolfman, personal short / King Biscuit Time, I Walk the Earth, music video / Coldplay, Don't Panic, music video / Robinson's, My Mum and My Dad, TV commercials / Sony PlayStation 2, The Wolfman, short film/commercial / Coldplay, Trouble, music video / One Giant Leap, My Culture, music video / Jimmy Eat World, Sweetness, music video / Tuborg

Beer, Beer Yourself, TV commercial / Walt Disney's, Treasure Planet I'm Still Here [Jim's Theme], music video / Hewlett Packard, Bang & Olufsen, TV commercial

kuntzel + deygas

www.winney.com

Paris-based directing team Florence Deygas and Olivier Kuntzel move between chic live action and kitsch-inspired '60s graphic styles. They have created work for clients including YSL Jazz, and electronic music artists St Germain and Dimitri from Paris, and designed the title sequence for Spielberg's feature Catch Me If You Can [2002]. They are currently developing a feature film based on their self-initiated character-based project, Winney.

Winney Incognito Tokyo Tour, personal short commissioned by onedottv / Winney — A Cute Candidate, personal short / Catch Me If You Can, film title sequence [Spielberg/Dreamworks] / Bertrand Burgalat, The Sssound of Mmmusic, music video / St Germain, Rose Rouge, music video / Dimitri from Paris, Sacre Francais, music video / Dimitri from Paris, Une Very Stylish Fille, music video / James, Destiny Calling, music video / Pierre Henri, Psyche Rock [Fatboy Slim remix],

music video / Fantastic Plastic Machine, Reaching for the Stars, music video / Yves Saint Laurent, Live Jazz advertising campaign / HSBC, Chicken + parrot commercials / Renault Clio, drummer commerical

le cabinet

www.dotmov.com

Le Cabinet was formed in May 2000 by Benoît Emery and Marc Nguyen Tan. Emery studied at London's Royal College of Art and Les Arts Décoratifs in Paris before freelance art directing for Comme des Garçons and Louis Vuitton. He co-founded the Shaman design studio in Paris. Nguyen Tan studied film at Paris University, then art directed TV on-air design. He met Emery while he was art director at the Shaman design studio. He created work as Dotmov, before teaming up with Emery and taking on projects for a range of clients in print, web and moving image. As a musician Nguyen Tan records under the name Colder.

Streets, personal short commissioned for onedottv / Routine, personal short / Honda promotional video / Jazz 6, title sequence for French TV music series / Eurosport Channel ATP/WTA, broadcast titles

logan

www.hellologan.com
www.murmursofearth.com

Los Angeles-based design studio Logan is comprised of Alexei Tylevich and Ben Conrad. Based in the former Grand Royal record label offices of The Beastie Boys, they produce a combination of live action, animation and illustrative work. They have an ongoing personal cross-media project called Murmurs of Earth.

Jurassic 5, What's Golden, music video / Nike/LFL, Action Hero TV spot / Chris Isaak, Let Me Down Easy, music video / Ishii Ken, Beep Twist, music video / Money Mark, Information Contraband, music video / No Doubt, Underneath It All, music video / Murmurs of Earth, personal project / Target, Justin and Christina TV spot / DKNY commercial video MTV, Best Hip-Hop Video Awards packaging / Motorola commercial / Panasonic commercial / Samsung commercial / Mattel commercial

Gap commercial / Fox Sports spot / ABC Networks spot / Sci-Fi Channel spot

geoff mcfetridge

www.championdontstop.com

Geoff McFetridge graduated from the Graduate Design programme at Cal Arts and founded his Los-Angeles-based studio, Champion Graphics, in 1996. He produces primarily illustrative and graphic design work for clients including Marc Jacobs, Stüssy, Burton Snowboards, Tokion magazine and Xlarge. His directing work now encompasses music videos and commercials. He has exhibited his work internationally.

Citizen Cope, If There's Love, music video / Plaid, Itsu, music video / Simian, One Dimension, music video / The Avalanches, Frontier Psychiatrist, music video / Burton Snowboards, Bigfoot commercial / ESPN Winter X Games, Bears TV spot / ESPN Winter X Games, Bunnies TV spot / ESPN Winter X Games, Squirrel TV spot / HP, Nanotechnology, commercial / Jinro, House and Office, commercial / The Virgin Suicides film titles

psyop

www.psyop.tv

Boutique broadcast design operation Psyop creates animation and brand communications for a range of clients. Founded in September 2000 by Eben Mears, Marie Hyon, Marco Spier, Kylie Matulick and Todd Mueller, Psyop is based in the East Village, New York City. Experimental projects have included pieces for the onedottv television series and for the Brasil Inspired book and DVD.

Bombay Sapphire, Drift, personal film/commercial film / PPP, Personal Power Pathways, personal project / Come for Brasil, personal short for Brasil Inspired / Company Flow, End to End Burner, music video / AT&T commercial campaign / ESPN TV spots / Intel commercial / Lugz Footwear, Arrow TV spot / Merrell Footwear, Run Wild commercial / Pfizer commercial / Screenvision commercial / Starbucks commercial / Starburst commercial / VH1,

My VH1 Music Awards, show packaging / VW commercial

motion blur; onedotzero

biographical notes

150 alexander rutterford

Alexander Rutterford graduated in Graphic Design from Croydon School of Art, UK in 1991. He first broke into the film industry designing graphics on sets for movies such as Judge Dredd, then moved on to become a CG artist at production outfit Lost in Space. He now works independently as a director, creating music videos and short films.

Monocodes, personal film / 3space, personal film / Amon Tobin, Verbal, music video / Autechre, Gantz_Graf, music video / Radiohead, I Go To Sleep, music video / Squarepusher, Come on My Selector, infographics for music video

160 shynola www.shynola.com

Shynola was formed in 1999 by Gideon Baws, Jason Groves, Chris Harding and Richard Kenworthy who met at Kent Institute of Art and Design. They quickly created an impressive body of music video work for acts including UNKLE, Quannum, Grooverider, Morgan, Radiohead, Stephen Malkmus and Lambchop. They have recently branched out from pure animation projects to include live-action elements in their work.

Blur, Good Song, music video / The Rapture, House of Jealous Lovers, music video / Blur, Crazy Beat, music video / Queens of the Stone Age, Go with the Flow, music video / Junior/Senior, Move Your Feet, music video / Athlete, You Got the Style, music video / Morcheeba, Otherwise, music video / Lambchop, Is A Woman, music video / UNKLE, An Eye for an Eye, music video / Stephen Malkmus, Jo-Jo's Jacket, music video / Radiohead, Pyramid Song, music video / Morgan, Flying High, music video / Grooverider Vs B-REAL, On The Double / Quannum, I Changed my Mind, music video / UNKLE, Guns Blazing, animations / S.F.U.K title sequence / Dopesheet, TV series stings / Radiohead, Kid A blips commercials/promos / NatWest, Fishing Line [TBWA], commercial / Orange, EAK [WCRS], commercial / Nike, Presto series [Wieden & Kennedy], commercials / The Littlest Robo, animated short film / Doug Gives a Talk on Electronics, short film

170 stylewar www.stylewar.com

Motion design group Stylewar are based in Stockholm. Since 1998 they have worked on a wide range of title sequence and broadcast animation projects. Their music video work increased after they produced the Main Offender video for The Hives, and they have created videos for Moby, Morcheeba, Koop, Millencolin, The Apex Theory and The Jon Spencer Blues Explosion.

Junior/Senior, Boy Meets Girl, music video / The Hives, Main Offender, music video / Moby, Sunday, music video / The Rolling Stones music video / Loop Troop, Fly Away, music video / Moby, In This World, music video / Morcheeba, Way Beyond, music video / Toploader, Some Kind of Wonderful, music video / MTV graphics, title sequence / Nar & Fjarran, title sequence / MTV Weekend, title sequence / Reaction, title sequence / Moderna svt, title sequence / Popstars, title sequence / Slussen, title sequence / Burntsibum, title sequence / Frezza commercial / Renault Polo, Petale, Couple commercials / Smilmer commercial / Vichy Nouveau, Ginseng commercial / H&M Sale commercial spot / Nike commercial spot / Terrain, personal short commissioned for onedottv

176 sweden www.swedengraphics.com

Stockholm-based Sweden focus mainly on graphic design and print illustration. Their most visible ongoing design work is probably their graphics for fashion label Hennes. Other clients include Diesel, Ikea, Fox, Doktor Kosmos and Stockholm Records. They have produced illustrations for magazines such as Arena, SleazeNation and Neo2.

swedotzero, personal short commissioned for onedottv / Stockholm Records showcase promo / Animation inserts for Hennes campaign

180 tanaka hideyuki

With a background in graphic and broadcast design at NHK, Tanaka Hideyuki produces a prolific range of work out of his Tokyo-based studio Frame Graphics. His music video direction includes Polynasia for Ishino Takkyu, which was voted one of the country's best ever music videos by MTV Japan. Through his studio and the Super Lovers brand started by his brother, he markets merchandise based on his cute character designs. Teamed up with Denki Groove's Pierre Taki and DJ Tasaka he has performed as the VJ group Prince Tongha.

Spectre 21, short film / Denki Groove, Nothing's Gonna Change, music video / Denki Groove, Flashback Disco, music video / Ishino Takkyu, Anna, music video / Ishino Takkyu, Polynasia VJ Edit [Kioon Sony], music video / Shingo Mama, Gakuen Tengoku, music video / Tomoe Shinohara music video / Bust-a-Move, Dance Summit 2001 animation sequence / PlayStation, Bust-a-Move, game series, character design / Super Lovers, fashion label designs and art direction / Fila, Snow Board and Body Board commercials / Flyer TV, Fuji Television Network / Ugo Ugo Looga, Fuji Television Network, kids' TV programme / Super Milk-chan, character design and TV titles

186 tanaka noriyuki

Tanaka Noriyuki spearheaded a multi-disciplinary design approach in Japan. Through his Alternative Space studio he creates brand communications, moving image, photography, painting, sculpture and exhibition design. Work includes music videos for Ishii Ken and Brahman; commercials and art direction for Japanese clothes brand Uniqlo; and experimental work such as NTV [Noriyuki Television].

Ishii Ken, Game Over, music video / Brahman, Arrival Time, music video / NTV, personal project / DECADE 1989-1999, book publication of artworks and activities / The Art of Clear Light [CD-ROM] / The Pillow Book [directed by Peter Greenaway], art direction

190 tanida ichiro www.jjd.co.jp

A graduate from Tokyo Art School, Tanida rapidly gained prominence for his print graphics. In 1987 he set up the Neo-Art Group with Sugiyama Hiro [Enlightenment], and continued experimenting with painting, drawings, and more video-orientated work. His John & Jane Doe [JJD] studio, founded in 1996, has produced visuals and music videos for Tei Towa, campaigns for Tokyo's Laforet department store, and ongoing print and motion design using Tanida's CG character, Jane.

Tei Towa, Mars, music video / Tei Towa, Fly, music video / Tei Towa, Technova, music video / Natural Calamity, Resonance, music video / GTS, Black & Rare Groove, music video / Hikaru Utada, Fly Me to the Moon, music video [with Ito Keiji and Aoki Katsunori] / MAWS, in-store video for clothing company PPCM / Da Pump, TV titles and shorts / SM Station, Run and Akiyama, shorts for anime TV pro-gramme / Laforet Grand Bazaar, '96-'99 campaigns / MTV jingle, spot / Honda HR_V commercial /

Suntory, Cocktail Bar commercial / NIJU, TV_TOKYO, direction / Roommania#203, Sega Dreamcast game, character design/direction / Underground AtoZ, CD-ROM

196 teevee graphics www.teeveeg.com

Founded in 1995 by creative director Kojima Junji, Teevee Graphics produce title animations, CG, commercials and music videos. Their work moves between computer-generated imagery, analogue-orientated hand-drawn animation, and live action. They have released a DVD of their exhibition of personal motion graphic films, Video Victim [which features over a dozen shorts], and continue to develop personal projects and short films.

Hyde, Hello, music video / Acidman, various music videos / Ishii Ken, Strobe Enhanced, music video / Yuki, The End of Shite, music video / Yoshinori Sunahara, Lovebeat, music video / Hoff Dylan, Season, music video / Audio Active, Element of Rhyme, music video / Kirinji, Drifter, music video Audio Active, Psychobuds, music video / Kazuyoshi Saito, Hey! Mr Angryman, music video / Evian, Evian Cup commercial / Shiseido, Praudia and D-program, commer-cials / NTT DoCoMo Kyushu,

i-shot, commercial / Calorie Mate Jelly commercial / Canon commer-cial / Honda, Fit commercial / WiLL commercial / Digital-TUKA Kyushu commercial / NTT DoCoMo, i-mode commercial / Animax broadcast branding / NHK broadcast brand-ing / Midnight Kingdom broadcast branding / News Station broad-cast branding / Vibe Index broad-cast branding

204 the light surgeons www.thelightsurgeons.co.uk

London-based VJ and filmmaking group The Light Surgeons have built on their reputation in club visuals, expanding their activities in recent years into audiovisual exhibition creation, short film direction and title design. Installations include 'Grande Hotel Salone' for Ron Arad Associates, 'The Sum of Three Parts' for Bloomberg, and 'Stealing Beauty' at London's Institute of Contemporary Arts.

The Chimera Project, Newcastle and Middlesborough, documentary films / Echelon_SWEN, short film / The City of Hollow Mountains, personal short film / Thumbnail Express, personal short film / Reel 9, personal short film / The Wild Man of New York City, person-al short film / Cornershop, Good Shit, music video / The Herbaliser, Wall Crawling Insect Breaks, music video / Stealing Beauty — British Design Now, ICA, installation exhibitions / The Sum of Three Parts, Bloomberg, installation film

/ Grand Hotel Salone, Ron Arad, installation film / Warhol Retrospective, Tate Modern, opening launch visuals / London Loves Laforet, installation films / Exhibit B, Budweiser, installation film / APB — All Points Between, live performance / Electronic Manoeuvres, live performance / Ocularis, live performance

210 zeitguised www.zeitguised.com

Henrik Mauler and Jamie Raap established Zeitguised in Stuttgart in 2001. Their animated work ranges from architectural explorations to music videos. They have also designed websites for Guise, Konkussiondeluxe, Change Your Face and Quartz CSD. Since March 2003 Zeitguised has been in collaboration with lostinspace, a global network of designers and filmmakers creating imagery for the commercials, features, broadcast, and print markets.

Popular Mechanics, Chicago Loop, personal short / Syntax of Construction, personal short / No C No K, personal short / Kontaktschmelze, personal short / Winkelgeister_PAL, personal short / Fold research project, stage visuals / MTV North, rebranding proposal / MTV Unpaused, MTV Networks Europe rebrand project

motion blur: onedotzero biographical notes

author biographies
and thanks

onedotzero

onedotzero's digital moving-image project was established in 1996, at the beginning of desktop digital filmmaking. The first onedotzero festival, directed by Matt Hanson and produced by Shane Walter, was an underground hit in 1997 at the Institute of Contemporary Arts, London. Later that year saw the founding of onedotzero limited, and the festival grew to encompass new forms and hybrids of moving image under the joint direction of Shane Walter and Matt Hanson. Matt Hanson stepped down as director at the end of 2001.

Since its inception onedotzero has collated and commissioned hundreds of hours of original programming for the eponymous annual digital creativity festival and other related projects. It has been the largest dedicated digital film festival in the world since 1999. Internationally onedotzero now has a presence in over fifty cities across the world and has a network of capsule festivals in countries from the UK to Japan, China to Australia. Its global reach, progressive programming and huge audience draw is unmatched.

In addition to the festival, onedotzero has produced the TV series onedottv and 12-part onedottv_global for the UK's Channel 4. Other production work includes award-winning short films, interactive media, installations and live event productions and commissions.

In Screen International's 25th anniversary issue, onedotzero was named as one of the top ten visionaries of the UK film industry, alongside Ridley Scott and Lynne Ramsey.

Since 2002 onedotzero has extended its audience reach with tours across key cities from London to Berlin, Paris to Tokyo, Melbourne to Shanghai. The onedotzero DVD label was also launched to much success in Japan. Recent film productions include Salaryman6, directed by Jake Knight and shot in Tokyo. It was the winner of the London Rushes Short Film Award, winner of the Raindance short film official selection and a Silver in the London International Film Festival's Turner Classic Movie Shorts award.

The onedotzero DVD label was launched in Europe in 2003 with new releases throughout 2004 and beyond. onedotzero is perfectly placed to begin active distribution of key films, making available the innovative works it has curated and produced to other outlets through its short film agency, launched in 2003. Continuing plans include further worldwide releases from the onedotzero DVD label, and ongoing film and television productions of short and feature-length projects.

onedotzero is now recognized internationally as an innovator in the digital film field, responding to briefs in a unique and original way which sets it apart from traditional creative agencies. Its cross-media approach allows innovative mixing of media, styles and techniques. onedotzero will continue to consult and work on select commercial projects in the area of moving image and brand development. With a defined outlook and relationships with the next generation of moving imagemakers, onedotzero is able to draw from an unprecedented range of talent, from non-traditional areas such as graphic design, illustration, architecture, new media, and club backgrounds, to produce startling original work.

Subscribe to the onedotzero newsletter to find out more at: www.onedotzero.com or email info@onedotzero.com

Shane RJ Walter

Shane Walter established onedotzero limited as co-director of the project and company in late 1997, drawing on his diverse background and experience as a producer and director across a range of media and industries from publishing and computer gaming to theatre and contemporary art.

He became involved in new media in the early '90s, the birth of multimedia CD-ROM releases and interactive film. As a freelance producer and director he worked on projects with properties such as Lara Croft and Tomb Raider for Eidos and 007 for MGM, as well as producing award-nominated online sites for The Edinburgh International Festivals and The London Marathon, working with Arawak Interactive Marketing.

A self-trained photographer, his work has appeared in national newspapers and specialist magazines including The Times, The Independent, Variety and Time Out. He has worked as a media consultant and marketing specialist for a range of clients in the artistic fields, and has written articles for publications such as Creative Review, CGI and New Media Age. He participates in many international events and film and media festivals as a speaker, judge and presenter.

For a number of years he was the producer for critically acclaimed mixed-media theatre company 606, commissioning new writing and producing neglected classics and European plays never before performed in the UK. The mixed-media productions involved collaborations with musicians, filmmakers, furniture designers and architects, including Scanner, Beaumont Hannant, EOS Chamber Orchestra, Alex Relph Furniture and Press+Bastyan. 606 also spawned the multi awarding-winning comedians The League of Gentlemen who went on to make radio, television and stage productions.

He continues to direct onedotzero and its related projects as well as consulting on the creative use of moving-image concepts in marketing, branding and advertising.

Matt Hanson

Matt Hanson is a writer and filmmaker, acknowledged as a leading authority on digital film and contemporary trends in moving image. He currently creates advanced moving-image projects through his studio, V.I.A. [Visual Intelligence Agency].

Hanson has been at the forefront of emerging cross-media artforms and new forms of filmmaking since the early '90s. In 1996 he created the onedotzero project as an extension of his writings and interest in contemporary filmmaking, producing, directing and developing a host of cutting-edge digital film/cross-media productions. In 2001 he stepped down from onedotzero to concentrate on developing new ideas and writing.

Early work included independently producing the first London Film Festival website, and being the first contributing editor for Dazed & Confused magazine. He has contributed to international publications including The Face, The Guardian, The Independent, Another, Trace, Blueprint, Design Week and Res. He recently completed a further book, The End of Celluloid: Film Futures in the Digital Age.

Acknowledgements

A huge thanks to all the exceptional filmmakers, designers, artists, producers, production companies and staff who contributed to making this book unique. Your spirit of adventure and ground-breaking progression is an inspiration for many.

Shane
I would like to dedicate this book to everyone who has been part of the adventures in moving image with onedotzero over the years and around the globe and who have all had a hand in making them possible, in particular Anna Doyle and all onedotzero colleagues; the onedottv crew; Andrew Thomas and onedotzero_nippon committee; and State.

Thanks to Jo, Felicity, Laura and Laurence at Laurence King for their belief and patience and most of all to Philip O'Dwyer at State.

An extra special thanks to my ever supportive partner Sophie and, of course, my Mum, sister Tania, my family and the Woods family.

Matt
Thanks to all the people who have supported me during my onedotzero adventures and beyond — filmmakers, artists, designers and colleagues — too numerous to mention; Shane, a great travelling and project partner through those five years of moving-image travels; Sam, for his dedication to the cause. And most of all to Leonie, for her belief, commitment and insight.

index

Figures in bold refer to main entries;
figures underlined refer to captions and illustrations

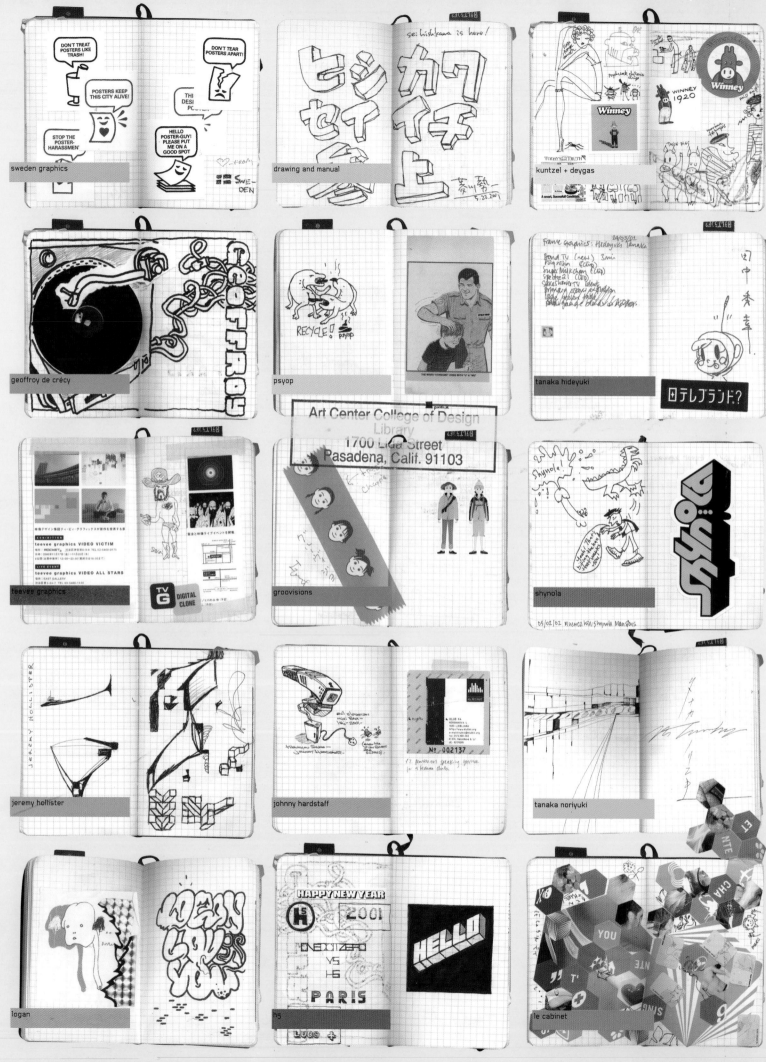

sweden graphics

drawing and manual

kuntzel + deygas

geoffroy de crécy

psyop

tanaka hideyuki

teevee graphics

groovisions

shynola

jeremy hollister

johnny hardstaff

tanaka noriyuki

logan

h5

le cabinet